THE EXTRAORDINARY IMAGE

THE EXTRAORDINARY IMAGE

Orson Welles, Alfred Hitchcock, Stanley Kubrick,
and the Reimagining of Cinema

ROBERT P. KOLKER

Rutgers University Press
New Brunswick, New Jersey, and London

Library of Congress Cataloging-in-Publication Data

Names: Kolker, Robert Phillip author.

Title: The extraordinary image: Orson Welles, Alfred Hitchcock, Stanley Kubrick, and the reimagining of cinema / Robert P. Kolker.

Description: New Brunswick, New Jersey: Rutgers University Press, 2016. | Includes bibliographical references and index. | Inlcudes filmography.

Identifiers: LCCN 2016012316| ISBN 9780813583099 (hardcover: alk. paper) | ISBN 9780813583112 (e-book (epub)) | ISBN 9780813583129 (e-book (web pdf))

Subjects: LCSH: Motion pictures—United States. | Welles, Orson, 1915–1985—Criticism and interpretation. | Hitchcock, Alfred, 1899–1980—Criticism and interpretation. | Kubrick, Stanley—Criticism and interpretation.

Classification: LCC PN1993.5.U6 .K58 2016 | DDC 791.430973—dc23

LC record available at https://lccn.loc.gov/2016012316

A British Cataloging-in-Publication record for this book is available from the British Library.

Visit our website: http://rutgerspress.rutgers.edu

Manufactured in the United States of America

The Imagination is not a State: it is Human Existence itself.

—William Blake

The greatness of images isn't in the coherence of their narrative logic, or the nuance of their dramatic implications, but in their excess—not in what they mean but in what they are.

—Richard Brody

It's funny how the colors of the real world only seem really real when you viddy them on the screen.

—Alex in *A Clockwork Orange*

CONTENTS

ILLUSTRATIONS

ACKNOWLEDGMENTS

My thanks to Marsha Gordon, who read the manuscript more than once and helped give it form and coherence. Any lapses in these pages are mine alone.

Nathan Abrams, my colleague in Kubrick, read the proofs with a sharp and knowing eye.

David Wyatt, a steady intellectual companion, was a source of ideas, encouragement, and good humor. Parts of this book were directly influenced by his work.

Many thanks to Marilyn Campbell at Rutgers University Press and Joe Abbott, who copyedited the book with an acute eye.

Leslie Mitchner, my editor at Rutgers, saw the potential of *The Extraordinary Image* when it was only an idea. She supported, corrected, and pressed me to realize that potential.

THE EXTRAORDINARY IMAGE

PRELUDE

Movies are about making images and editing them into stories. Editing is an art. Image making, as its root meaning suggests, is about imagination. For me, the most important thing about a movie, often secondary even to its story, is the image: what filmmakers show us and what we make of what we see. The French director Jean-Luc Godard made a pun about the images in his films: "Ce n'est pas une image juste, c'est juste une image": It's not a perfectly right image; it's just an image. Godard's pun, a disingenuous act of modesty from a filmmaker whose images (and editing) in the 1960s changed the look of film worldwide, contains some useful wisdom: if what we see when we look at a film is just an image, and most films are made of perfectly ordinary images, just images, we tend to look through them at the story they tell. And this is what most directors want to happen. "I just want to tell a good story," they will say if pressed. But what happens if a director creates *une image juste*, a perfect, precise, extraordinary image, even, as Richard Brody suggests, an excessive image. John Ford made extraordinary images. His compositions of westerners riding between the crags of Monument Valley create an imaginary vision of the country's past, an indelible representation of a history that exists only in Ford's films. Other directors have flashes of extraordinary image making, moments

of visionary greatness. Robert Altman's anti-Ford western *McCabe and Mrs. Miller* creates a frigid world of figures scurrying through the blue cold of a half-built frontier town or the golden light of a saloon or brothel, nervously composed by his fluid zoom lens. Oliver Stone makes extraordinary images. His great films of the early 1990s—*JFK*, *Natural Born Killers*, and *Nixon*—are not only made by strong, bold images but by tying the images together to create powerful montages of history and violence. Paul Thomas Anderson, in *There Will be Blood* and *The Master*, makes strong, arresting images.

There are others, directors who take their time to interpret the world, indeed create it through a cinematic eye. Three of these depend so thoroughly on the image, sometimes working outside of, even against, the conventions of popular movies, that their films can be placed in a class of their own. They fascinate and move me enough to write a book about them. Orson Welles, Alfred Hitchcock, and Stanley Kubrick show a consistent regard for building their images and telling their stories by means of them. These images differ markedly for each director, but within their specific originality is a regard for the eye, for the world that is uniquely seen and interpreted.

Alfred Hitchcock told François Truffaut: "The placing of the images on the screen, in terms of what you're exactly expressing, should never be dealt with in a factual manner. Never! You can get anything you want through the proper use of cinematic techniques, which enable you to work out any image you need. There's no justification for a short cut and no reason to settle for a compromise between the image you wanted and the image you get. One of the reasons most films aren't sufficiently rigorous is that so few people in the industry know anything about imagery." Hitchcock, Welles, and Kubrick knew everything about imagery. They knew that the stories they want to tell are based on the ways in which they are seen and communicated. They *depend* on our willingness to come the terms with them in a compact that few other filmmakers are daring enough to make, that we will be

willing to meet them on their terms, to read a Hitchcockian high-angle shot, an uncanny Kubrickian symmetrical composition, a sinuous Wellesian tracking shot. Read them, respond to them, and understand them. Few directors are as daring in their approach and as daring in their demand that the viewer be with them.

In *The Daemon Knows: Literary Greatness and the American Sublime*, Harold Bloom talks about his selection of writers (Hawthorne, Melville, Whitman, James, Frost, Eliot, Faulkner, among others) as writers who "represent our incessant effort to transcend the human without forsaking humanism." These are writers driven to reach beyond the quotidian, who attempt to discover how far they can go before their reach exceeds their grasp. They redefine the human, they traffic with the uncanny, and they engage the form of their art with incredible passion. They are also writers who touch Bloom himself deeply, passionately and define for him what he calls the American sublime "extraordinary hyperbole—not an exaggeration but an untamed casting, in which the images of *voice* break or scatter ashes and *sparks*." If I substitute the *eye* for Bloom's *voice*, we have an adequate description of all three of our directors. Sparks are scattered by each of them.

Ashes are scattered far more by Hitchcock and Kubrick, for their vision is dark and violent. Welles scatters fire as well as sparks. His is the sublime of excess, which, as William Blake knew, leads to the palace of wisdom. But all three understand that wisdom lies in the knowledge that seeing too much is never seeing enough, that the more the camera probes, explores, and shatters what it sees, the more there is to see still more.

I'm struck by how close Bloom's definitions of his choices come to my own choice of filmmakers in this book. These are filmmakers of the sublime. They move me out of myself; they outstrip the ordinary and create worlds distinctly cinematic, expressively personal, resonant with complex ironies. Welles is a consummate humanist; Kubrick often looks

at the ways the human is transcended or, more often, diminished; Hitchcock, in his own sublimity, is never quite sure about where humans stand in their exposure to violence and their sexual confusion. But no matter what, the work of these filmmakers remains inimitable, and yet their influence extends to almost everything we see on the screen.

The Passion of Film

Writing about film is a great pleasure. My love for film, my emotional and intellectual engagement with movies, with the moving image itself, has allowed me to trace that engagement across many books. My particular attachment to and enthusiasm for the films of Orson Welles, Alfred Hitchcock, and Stanley Kubrick have made me want to talk about their films, get closer to them, share the intimacy that I feel toward these extraordinary artists, whom I know only through their work. My hope is that the reader will share my pleasure, will want to be engaged with a pursuit through their films, to enjoy a conversation with them, about them, in a proximity to their work.

But why these three when there are so many more to talk about? Part of it is sticking power. I watch a lot of movies, so many that given my old, not fully functional memory, I need to refer to a list to remember what I've seen. When I'm asked by friends what I can recommend, I need to offer to e-mail them recommendations after I look them up in my Netflix history. Add to that, as far as contemporary film goes, the reality is that I'm finding more interesting original material on HBO, Netflix, or Amazon streaming, and there is a real experience of being overwhelmed by images and the narratives made out of them, whether they are extraordinary or not.

The problem is amplified further by the fact that I'm not a film snob. My tastes are crazy—from high serious to low comedy to shoot 'em ups. *Vertigo* may be a favorite, *Touch of Evil* a constant source of pleasure, *2001:*

A Space Odyssey guaranteed to excite no matter how many times I've seen it, but for my wife and me the 1930s screwball comedy *The Awful Truth* is "our film," and the latest Melissa McCarthy film will make us laugh immoderately. I love to watch Jason Statham or Liam Neeson firing away at Russian mafiosi. I concluded a recent textbook with a comparison, not unfavorably, of *Vertigo* and Judd Apatow's *This Is 40*. All of this is to say, despite my attachment to strong image making, that film in so many of its manifestations gives me enormous pleasure, which is carried over into writing about film and its delights.

At the same time, writing about film has certain risks when talking seriously about a subject that is often not so serious and not taken seriously. Serious film criticism is a relatively young discipline and doesn't quite have the history and gravitas of more established humanities fields like literary studies, art history, or history itself—good film criticism borrows from all of these. People may want a poem or a painting explained but not necessarily a film. And most filmmakers don't want to make films that require an explanation. Writing about film therefore requires a passion that overcomes these certain risks and a means of communicating that passion. If I am forever intrigued and delighted by the way films create their imaginative worlds and invite us to briefly live in them, I want to believe that a reader will share that delight. To paraphrase George Toles, I want to know, as I watch, what a director intends to do—will he move his camera, create an interesting composition, create a startling edit, do something that moves me beyond the plot? Will the plot itself reveal a new way of thinking about how characters interact, about how the filmmaker thinks of the world? Will you, reading this, see how thrilling this can be?

But I haven't yet answered the question about why I've chosen, in this book, to concentrate on Orson Welles, Alfred Hitchcock, and Stanley Kubrick. Allow me to arrive at this with some background. In the fall of 1968 I went with some friends to a screening at the New York Film Festival of Orson Welles's new film, his first in color (at least the first

in color that got released—he shot color footage for his unreleased *It's All True* documentary in the early 1940s), a short film made for French television, *The Immortal Story*. The previous spring, I had returned from nine months in London, where Columbia University sent me with a generous fellowship to research my doctoral dissertation on William Blake and eighteenth-century poetics. It was called "The Altering Eye." During my London stay I spent most afternoons at the British Museum, reading eighteenth-century books. Most evenings were spent at the National Film Theatre with my late friend David Gold, a fellow who in those days would have been called a "film buff." Those evenings were happier and more satisfying than the afternoons at the dimly lit BM reading room. There, I learned a lot about how ideas of poetry, of perception itself, were changing in the late 1700s. What I learned about the eighteenth-century concept of the sublime has influenced this book. At the NFT I learned about the power of narrative images—or perhaps more accurately, I *felt* the power of those images. The learning was still to come.

I always went to the movies. Living in Long Island City, with many movie theaters in our neighborhood, my parents took me regularly. When I reached an independent age, I took myself. I remember seeing *The Third Man* (in which Orson Welles has a prominent role) with them in 1949, and I recall a nightmare after seeing Nicholas Ray's *Knock on Any Door*. In 1951 I ran out of the theater in terror when the alien's arm was severed in Howard Hawks and Christian Nyby's *The Thing from Another World*. I was movie impressionable. The fright over *The Thing* did not dampen my love for science fiction, but soon other things intervened in my moviegoing life. There was a gap during the late 1950s and early 1960s while I was in college. My interests were first in science and then in English literature. I spent my time reading, listening to Jean Shepherd on the radio, and investigating the endless possibilities of New York. I was a regular at the Village Vanguard's Sunday afternoon jazz sessions (admission ninety-nine cents), where I saw every major jazz artist and some comedians like Mike Nichols

and Elaine May. My earliest public writing was a jazz column for the Queens College paper.

I was reintroduced to film when I was at Syracuse University, preparing for my MA in English literature. My thesis was titled "Toward a Definition of Myth in Literature" and was influenced, as is everything I have written since, by Northrop Frye's *Anatomy of Criticism*. The university theater mounted a season of films by Luis Buñuel, the great Spanish surrealist, whose films ranged from the early *Un chien andalou*, made in collaboration with Salvador Dalí, and *L'âge d'or*, to the late *Belle de jour* and *That Obscure Object of Desire*. The films I saw in Syracuse were largely from Buñuel's Mexican period (he was exiled from Spain during the Franco reign), films like *Los olvidados*, but also *Viridiana*, which he made quietly back in Spain until the film was discovered and Buñuel was kicked out again. The effect on me was astonishing, my eye altered: I could see a visible continuity and coherence from film to film—not merely in what Buñuel was saying in the films but, even more important for me, a formal continuity, the way the films looked, the way Buñuel and his frequent cinematographer Gabriel Figueroa managed the subtle grayscale and the composition of the images from film to film. The idea of coherence and continuity is of course basic to the study of literature. It is commonplace that an author or poet develops a recognizable style and coherent set of themes that are developed from work to work. The anonymity of film, before the dawn of film studies, worked against the notion of continuity. Each film was thought to come fresh born out of nowhere. And, with few exceptions (like Hitchcock, who worked to assure his recognition), the director was rarely known or recognized. The stars were the ones who drew attention.

In the course of viewing the Buñuel films, I was apparently discovering for myself the auteur theory of film criticism. The French had already done that in the late 1950s. I came to it, naively and independently, just as many others at the beginning of film studies were doing, though perhaps with less naiveté. Andrew Sarris was creating the auteur theory for

American film in his columns for the *Village Voice* and in his 1968 book, *American Cinema*. He also published, in English, a year's worth of the French auteurist journal *Cahiers du cinéma*. Pauline Kael would be busy attacking auteurism in the *New Yorker*. But Sarris's book was an important landmark. While there might never be any doubt that Luis Buñuel was the creative force behind his films, as was the case with many other European directors, American cinema had suffered from that inherent anonymity I noted earlier. The studio system banked on stars, not the creative craftspeople behind the camera. Beginning in the 1950s the French began speaking authoritatively and passionately about filmmakers like Howard Hawks, John Ford, Orson Welles, and Alfred Hitchcock. American film was being rediscovered through the use of a proper name. In his book Sarris created a veritable encyclopedia of American directors and led the way for the auteur theory to take root and allow American movies to be taken seriously. He classified and ranked directors, offering short and insightful comments on each. He allowed us to see that American film could be honored and that the director was in charge of translating the words of a screenplay into the images we see on the screen.

I expanded my own viewing from Buñuel to the wide range of European cinema that was arriving in the early 1960s—Godard, Truffaut, Chabrol, Antonioni, Fellini, Bergman, the British "Kitchen Sink" films—and I began to look more closely at American film. A 1940s Warner Bros. film (I forget the title, but it may well have been *The Maltese Falcon* or *Casablanca*) shown at the Syracuse art theater was a revelation. There was, I realized, a richness there, the collective work of a studio, its actors, screenwriters, cinematographers, production designers, directors, and editors that produced an illusion of seamlessness so seductive that it seemed to demand either complete surrender to the images, dialogue, and story or an analytical stance that would attempt to parse the film's complex syntax that worked to render that very syntax invisible. I chose both.

My introduction to Welles also took place at Syracuse University, and it was not via *Citizen Kane* but a later film: his 1962 adaptation of Franz Kafka's *The Trial*. Here was Welles at his most heatedly baroque, his images huge and overwhelming, his camera lunging through the wastes of an abandoned Paris railway station made to stand for the labyrinths of Josef K's nightmare. This was filmmaking at its most frenzied and committed to the eye's ownership of the space that it created. Where Buñuel showed me the consistency of style and idea, a neorealism of the unconscious as I once called it, Welles showed me the persistence of a vision that was antirealist and fully in command of the creation of an alternative cinematic universe.

By the time of the screening of *The Immortal Story* at the New York Film Festival, I had become fully committed to Welles's work and the study of film, all the while continuing my dissertation on William Blake. The title, "The Altering Eye," came from a line in his poem "The Mental Traveller": "For the Eye altering alters all." After I got my degree, the title was all that remained of the dissertation; I used it for my book on international cinema. Now I was looking at *The Trial* at least once a year. It became a touchstone for me, a way to judge film reviewers and critics. I assumed that if they did not like this film, the rest of their judgment was suspect. Even though I didn't see *Citizen Kane* until my London stay (at a local cinema in Golders Green with my friend David—after the film someone asked me what *Rosebud* was), I was captivated by Welles in a way that, at that point, no other artist has ever held my imagination. I became what one of Welles's biographers, Simon Callow, called a "Wellesolator," for whom poor Orson could do no wrong. As an amateur photographer I began making dark, high-contrast Wellesian images. So, when I left the festival screening of *The Immortal Story* and my friends wanted to talk, I was so moved by this little film that Welles made for French television that I left them behind, took the bus up to 110th Street, and wrote on my program: "If Mahler had written a chamber work."

Kubrick's *2001: A Space Odyssey* became another touchstone. I saw it during its premiere engagement at a Cinerama theater in Leicester Square during my London stay. The screen was enormous, the images overwhelming. As would be my experience (and that of many others) with many of Kubrick's films on first viewing, I was less than impressed. I saw it again back home—and again, and again. The intricacy of its images, the audacity of its ideas kept revealing themselves. I saw it yearly, just like *The Trial*. *2001* was not my first Kubrick. I had seen *Dr. Strangelove or: How I Learned to Stop Worrying and Love the Bomb* when it first appeared in 1963. The boldness of the film was breathtaking, its politics astonishing. As I grew older, I became more and more attached to Kubrick's work. (My wife and I began referring to a particular color favored by the director as "Kubrick blue" and a crescent moon as a "Kubrick moon.") I wrote about his films in *A Cinema of Loneliness*, rethinking and reevaluating his work across each edition. More thinking, more writing, more teaching, and Kubrick's films, indeed Kubrick himself, became a touchstone of my intellectual life. So much so that I tried to contact him in the early 1990s, hoping to write a biography. I was able to exchange faxes with Kubrick's assistant, Leon Vitali; I spoke with Alex Singer, his childhood friend and early collaborator. I made contact with James B. Harris, Kubrick's producer on *The Killing*, *Paths of Glory*, and *Lolita*. My university librarian even offered to purchase Harris's archives. Harris did not see any value in posterity. With a curt note from Julian Senior, Warner Bros.' London publicist and Kubrick protector, I was denied any access to Kubrick and his archives. This turned out to be a good outcome: it kept alive for me a cherished myth, that here was a kindred spirit, another New York Jewish intellectual who loved to walk the streets of his city during his youth. Kubrick turned to photography and then filmmaking; I took pictures, too, but ultimately turned to writing about film, including Kubrick's, including Welles's, including Hitchcock's. Meanwhile, with his archives now available at

the University of the Arts in London, Kubrick awaits a biography of the stature of Richard Ellmann's *James Joyce*.

I saw *Psycho* when it first appeared in 1960 and was as stunned as any other viewer at the film's boldness, its extravagant violence and lack of sentimentality. But my understanding of the intricacies and ironies of Hitchcock's work grew with my reading about him. This was a case of learning about Hitchcock from film scholars who, early on, were analyzing his work deeply and passionately. In addition, Hitchcock was also a scholar of his own films. His career interview with François Truffaut was an affirmation of a formalist imagination. His interest in form over content, though occasionally disingenuous or simply diversionary, his way of evading what he thought his films were actually saying, confirmed for me an ontological fact—that films are formal structures first and foremost, that content flows from form, that great filmmakers speak through the images they make and the ways those images are put together to create a narrative, a story. Hitchcock never quite entered my pantheon with the emotional surge of Welles and Kubrick, but he has remained a fascinating, extremely teachable filmmaker, some of whose films—*Shadow of a Doubt, Notorious, Vertigo, North by Northwest,* and *Psycho*—are part of my "imaginary museum"—a wonderful term invented by Martin Scorsese in his *Personal Journey with Martin Scorsese through American Movies*. And so Hitchcock has ended up as one of the trio of filmmakers celebrated in this book.

■ ■ ■

Allow me to namedrop. I don't have many names to drop. Some years ago I had lunch with the screenwriter and director Paul Schrader. He was visiting a film festival at the University of Virginia, where I was teaching at the time. We talked about our projects, and I told him I was thinking about a book on Welles and Hitchcock. "A well-trod road," he replied. The screenwriter of *Taxi Driver*, the director of, among many other films, the wonderful *Light Sleeper*, essentially told me that my

idea was done to death. I became depressed about the project and proceeded to work on other things, textbooks and edited collections, one of them on *2001: A Space Odyssey*, and a new edition of *A Cinema of Loneliness*. But those other things did not entirely crowd out my affection and passion for these filmmakers. I wrote and taught a lot about Kubrick in the interim, and he became the most important part of my pantheon, edging out Welles but sharing with both Welles and Hitchcock a passion for making extraordinary images and weaving a complexity of ideas. I developed a course on Welles and Hitchcock, a comparison that puzzles the students and always intrigues me. They take easily to the apparent neatness and directness of Hitchcock's films and are sometimes thrown by the exuberance of Welles.

My passion for form, the urge to discover how filmmakers express the world in cinematic terms, is what ultimately led me to link these three directors together, despite the apparent differences in the ways they embrace and employ their art—and those differences are considerable. Orson Welles, Alfred Hitchcock, and Stanley Kubrick are directors who share specific ideas about how to organize cinematic space, how to regard their characters within those spaces, and from that regard to build a consistent and coherent view of human behavior and moral peril. They are modernists in an antimodern art, a paradox I will explore throughout this book. They each in their own way reimagine what movies can do and in doing that make us see films, theirs and others', in new ways. Indeed, to see the world itself in ways that only cinema can do.

When teaching Hitchcock, Welles, and Kubrick, I needed to push a contrast between their work and the ordinary flow of mainstream cinema. Kubrick's films almost teach themselves. Most students are quickly taken with his style, his visual energy, and, curiously, the ironic pessimism that pervades his work. I teach Welles and Hitchcock together in one course, and the students' response to this coupling is interesting, challenging, and revealing. Although they are immediately

taken by Hitchcock's accessibility, and intrigued by the evident complexity of his style, they are less amenable to the deeper resonance of his most difficult films of the mid and late 1950s. They all love and want to write about *Rear Window*, a film that points the way to the great trilogy of *Vertigo, North by Northwest*, and *Psycho* but is not itself a completely thought-out work. But they are taken with its scopophilia—its obsession with looking—and voyeurism, though perhaps less so with the problem of castration and impotence that pervades the film. *Vertigo* is often a problem for them as it was for audiences in 1958. Then, audiences could not come to terms with, or even see, its emotional complexity. Now it's a problem fraught by age and gender. The breakdown of a middle-aged white guy who abuses a helpless woman does not resonate; analyzing the film's complex narrative and visual structure helps only a little. So with *Psycho*. The fright factor is available to them. The careful visual design of the film requires some convincing.

They are sometimes troubled by Welles. The tight structure of Hitchcock's best work pleases them; the exuberance of Welles's films, his visual abandon, is often out of their reach. So is the danger of victimhood, of the fact that Welles continually ran in to trouble with studio or producer interference on so many of his films. I have to tread carefully on that subject to avoid the "poor Orson" syndrome. Whatever perspective I offer, some remain confused by Welles, or overwhelmed. Hitchcock's coolness and Welles's heat seem for them mutually exclusive.

One of the things driving me to write this book is a desire to overcome the uneven responses to these three filmmakers—responses that I'm sure are shared by filmgoers who are not taking a film class—and to show how each is a unique cinematic stylist who at the same time shares a common trait with the other two. Beyond the mechanics of plot, each is concerned with the imagery he makes and the way those images are put together to create amazing cinematic visions. These filmmakers see their worlds in cinematic terms, which they exploit to

the end of making *us* see, along with them, what we do not see in the work of conventional filmmakers or the world as we see it every day.

What follows, then, is the result of many years of thinking, writing, and teaching the films of Welles, Hitchcock, and Kubrick. It is an invitation to think along with me about how movies work, why they bring pleasure, what they mean. It is an invitation to explore the cinematic minds of three of the great artists of the twentieth century. My intention in *The Extraordinary Image* is to explore the sublimity of the work of my three directors from a variety of perspectives and approaches. I want to think and share with you how these filmmakers and their films work, why they work, what makes them work, and why this is important, indeed fascinating, perhaps extraordinary.

What We Talk about When We Talk about Film

The approaches to film are so varied, from high theoretical abstractions that apply to all of cinema, to the history of films themselves, to even more focused studies about such things as distribution patterns; there are close, detailed analyses of individual works or the body of works by a particular director. There are any number of biographies, especially on Hitchcock and Welles. Essays, monographs, books—for such a relatively young discipline, the literature on film is enormous. I've contributed my share, and my approach, though focusing on the director, is otherwise quite eclectic. What I want to talk about in this book ranges across many possible areas of inquiry. Starting off with some brief biographical details, I'll move on to an overview of the output of the three directors, which will act as a kind of seedbed that will be cultivated further as we proceed. I've included a section on the acting in their films. Acting still receives little comment in film studies, despite the fact that it is the most immediately visible part. Welles, Hitchcock, and Kubrick use their actors and create their characters in

very different ways, but the place and function of the body in each of their films is important and intriguing. There are not only good performances in their films but a sense of *performance* on the part of their characters, a consciousness of being watched, whether it's Roger O. Thornhill in *North by Northwest*, who is told by his captor, convinced that he is a government spy named Kaplan, "with such expert play acting, you make this very room a theater"; or Alex, in *A Clockwork Orange*, who is put on a stage to perform his reformation from thug to abysmal law-abiding citizen. All of Welles's films and the characters he plays in them are big, energetic performances.

The narrative of a film, the ways in which the filmmaker tells his story, will take us into the heart of these directors' work and expand on the brief overview of their work presented earlier. I want to talk about *how* their films tell their stories, how they create the visual space in which we see the characters and which, if we are willing, engulfs us as we watch. Welles, Hitchcock, and Kubrick were masters of cinematic space, the visual dimensions of their filmic worlds. Their distinction, indeed their uniqueness, lies in the ways they see the world cinematically, how they "think with their eyes." And out of those spaces, the worlds of their films, inhabited by a variety of characters, comes meaning. Once we discuss time and story space, we can move on to theme and variations, the stories told. And these stories are as rich and complex as the visual strategies that communicate them.

I love complexity, which is one reason I'm drawn to these filmmakers. Their vision, their sense of how to use an emotionally and intellectually rich palette, invites speculation and analysis. I hope you will share in my exploration. I promise to tread lightly but thoroughly; I will offer general observations and occasionally provide close analysis of particular sequences. There will be some autobiographical forays, but mostly I will put myself at the service of the filmmakers I love, who have changed the way I think about movies, and who remain, long after their deaths, figures of admiration, intimidation, and imitation

and whose works remain alive and open to pleasure and understanding, who made films of great intelligence that touch the heart. What follows is a memoir of my love of movies and my passion for these three directors who have each enriched my life and guided the ways I think and write about movies.

∎ ∎ ∎

Finding the heart of any film is never a direct, linear process. If a film has a heart, an emotional and intellectual core, it is a complex organ made up of the formal structure that creates the film's meanings and makes visible the director's style. Style is form informed by personality and clarified by repetition from film to film. Welles's films have an open and burning heart and a fiery intelligence. His camera plunges into space and devours it. Hitchcock is all about style, cool and passionate at the same time, his films play a game of hide-and-seek. They might throw a viewer off the trail, following a MacGuffin (the plot device that engages the characters but is of no importance to the meaning of the film—the secret information the spies are searching for, for example). Hitchcock's films might create shock or suspense when what they are really after is incomprehension. The plot of a Hitchcock film may be a mystery, but that mystery has a more interesting mystery inside, which has much to do with the ways in which men manipulate women. Kubrick's films are all cool surfaces, exquisite detail, and startling compositions, most often lit with a high fluorescent shine (the exception being the candlelight of *Barry Lyndon*). Their icy exterior glosses a structure of profound irony, itself the reflection of a cool state of mind and a passion that prizes intellectual inquiry over sentimentality, yet covers a profound emotional attachment to the world and characters being dissected, even destroyed.

The bodies of work of our three directors may be unequal in quantity, different in execution and intent, yet they share many similarities. First and foremost, their films are inquiries into the cinematic condi-

tion. They are films that explore and push out the boundaries of what film can do. They are—all in the case of Welles and Kubrick, many in the case of Hitchcock—experimental if only because they are different from the general run of American film and because they make demands on us, something the general run makes certain will not happen. Hitchcock's films remain audience friendly, but that friendliness extends only to the rhythms of plot and the external geniality and comeliness of some of his characters, not the depths of despair and death into which so many of them fall or cause others to fall.

What each of these filmmakers have in common is an uncommon control over their medium and their filmmaking lives. Hitchcock gained that control by making commercially viable films and by being studio friendly, not only because of the commercial and critical success of his work but also in his ability to get along with studio heads. Kubrick gained control by the force of will, by working alone and turning out, by and large, commercially successful films without having to deal with studio hierarchies. He demanded and he received the kind of special treatment afforded to few other filmmakers. Shortly after making *Dr. Strangelove*, Kubrick wrote to Columbia Pictures, the film's distributor, which offered him a contract for two more films: "I cannot, will not, ever (at least this year) be in a position when I must shoot anything or must change anything, or must cast anyone, because Columbia wants me to. I must have complete total final annihilating artistic control over the picture, subject only to approval of the budget, approval of the two principal players." He wound up rejecting Columbia's offer.

Orson Welles felt the same way about his work and his control over it, and had it once, on *Citizen Kane*—even to the approval of the principal players. But unlike Kubrick, Welles's career was, after *Kane*, a constant, often losing, battle for funding and control, so much so that he spent the last years of his life working on a project—*The Other Side of the Wind*—that seems in retrospect a kind of obsessive need to

assert, if only to himself, that he could remain in control of his work. That control was so often compromised, sometimes brutally after the fact, when other people took his films from him. But once he actually turned on the camera, it was his eye and his visual imagination at work. The studios or his wayward producers may have reedited his films and shot extra footage, but they could not tinker with the shots themselves. Welles's control was in the creation of extraordinary images, *his* images that annihilate any tinkering by others.

It has been said that at least two of our filmmakers operated in the face of a certain fear, manifested in their films and in their lives. Michael Wood says of Hitchcock: "Hitch was a frightened man who got his fears to work for him on film." Geoffrey Cocks speculates about "Kubrick's obsessive fear of the world" that led to his "obsessive desire to control all aspects of life and art." Welles was perhaps the least fear-ridden of the group, certainly as manifested in his films and his recorded conversations. Even his Josef K. in *The Trial*, a tale of individual will lost in the giant mechanisms of the Law, is a rebellious figure, fighting against the enormity of obliqueness. Whether Welles was fearful in life is not clear, though my impression is that he took life as it was, lived through the disappointments over the funding and reception of his films before entering the somewhat chaotic late years of his life. As to Hitchcock's and Kubrick's fears, the biographical has to merge and finally drop out in the face of artistic results. There are certainly no traditional heroes in their films, no fearless characters—though in Kubrick's case some may begin as fearless only to be destroyed for their pains. Hitchcock's characters are full of fears, Welles's full of diminished or diminishing bravado. Whatever occurred in their lives—circumscribed in the case of Hitchcock and Kubrick, full of event and vitality in Welles—the films tell their stories as much as or more than their lives are told in their films. It is, in the end, the films that are full of event and vitality.

■ ■ ■

A brief word about "quotation." The biggest drawback in writing about film is the inability to quote from the moving image. Still images help, but they are no substitute for what audiences actually see when they watch a film. That's why I have attempted from time to time to give a close analysis of key sequences. Words, of course, cannot substitute for the images themselves, but they will act as a useful surrogate.

The Body of Work

There is so much biographical work on our three filmmakers: innumerable biographies and storybooks about Orson Welles, among which are the "authorized" biography by Barbara Leaming and the not always respectful (especially to Welles scholars) three (ultimately to be four) volumes by Simon Callow. Patrick McGilligan has published a rich biography of Welles's early years. There seems to be an unquenchable cultural hunger to know about Welles, who, more than his films and long after his death, is an ongoing unfinished production. There are two important biographies of Hitchcock: Donald Spoto's sensation-filled *The Dark Side of Genius* and Patrick McGilligan's more reasoned *Alfred Hitchcock: A Life in Darkness and Light*. There are any number of other semibiographical and "makings of" about Hitchcock and his work, not to mention an enormous amount of scholarship. There is as yet no definitive biography of Kubrick. Vincent LoBrutto's book is full of detail, and John Baxter's volume does a good job of contextualizing Kubrick's work within the business of film. With the recent availability of Kubrick's papers, we can expect more details to come on the most private of our three filmmakers and hopefully a biography worthy of his talent.

The biographical work is but a fraction of the other books and articles on these directors and their films. Analyses of various kinds, from many points of view, fill library shelves, scholarly journals, and

fan sites. "A well-trod road," as Paul Schrader said, but a road still under construction and with many interesting side streets and horizons remaining to be explored.

Origins

The origins of the three couldn't be more different. Hitchcock was born in 1899 to a lower-middle-class family. His father owned a London grocery. He attended a Jesuit school, which has led to speculation that the rigor of a Jesuit education may be responsible for the formal rigor of his films. He himself said the Jesuits taught him fear, realism, and reason, though fear seems to predominate in most of Hitchcock's films, and "reason" more often than not leads to a very non-Jesuitical chaos. In his apprenticeship he took art courses, wrote some short stories, and began his film work by writing and designing intertitles for silent films and doing art design for Famous Players–Lasky, the British branch of a Hollywood studio that would become Paramount Pictures. In the 1950s Hitchcock would return to Paramount, this time in Hollywood, where he would do his greatest work. He began directing in 1922 with the long-lost *Number 13* and also visited the Ufa studios in Germany. The response to that visit, the influence of German expressionism, with its looming shadows and distorted spaces, would remain with him for the rest of his career. Once he started directing, he never stopped. He directed some twenty-five films in England, including Britain's first sound film, *Blackmail*, before being lured by David O. Selznick to Hollywood, where he remained from 1939 until his death in 1980, making thirty more films, not including the episodes he directed for his television series.

All the biographies seem to agree that Alfred Hitchcock lived a rather sedate life, with an active imagination both onscreen and off. His closeness with his wife and coscreenwriter, Alma Reville, is legendary.

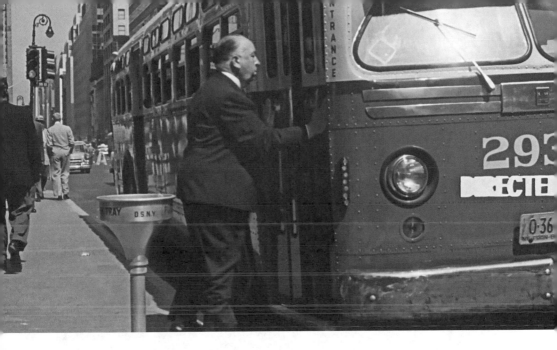

FIGURE 1 Alfred Hitchcock tries to catch a bus in *North by Northwest*.

His infatuations with his female stars, climaxing with the unhappy and perhaps abusive relationship with his late-life discovery, Tippi Hedren (he sent her a miniature coffin as a gift and, during the filming of *The Birds*, had living and stuffed birds tossed at her for a number of takes). This was an unpleasant ripple in an otherwise placid existence and perhaps a sign of the beginning of his artistic decline. When personal obsessions become difficult to sublimate into art, they may make themselves more visible in day-to-day interactions.

Orson Welles was born in 1915 in Kenosha, Wisconsin, to an odd family: his father was a high-living, itinerant, alcoholic who worked hard, failed, and worked hard again. His mother was a pianist and lover of culture, who gave recitals interspersed with lectures and poems. Welles's early exploits at the Todd School, where he wrote about and acted in Shakespeare, and his teenage travels in Europe and Ireland, where he acted at the Dublin Gate Theater, are well documented, as is his radio and theatrical work in New York in the 1930s. What is important to note about Welles in the 1930s is a counter to the tedious legend that he made a great film and then fell into diminishing creativity.

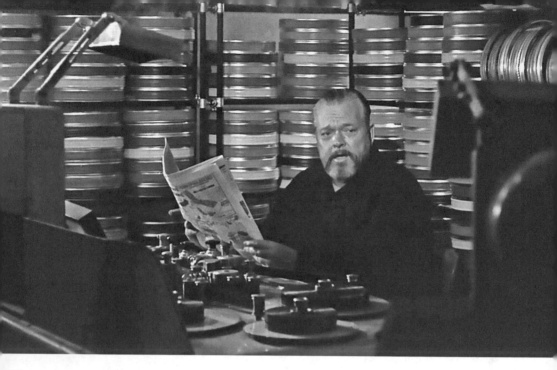

FIGURE 2 Orson Welles in *F for Fake*.

His creative theatrical and radio work—the voodoo *Macbeth*, the fascist *Julius Caesar*, the panic-causing radio broadcast of *The War of the Worlds*—made this the most busy and commercially successful period in his life. During this period he made his second movie, recently come to light, an accompaniment to the play *Too Much Johnson*. (His first film, *Hearts of Age*, had been made with his Todd School companions.) His move to Hollywood in 1939, the same year Hitchcock arrived from London, marked the beginning of a split in the graph of Welles's life. His commercial viability fell while his creative energies, focused now almost exclusively on filmmaking activity, grew from *Citizen Kane* onward. It became increasingly difficult for Welles to make films, but his desire to do so, and his increasingly infrequent success in getting his films funded, continued to the moment of his death in 1985.

Welles was, in effect, broken by the same studio that gave him the golden opportunity to make *Citizen Kane*. Because of the enmity of William Randolph Hearst over *Kane*; because his second film, *The Magnificent Ambersons*, previewed poorly (Welles was away in Brazil

making a government- and studio-sponsored goodwill documentary when he could have been editing it); and because ownership at RKO changed, he found himself out of a job and a pariah. Though his subsequent films show a steady rise in conception and execution, Welles remained tarred with the legend of someone who made his one great film and then went into some kind of self-destructive decline. In fact, the only thing that declined was his ability to procure adequate funding for his projects. Each succeeding film had its own story of struggle and triumph and more struggle. For Welles, filmmaking became a constant quest for control and a constant expression of a restless imagination that never flagged or failed.

Stanley Kubrick was born in New York City to a middle-class Jewish family in 1928. His father was a doctor, and the signal event of his childhood was when his father gave him a camera. Photography so absorbed his interest and creative potential that it overshadowed his academic work at high school to such an extent that he did not go on to college. He did sit in on courses at Columbia taught by Lionel Trilling and other luminaries, but his main occupation was as staff photographer for *Look* magazine, a picture-rich publication second in popularity only to *Life*. An autodidact, Kubrick read widely and attended screenings at the Museum of Modern Art, and his fascination with photography progressed to a fascination with the moving image. He had extraordinary luck in interesting distributors for his early work. His short film, *Day of the Fight*, following a boxer and his twin brother manager through their preparations for a match, was distributed by RKO, as was *Flying Padre*, following an itinerant priest in the Southwest. *The Seafarers*, an institutional documentary on the seafaring union, was a color production (while Welles filmed color footage for his never completed Brazilian documentary, he did not release a film in color until *The Immortal Story* in 1969).

With money borrowed from relatives, he went to Los Angeles and made his first feature, his first war film, *Fear and Desire*. His second

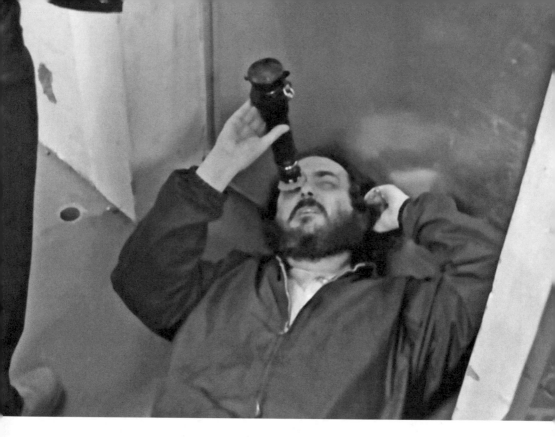

FIGURE 3 Stanley Kubrick composes Jack Nicholson in the documentary about the making of *The Shining*.

feature film, *Killer's Kiss*, was made back in New York, where he met James B. Harris, who would become his producer and who helped establish Kubrick in Hollywood with his third feature, *The Killing*, the film that brought him to the attention of Kirk Douglas, which in turn led to *Paths of Glory*, perhaps the first film that bears a true Kubrickian signature. Douglas was soon involved in producing his sword-and-sandal epic *Spartacus*. Displeased with the work of its initial director, Anthony Mann, Douglas hired Kubrick to replace him. Douglas allowed his young director so little control that Kubrick vowed never to work under the Hollywood producer system again. He made all of his subsequent films in England, eventually settling there until his death in 1999, just as his last film, *Eyes Wide Shut*, was getting ready for release. From *A Clockwork Orange* on, Kubrick worked under the protection of Warner Bros. executives Ted Ashley, Terry Semel, Steve Ross, and John Calley in Los

Angeles and Julian Senior in London, who looked after Kubrick's interests, freed him from having to find backing and distribution for each new project, and provided him the control he needed. His brother-in-law, Jan Harlan, became his executive producer, thereby sealing that control by keeping his work in the family.

The differences in these directors' origins are matched by the differences in their filmmaking lives. Kubrick's reluctance to present himself as a public figure was legendary, and as I mentioned, I experienced it personally when, in the early 1990s, I tried to make contact in order to write a biography. More important, his filmmaking life is the opposite of those of Welles and Hitchcock, whose public personae were, in Welles's case, larger than life, and in Hitchcock's a calculated effort to maintain his presence, well controlled, in the public eye. Welles was frequently visible, as an actor in prestige productions as varied as Carol Reed's *The Third Man* (1949) to Richard Fleischer's *Compulsion* (1959). Some of his acting had the odor of humiliation in films that he wanted to direct or should have directed himself: John Huston's *Moby Dick* (1956) or Mike Nichols's *Catch-22* (1970). In his later years, when he returned to the United States once more from self-exile in Europe, he made commercials and talk show appearances to maintain a small bankroll for the films he wanted to make but that no one in Hollywood wanted to back. To this end he also engaged the services of Iranian backers in deals so complex that, along with the vigilance of his daughter, who keeps his estate, and his mistress, Oja Kodar, some of his films remain undistributed or uncompleted. There is finally a DVD and Blu-ray of his greatest fiction film, *Chimes at Midnight*, which was unavailable almost from the moment of its original release in 1965. His unfinished *The Other Side of the Wind* is still, as of this writing, being kept from release. There was an attempt to raise money for restoration and editing through "crowd sourcing" online. Backers seem ready to fund the restoration. Oja Kodar appears to be the last person holding on to rights to the film.

Welles remains, long after his death, a figure of fierce admiration, of pity and misconception, but, paradoxically, full of vitality even after death, and always, like Kubrick, just out of reach. He continues to be in the public mind. The recent discovery of a short film he made to accompany his 1938 play, *Too Much Johnson*, made headlines. The one-hundredth anniversary of his birth received widespread media attention. Turner Classic Movies came up with a print of *Chimes at Midnight* to broadcast in 2015; Oja Kodar sold to the University of Michigan papers that included what appeared to be jottings for a memoir, "Confessions of a One-Man Band." When the *New York Times* reported this, Michael Cieply and Brooks Barnes couldn't resist the reigning clichés: "Yet another unfinished work by Orson Welles, that master of the incomplete. . . ." Never mind the thirteen completed films. Never mind that Hitchcock had unrealized projects, and Kubrick abandoned three major works for which he had done extensive research and preparation: a film about Napoleon; a film about the Nazi extermination of the Jews, *Aryan Papers*; and *A.I.: Artificial Intelligence*—the last ultimately made by Steven Spielberg in 2001.

It will be interesting to see what Welles's memoir fragments reveal, but, as I noted earlier, by all accounts of his life, there seems to have been a minimum of self-pity and a maximum of moviemaking appetite throughout his career, despite the many setbacks. From the time he left theater and radio in New York to become the boy genius at RKO in 1939, Welles wanted to make movies, and he maintained a public presence with that desire in mind. His disappointments, and there were many, were buried in an active political life during the 1940s and an active acting and directing life after that, even when, late in life, he gathered a group of young sycophants and director John Huston in a final attempt to create a legacy film. Josh Karp's *Orson Welles's Last Movie: The Making of "The Other Side of the Wind"* is a disturbing look at a somewhat desperate filmmaker, flailing around to make his last film. Despite that, and maybe because I need to, I think those many

years at the end of Welles's life were less of a desperate man and more of a filmmaker understanding how difficult it would be to get dependable funding but enjoying the process and the company of young filmmakers and critics. In the end Welles released the same number of completed films as did Stanley Kubrick. No one faults Kubrick for not releasing more; almost everyone still looks upon Welles, all proof to the contrary, as the "master of the incomplete."

By means of his cameos and his presence on his television show, *Alfred Hitchcock Presents*, Hitchcock was always in the public eye and never lacked the means to make films. Where Welles and Kubrick managed to release thirteen features apiece in their lifetime, Hitchcock averaged a film every two years, though, like Welles and Kubrick, he had a number of projects that never came to fruition. And being prolific did not guarantee consistent quality, as Hitchcock's uneven output demonstrates. The films of the 1940s contain some masterpieces and some inert films like *The Paradine Case* and *Spellbound*. For each *Shadow of a Doubt* or *Vertigo*, there are the early 1950s films *Stage Fright* and *I Confess*, which are, to my eyes, lugubrious films without wit or irony. Many admire *Strangers on a Train*, which seems to me a flat-footed film hampered by the fact that Hitchcock fired its original writer, Raymond Chandler, and hired the unknown Czenzi Ormonde, Ben Hecht's assistant, to write the script. All of this is to say that, because of his enormous and unequal output, there will be incommensurate treatment of Hitchcock here. It will be impossible to cover all of his films, and I will concentrate on those I like and believe to be his best.

The Films They Made

For Welles and Kubrick, paucity of output allowed for a concentration on the projects that did come to fruition, but in very different ways. Welles always had films he wanted to make but lacked the means to

make them. From *Citizen Kane* on, he was in contention with the studio system that had first given him carte blanche and then, in effect, blacklisted him. He did not like the studio system, and the system and its representatives returned the favor. William Randolph Hearst's attempt to destroy *Kane*, because it was a little too close to the facts of his life, and the bad previews of *The Magnificent Ambersons* that occurred while Welles was in Brazil making a documentary, sealed his fate rather quickly. When he returned, or rather was recalled, from Brazil, RKO had sliced and diced *Ambersons* and filmed for it a new "happy" ending. His RKO patron, studio head George Schaefer, was pushed out, and new management advertised rather cruelly "Showmanship in Place of Genius: A New Deal at RKO." The boy genius, whose first film failed commercially and whose second film was removed from his control, the young filmmaker, who came to Hollywood wearing a beard and possessing the right to final cut (releasing the film he wanted to release in the form he wanted it to be in), immediately made him the object of scorn and jealousy, and he was now essentially out of work. *Ambersons* remains a film of longing and regret, not only in what it has to say about the fading of a mythic simpler time but about the film itself, which should have been the brilliant successor to *Citizen Kane* but is only a glorious rump of what it might have been. *Ambersons*—that is, the *Ambersons* we have—has extraordinary sequences with even more startling use of deep focus and chiaroscuro than *Citizen Kane*. It is a film of regrets, for an imagined life of wealth and ease, for the despoiling of the landscape by the automobile, for the decline and fall of a wealthy family, and for the film it should have been.

Welles directed only three more films during the 1940s: *The Stranger*, *The Lady from Shanghai*, and *Macbeth*. He probably had a strong hand in Robert Stevenson's adaptation of *Jayne Eyre*, in which he played Rochester. He made *The Stranger*, by his own admission, to prove that he could make a film that looked like anyone else's. As he told an interviewer, "I did it to show people that I didn't glow in the

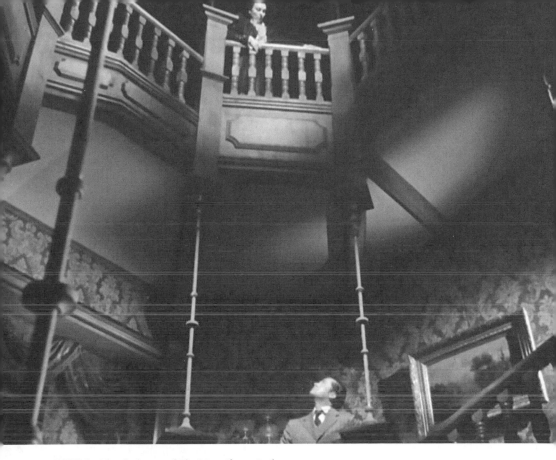

FIGURE 4 The darkness of *The Magnificent Ambersons*.

dark. That I could say 'action' and 'cut' just like all the other fellas."
In this he succeeded and failed. While less flamboyant than usual for
Welles, this is unmistakably a Welles film, the first to show footage of
the recently liberated Nazi concentration camps. I'll talk later about
how *The Stranger* works, but suffice it to say here that it does glow in
the dark and, in addition, is reflective of the political work that Welles
was doing during the 1940s. It was also his only commercially success-
ful film.

The Lady from Shanghai was the result of Welles's running out of
money on a stage production of *Around the World in Eighty Days*, a tan-
gle with Columbia chief Harry Cohn, and the current state of his per-
sonal life, specifically his decaying marriage to Rita Hayworth. She is
the killer woman of the film's title, a cold figure with a masklike face in a

film whose visual complexity is greater than the complexity of its plot. Despite the massive tinkering done by Cohn's editor, Viola Lawrence, it is a film that shows more than it says. As Michael Anderegg says about Welles's films in general, *The Lady from Shanghai* "approaches something resembling pure cinema, images and sounds that have an emotional and intellectual resonance apart from rational discourse." I find it remarkable that, as many times as I teach, write about, or simply watch a Welles film, whether it be *The Lady from Shanghai* or *Touch of Evil*, the thing that interests me least is the film's plot, so caught up am I in the images, the wonderful energy of Welles's visual imagination.

Macbeth was what would be the first of three Shakespearean adaptations and was made for Republic pictures, best known for low-budget cowboy films. It is an odd piece of work, made on the studio sound stage, with the original dialogue, spoken with a Scottish accent, recorded *before* filming, so that the actors had to mouth their lines as they were being filmed and while the recording of the dialogue was being played back. The experiment did not quite work, and Welles was asked to redub everyone without the accent. But with or without, the film was not a success and just barely survives as a curiosity in a lovely Blu-ray edition, Scottish burr returned.

And then Welles left for Europe, to escape the clutches of the House Committee on Un-American Activities (FBI director J. Edgar Hoover had been keeping a file on Welles since the 1930s and considered him a communist), and with the knowledge that he would not be getting work any time soon. Overseas, he starred in his most famous acting role, Harry Lime, in Carol Reed's *The Third Man*, and he filmed Shakespeare's *Othello* over a period of four years, acting for money to support the production, calling crew and actors back together, filming until money ran out. The off-again, on-again production had remarkable aesthetic effects. While the film does contain some of the long takes for which Welles is famous, it also introduces a slashing editing technique that, born of the necessity of cutting together pieces of film

made over the course of the production in various parts of Europe and the Mediterranean, would become part of the Wellesian technique in many of the films that followed. *Othello* has undergone various restorations and stands as a strong Shakespearean adaptation, cutting the play to its bone and maximizing a visual frenzy that communicates the breakdown to murder of its central character.

Mr. Arkadin (also known as *Confidential Report*) was funded by a political mentor of Welles's, Louis Dolivet, who turned on him and the film, took it over, and reedited it. There are multiple versions of the film, each differing somewhat in narrative chronology and arrangement of scenes. *Mr. Arkadin* may be the ugly duckling of Wellesian cinema, but it contains some of Welles's most breathtaking compositions and extraordinary comic acting by Akim Tamiroff. I take *Mr. Arkadin* to heart, a marred and powerful film about abusive power and the power of extraordinary images, a film about postwar Europe and the dictatorial state of mind.

Welles returned to the United States in 1953 to perform in *King Lear* on television. He returned again in 1955 and made a television pilot for Desilu—he got along well with Desi Arnaz and Lucille Ball, appearing on *I Love Lucy* during this period. *Fountain of Youth*, the television pilot, is an odd, spare piece with Welles narrating as the actors appear, often as still images, sometimes with Welles's own voice coming out of their mouths, against plain backdrops. It prefigures, in style and content, *The Twilight Zone*, which would appear in another four years. Perhaps it proved too advanced for 1950s TV or too Wellescentric. It aired once, but the series it was supposed to inaugurate never materialized. The most important outcome of this return visit was *Touch of Evil*, which Welles made for Universal-International. The story is that Welles was hired, along with Charlton Heston and Janet Leigh, to act in a potboiler detective film. Heston insisted that Welles direct, and direct he did, turning the potboiler (from a rather dull detective novel called *Badge of Evil*) into a visually explosive climax to the film noir genre.

Touch of Evil is the last film Welles made under the auspices of a Hollywood studio, and despite the studio's reediting it and shooting additional scenes, it remains one of the great works of the 1950s, standing alongside *Vertigo* and John Ford's *The Searchers* as a marker of how a decade of repression still managed to produce great, even transgressive, cinema. Unlike RKO, which destroyed the footage it had cut from *The Magnificent Ambersons*, Universal kept much of the material it edited out of *Touch of Evil*. Rick Schmidlin and Walter Murch did a reconstruction of the film based on a long memo Welles wrote to the studio after filming was completed. Released in 1998, the most visible result is the removal of the credits the studio had placed over the complex, almost three-and-a-half-minute shot that opens the film and the restoration of the sound and music design that Welles had originally wanted. There are other versions of the film that Universal has made available on DVD and Blu-ray, including one shown to a preview audience that contains some additional footage that allows the possibility of further rebuilding the film close to the one Welles wanted to make. All of this was fine for Universal. They got more income from the film; Welles profited not at all.

The rending of *Touch of Evil* was a horrible experience and caused Welles to leave the country again. He managed to find financing in Europe for two of his finest films—films made in his maturity and under his control: his adaptation of Franz Kafka's *The Trial* and his conflation of Shakespeare's Henriad and Falstaff plays, *Chimes at Midnight*. The first is Welles at full bore, a visual labyrinth of figures scurrying through a blighted landscape. *Chimes at Midnight* is Welles's autumnal work—restrained (by Wellesian standards), lyrical, and elegiac—including a battle sequence unequaled in its brutality. And that more or less was nearly the end of the finished Welles films. There is the plaintive *The Immortal Story*, the short film made in color for French television that so moved me at its New York Film Festival premiere, and the playful *F for Fake*, something like a documentary about the

FIGURE 5 The labyrinth of Orson Welles's *The Trial*.

magic of deceit. His *Filming Othello* is essentially a long conversation with colleagues about the making of that 1952 film. The rest remain as fragments or screenplays only—like his attempt to make a film about the 1930s theater piece *The Cradle Will Rock* (filmed indifferently by Tim Robbins, who wrote his own script) or are hidden in vaults.

Hitchcock needed the studios. They offered security and a working environment that allowed for a certain freedom. As noted, he began his filmmaking work for the British branch of the early Hollywood studio, Famous Players–Lasky, and the growing popularity of his films allowed him, even during his early years, a great amount of freedom. The British films vary in quality and execution. Some look awkward, even primitive when compared to the work Hitchcock did when he came to the United States. But many are strong statements of themes that would concern him throughout his career. *The Lodger*, a silent film, begins Hitchcock's concern with serial killers, an interest that would blossom with *Shadow of a Doubt* and *Psycho*. *Sabotage*, his adaptation of Joseph Conrad's *The Secret Agent*, is a strong film about

domestic betrayal and brutality. Two of the later British films, *The 39 Steps* and *The Lady Vanishes*, stand as remarkably charming and imaginative works. Hitchcock remade and refigured *The 39 Steps* in his maturity and called it *North by Northwest*. He remade another of his British films in the 1950s, *The Man Who Knew Too Much*, under the same title.

The freedom Hitchcock enjoyed in Britain was threatened when he came to the United States. In 1939 Hitchcock left England for Hollywood, under contract to David O. Selznick, the producer best known for *Gone with the Wind*. Selznick was the definition of control freak (a label often applied to Stanley Kubrick, a filmmaker of considerably more talent), firing directors at will if they did not suit his less-than-imaginative vision for a particular film. *Gone with the Wind* went through three directors. Hitchcock chafed under Selznick's collar, and, after *Rebecca*, which Selznick had pressured Hitchcock to make in a way that remained faithful to Daphne du Maurier's novel, he made his best films of the 1940s under loan to other studios: *Shadow of a Doubt* for Universal; *Notorious* for RKO. Long after his contract with Selznick ran out, the producer remained for Hitchcock a figure to hate or make fun of: Lars Thorwald, the wife murderer in *Rear Window*, looks like Selznick. Roger O. Thornhill adopts the producer's middle initial. Together his initials are ROT.

With British producer Sidney Bernstein, Hitchcock tried his hand at independent production, forming Transatlantic Pictures in 1945. The films that were made under this logo—*Rope, Under Capricorn,* and *I Confess*—are among the least successful of Hitchcock's output, although *Rope* is an important experiment in using long takes, creating the illusion of an all-but-unedited film. But by the time of *I Confess*, the success of the independent endeavor was clearly in doubt, and the film was picked up for distribution by Warner Bros.

There is one important film that almost came to fruition as a result of the collaboration of Hitchcock and Bernstein. In 1945 Bernstein was invited to view documentary footage of the liberation of Nazi concen-

tration camps. He asked Hitchcock to assemble it under the working title "German Concentration Camps Factual Survey." There are two stories about why Hitchcock did not complete the project, both probably true. One was that the British did not want to upset the Germans during the postwar denazification program (and the Germans no doubt did not want to be reminded of their immediate past). The other is that Hitchcock was so appalled by what he saw that he could not continue the work. Some of the footage, housed in the Imperial War Museum, London, was incorporated into a 1985 Public Broadcasting program called *Memory of the Camps*. A more complete presentation of the material was incorporated into a film edited by André Singer called *Night Will Fall*. Hitchcock's experience with these horrendous images had a lasting effect, and I believe that the trauma emerges in *Psycho*, a film whose darkness and refusal to rationalize the sources of violence has ghostly echoes of the Nazi extermination of the Jews.

Hitchcock's greatest films were made under the Paramount and MGM logos. In these films, as in many of his earlier ones, he acted as producer as well as director. But despite his control and reputation, the studios cosseted him, giving him a place and the technical facilities he needed to work, and he created his greatest films: *Vertigo, North by Northwest*, and *Psycho*. By the time of *Psycho*, he was being wooed by Lew Wasserman to Universal, Hitchcock's final home and the studio that witnessed his decline.

That decline can be attributed to many causes—age, for one; Hitchcock's infatuation with Tippi Hedren, for another; or "late style," which the critic Edward Said defined as an "artist's mature subjectivity, stripped of hubris and pomposity, unashamed either of its fallibility or of the modest assurance it has gained as a result of age and exile." Hitchcock was in his later years indeed "exiled" from the plush glories of the high studio period. He also was in the position of not having to show off as much as he did in his previous films; he pared things down. *The Birds* and *Marnie* read like essays on Hitchcockian themes

and practices. Their mise-en-scène—that is, the very look of the films and the ways the director uses cinematic space—has been washed of depth and resonance. They are studio bound in a most artificial way. Hitchcock famously hated to shoot on location because of the lack of control that came with shooting out in the open. Still, these are interesting films, but interesting as retrospectives, as an aging artist looking back on his work and remarking on it, as if saying "This is what I meant in *Psycho* and *Vertigo*—chaos is inescapable; women are subjugated by the images men want of them; the world is not a safe place." The films following *Marnie*—*Torn Curtain*, *Topaz*, *Frenzy*, *Family Plot*—are less than retrospective and more like reflections, sometimes weak ones at that. Much of this can be explained not only by age but by the loss of Bernard Herrmann, the composer whose music infused the images of seven Hitchcock films. In a heartbreaking moment, under pressure from Universal to use more contemporary music, Hitchcock severed his relationship with Herrmann. There was the loss of cinematographer Robert Burks and editor George Tomasini, who worked with Hitchcock on many of his major films of the 1950s. Some have speculated that the loss of a stable group of players—Cary Grant, Ingrid Bergman, James Stewart, Grace Kelly—left Hitchcock increasingly at odds and at a loss. To paraphrase what Norman Bates says about his mother, the fire had gone out.

Stanley Kubrick's body of work is a study in independence, control, extraordinary research and preparation, and perhaps a touch of timidity that was caused by being a sole proprietor. Kubrick edged into Hollywood as an independent, making some short films and then self-financing (actually getting money from relatives) his first two features, *Fear and Desire* and *Killer's Kiss*. After finding a sympathetic and competent producer in James B. Harris, Kubrick moved into Hollywood production with *The Killing*. The film gained Kubrick notice among other filmmakers—at one point he was conferring with Marlon Brando to direct *One-Eyed Jacks* until the stronger ego pre-

vailed and Brando directed the film himself. The first break, and what would eventually prove to be a final break, came with *Paths of Glory*, Kubrick's unrelentingly grim film about the cruel treatment of French troops by their own commanders during World War I. Kubrick and Harris had the property, had a script, and were on the lookout for a star. Kirk Douglas, at the peak of his popularity, agreed to play Colonel Dax, the film's central figure, if the film were made under the rubric of his production company, Bryna. The film delivers Douglas's best performance, which the star may or may not have recognized when he hired Kubrick to take over the troubled production of *Spartacus* from director Anthony Mann.

Spartacus may be the best-known Kubrick film by people who don't know Kubrick's work. The late 1950s and early 1960s saw a plethora of biblical and sword-and-sandal "epics." Fine directors like Mann, William Wyler, and Nicholas Ray, and not so fine, like Cecil B. DeMille, tried their hands at these bloated films that mixed piety with action, mid-twentieth-century religiosity with bad acting and, especially in DeMille's work, downright vulgarity. A dead-end genre, despite occasional attempts to revive it, these epics toppled the imaginations of those who attempted them. Kubrick's was no exception. Douglas, as producer, ran herd on his hired hand, and Kubrick had to deal as well with the egos of Lawrence Olivier and Charles Laughton, not to mention the requisite "cast of thousands."

There are some fine compositions in *Spartacus*, some symmetrical framings that betray Kubrick's hand. But in the end the importance of *Spartacus* lies in what it meant for the blacklist—Douglas allowed blacklisted screenwriter Dalton Trumbo's name to appear in the credits—and Kubrick's future career. His experience on the film caused him to flee Hollywood, begin setting up shop in England, and eventually begin making his films as a one-man cottage industry. The financial success of *Lolita*, *Dr. Strangelove*, and *2001* gave him the security he wanted and a unique relationship with Warner Bros. that began

with *A Clockwork Orange* and that allowed him the independence he needed. This isn't to say that the urge for large-scale films was completely out of his system. His desire to make a film about Napoleon led him to do massive amounts of research on a huge project that never reached fruition. It morphed into the subtle and glorious costume drama *Barry Lyndon*. And certainly *2001* is a kind of epic, though with a mostly human cast of much fewer than thousands.

Kubrick's talent is with relatively small films that contain huge ideas. Even *Barry Lyndon*, a close second to *2001* as the best of Kubrick's work, is an intimate film on a big canvas. The film that immediately followed *Spartacus* was also an intimate film with a huge footprint. *Lolita* is an unusual Kubrick film. Visually more restrained, done in lengthy takes, composed and edited for story rather than for the startle effect we find in the other works, *Lolita* is somewhat respectful of its source, perhaps because Vladimir Nabokov himself wrote an initial four-hundred-page screenplay that Kubrick and Harris had to rewrite into filmable form. But despite the respectfulness, Kubrick's *Lolita* is very much Kubrick's film. Still, this was a project potentially fraught with problems, given the nature of its source. During the late 1950s and early 1960s, the Production Code, to which every script had to conform for approval, was undergoing some changes both in the management of the Production Code Administration office of the MPAA (the Motion Picture Association of America) and in public taste. Filmmakers were getting bolder. Hitchcock's *Psycho* delivered a devastating blow to the Code's impossible restrictions, and James B. Harris was able to navigate the script of *Lolita* through the shoals of the Code and by moving the production to England, where the economics of the deal were better and Kubrick and Harris could more easily evade the reach of the Code and deal with the British Board of Film Classification largely by exchanging letters and assurances. The resulting film is less profane than Nabokov's novel, but funnier. This may sound like heresy, but I find Nabokov's novel tedious and, though this may not be the appro-

FIGURE 6 Seducer and seductress in Stanley Kubrick's *Lolita*.

priate critical word, ugly. Kubrick's *Lolita* is a brighter, more peculiarly ironic work, eliciting sympathy for the totally unsympathetic Humbert Humbert, and, with the chameleon quality of Peter Seller's performance as Clare Quilty, creepier and more threatening. As for Kubrick himself, the move to England would prove life-changing as he and his third wife, Christiane—who plays the German singer at the end of *Paths of Glory*—would settle, stay, and work there for the rest of Kubrick's life.

That life was unlike any other American film director's. As an expat in the north of London—averse to travel, happy at home, once settled, he did not return to the United States—Kubrick was sheltered from celebrity, from the vagaries of a director's life in Hollywood, but also from American culture, with which he kept in touch via videotapes of American television, movies, and sports. With the protection of Warner Bros. Kubrick was as sheltered as Hitchcock was at Paramount and Universal. Perhaps more so. Hitchcock still had to deal with studio heads; studio heads had to deal with Kubrick.

Before Warner Bros. there were the major films of Kubrick's early career: *The Killing, Paths of Glory, Lolita, Dr. Strangelove or: How I Learned to Stop Worrying and Love the Bomb*, and *2001: A Space Odyssey*. (His two early films, *Fear and Desire* and *Killer's Kiss*, were tryings-out, films in search of a style.) After Warner Bros. the films began to come more slowly: *A Clockwork Orange* in 1971; *Barry Lyndon* in 1975 (beginning with this film, Jan Harlan, Kubrick's brother-in-law, became his executive producer, further enfolding the director within the comfort of his family); *The Shining* in 1980; *Full Metal Jacket* in 1987; and *Eyes Wide Shut* in 1999, released after Kubrick's death.

Most of these films were commercial successes. Kubrick gauged his audience and the cultural moment of films wisely. For example, in its time, *2001: A Space Odyssey* took part in a burgeoning film culture in the United States. On its release in 1968 it was promoted as "The Ultimate Trip," inviting young audiences to view the film stoned or while doing acid in order to enjoy the elaborate light show near the end. Kubrick played an active role in all his films' marketing and exhibition, sometimes contacting theater owners to instruct them about the proper conditions for projecting his films. One of his last trips to the United States was to promote *2001*—his ultimate trip. This active engagement allowed him to gauge his audience and position his film to join the ranks of *Bonnie and Clyde, The Graduate*, and *Easy Rider* in America and the films of Godard, Fellini, Antonioni, and Bergman from abroad as part of the reinvigorated presence of an active and imaginative film culture. "The Ultimate Trip" was aimed at an audience getting high on the psychedelics of the light show that constituted the "Star Gate" sequence of the film. But there was, of course, more going on than simply playing to a contemporary audience—a ploy that nonetheless paid off by making the film a major commercial success.

There was no financial pressure on Kubrick to be more prolific, but there was an ongoing struggle to find, research, and execute the

right project. There was the early failure of the Napoleon project, the film Kubrick wanted to make after *2001: A Space Odyssey*. He could not pull financing together—films on the subject had appeared and failed, and MGM, which had distributed *2001* and had shown interest in the Napoleon film, was slowly going under. *Barry Lyndon*, a costume drama, became, in effect, the substitute for the disappointment over this loss of a favorite subject. During the long interim between *Full Metal Jacket* and *Eyes Wide Shut* Kubrick, as mentioned, researched a film on the Nazi extermination of the Jews, to be called *Aryan Papers*. He abandoned the project when Spielberg's *Schindler's List* appeared but perhaps more trenchantly because, according to his wife, researching the subject was emotionally destructive. Another project, a science fiction film to be called *AI*, based on a short story by Brian Aldiss, went through scripts and production sketches. It was abandoned, allegedly, because Kubrick felt that computer-generated imagery in the 1990s was not up to the task. My guess is that he could not wring the inherent sentimentality out of the story about a robot child trying to earn the love of his human mother. At one point Kubrick suggested that his friend Steven Spielberg direct the film with Kubrick acting as producer. Spielberg has subsequently said that the demands Kubrick made on him, including installing a fax machine in his bedroom (Kubrick's favorite means of communication after the telephone), proved impossible. After Kubrick's death, Spielberg made *A.I.: Artificial Intelligence*. While Spielberg kept Jan Harlan on as executive producer and used some of Chris Baker's original production designs, the resulting film, while visually complex, is nevertheless overwhelmingly sentimental. In it one can detect a tension between, as one critic has said, Kubrickian irony and Spielbergian sentimentality.

Which brings us to *Eyes Wide Shut*. This film had the longest development of any of the others. Kubrick began thinking of an adaptation of Arthur Schnitzler's 1926 novella *Traumnovelle* in the 1950s, and it became his fallback when the other projects in the 1990s were

abandoned. (It is interesting that Austrian television had made a film of the novel in 1969. It's available subtitled on YouTube.) I remember so clearly my first viewing of this film in a theater in Naples, Florida. "Clearly" might not be the right word, though, since the projection in the theater was not bright enough—the kind of problem that so concerned Kubrick when he personally, if from afar, supervised the distribution and exhibition of his films. My heart sank: the film was long and seemingly pointless. What was Kubrick thinking? Like Hitchcock, had his imagination failed him in late age? I reminded myself that very often my first reaction to a Kubrick film was less than enthusiastic. This had happened with *2001*, *A Clockwork Orange*, and *The Shining*. Subsequent viewings opened the films out, revealed more, and they became more exciting, more resonant. The case with *Eyes Wide Shut* is different. I now appreciate the film, am astonished by it, but even more, I have become obsessed by it. Like so many Kubrick scholars, I want to write about it, explain it, explore it, perhaps as a means to find its heart. Sometimes I think I have found it—this puzzle about sexuality, privilege, and celebrity—but mostly I think that it will always exceed my grasp.

THE WORK OF THE BODY

Hunger Artists

From one perspective it may come down to food. Hitchcock loved to eat and drink. The changes in his waistline over the years attested to his need to ingest in an endless cycle of stuffing and dieting. Welles's gormandizing is legendary: many bottles of wine, huge lunches, enormous dinners—his weight a constant source of opprobrium late in his life. Kubrick liked to cook. Frederic Raphael, who collaborated on the script of *Eyes Wide Shut*, complained that he was fed tuna sandwiches during their work together. Kubrick's wife, Christiane, however, anxious to humanize the director after his death, noted: "Stanley had a secret fantasy of being a short-order cook. He was very good. The kitchen was a bit full of blue smoke and too many dirty pans, but he was very good at that. He did a sort of American food that Europeans find so astonishing—hamburgers, and then, later on, he was king of sandwiches. He would pile up high things. He was a good host and was trying desperately to tidy everything up so people didn't say we're sloppy." Hitchcock claimed the same urge to tidiness about another domestic space, one that turns up in *Psycho* and in almost

every Kubrick film: "When I take a bath, I put everything neatly back in place. You wouldn't even know I'd been in the bathroom. My passion for orderliness goes hand in hand with a strong revulsion toward complications." Eating and defecating; pleasure and filth. But always complications. In *Psycho* Marion has a bite to eat in the parlor with Norman before he (his mother, both in the same body) kills her in the bathroom, which he then dutifully makes appear as if no one had even been there. Afterward, he chews on something while waiting for the car carrying her body in the trunk to slowly, hesitatingly sink in the filthy swamp.

There are two or three things people say about those who love to eat: that food is a compensation for something missing in their lives; that they have a kind of narcissistic need to satisfy themselves in one way or another—sex or food; that they just enjoy eating. An argument could be made, were one in a psychoanalytic frame of mind, that Welles fits the first proposition. Continually facing difficulties in getting his projects financed, needing to pick up acting jobs to stay solvent, he ate. Perhaps eating was his basic fulfillment—or he just enjoyed food and company. He was a Falstaffian figure, and his celebration and elegy for Falstaff was the subject of his last, perhaps his greatest, completed fiction film, *Chimes at Midnight*. "Are you still eating?" Jed Leland asks as Charles Foster Kane stuffs himself at his desk at his newspaper, the *Inquirer*. "I'm still hungry," he responds. During the course of an extraordinary four-minute-long take in *The Magnificent Ambersons*, George Amberson Minafer, spoiled scion of a fading family, stuffs his face with strawberry shortcake in the Amberson mansion kitchen as his Aunt Fanny worries over the family.

There are a few important eating scenes in Hitchcock: Sylvia stabs her horrible husband after dinner in *Sabotage*; Uncle Charlie reveals his psychopathology over a family dinner, turning his face to the camera in a huge close-up that threatens the very borders of the screen, telling us of the terrible world he sees. There is Alicia's roast chicken in *Notorious*, get-

FIGURE 7 The threatening close-up of Uncle Charlie at the dinner table in Hitch-cock's *Shadow of a Doubt.*

ting cold while she embraces Devlin in an extended kiss. The wine cellar in that film holds its MacGuffin: Uranium 235, hidden in wine bottles. Eve Kendall seduces Roger O. Thornhill in the dining car of the train to Chicago in *North by Northwest.* They are eating trout—"a little trouty," she tells Roger. Chief Inspector Oxford's wife serves him appalling meals in *Frenzy.* Norman Bates unwittingly gives everything away when serving milk and sandwiches to Marion Crane in the parlor behind the office in *Psycho.* "You . . . you eat like a bird," he says. "And you'd know, of course," she replies, looking at the stuffed birds surrounding the empty vessel that is Norman and his mother.

Bathroom scenes outnumber eating scenes in Kubrick's work. Kubrick's bathrooms! They are everywhere, in every film from *Lolita* on (though I might consider the "oysters and snails" sequence in

Spartacus—where Crassus attempts to seduce his slave Antoninus in the bath—perhaps Kubrick's first bathroom sequence). Humbert writes his diary in the bathroom and gets word of his wife's death while taking a bath in *Lolita* (Charlotte had already shown Humbert her "European" bathroom on her tour of the house). Buck Turgidson is first heard in the bathroom, and Jack D. Ripper shoots himself in the bathroom in *Dr. Strangelove*. Alex has a pee and later reveals himself by singing "Singin' in the Rain" while taking a bath in Mr. Alexander's bathroom. Barry Lyndon kneels before his wife in a bathtub in *Barry Lyndon*. Jack Torrance meets a strange woman emerging from the bath and is later dressed down by the ghost of Delbert Grady in the blood-red bathroom of the Overlook Hotel in *The Shining*. Private Pyle shoots Sergeant Hartman and himself in the latrine in *Full Metal Jacket*, a film in which the marines talk about living in "a world of shit." The opening of *Eyes Wide Shut* has Alice having a pee before going out with Bill to Ziegler's Christmas party, where the prostitute Mandy is passed out in the most elaborate bathroom of them all (see figure 37).

Norman O. Brown's *Life against Death: The Psychoanalytical Meaning of History* was a popular book on Freud and psychoanalysis published in 1959, a book, given Kubrick's fascination with Freud, the filmmaker probably read. Brown popularized the term "excremental vision" with which he argued that the revulsion/attraction to the body and its functions manifested Freud's theory of the return of the repressed. The more we hide, the more we evade; the more we try to flush down the toilet, the more the repressed returns in a disguised, probably neurotic, manifestation. Kubrick doubtless agreed with Brown's notion that there is a "general neurosis of mankind" and elaborated that belief in a number of ways in his films. Kubrick's bathrooms are places of pleasure and pain, of relief and self-destruction, of comedy—as is the case in *Strangelove* (at least the part where Miss Foreign Affairs tells a caller that Turgidson is in "the powder room")—and *2001*, where Heywood Floyd, on his way to the moon, has to hold it while he reads the

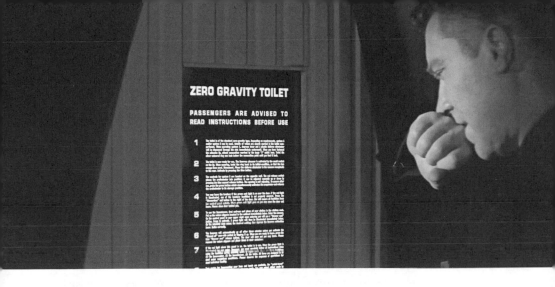

FIGURE 8 Heywood Floyd reads instructions for the zero gravity toilet in *2001: A Space Odyssey*.

detailed instructions on how to use the zero gravity toilet.

Of course there are eating scenes in Kubrick (without which there would be no bathrooms). The tattered soldiers in *Fear and Desire* stuff themselves with disgusting food when they capture an enemy's house. The cold warriors of *Dr. Strangelove* have access to a lavish buffet set out in the War Room. "Your eggs, then, they are fresh?" asks Russian ambassador de Sadesky. There follows an argument over Cuban cigars and gastric upset brought on by Cold War queasiness:

GENERAL: Try one of these Jamaican cigars, Ambassador, they're
 pretty good.

DE SADESKY: Thank you, no. I do not support the work of imperial-
 ist stooges.

GENERAL: Oh, only commie stooges, huh?

GENERAL: *whispers, clutching his notebooks to his chest*: Mr. President,
 you gonna let that lousy commie punk vomit all over us like
 this?

In *A Clockwork Orange* Alex's meal of spaghetti at Mr. Alexander's Home presages his fall, quite literally as he falls face down into his plate and later throws himself from a window, unable to endure the torture of listening to Beethoven. In *Barry Lyndon* Redmond Barry

faces two turns in his career at meals. He hurls a mug at John Quin's face when, at a family dinner, he learns Quin will marry his cousin and beloved, Nora Brady, and pay for the favor. Much later, while spying for the Prussian police, he meets the Chevalier de Balibari, enjoying a sumptuous breakfast. They become partners in a Europe-wide gambling escapade. But the key eating scene in Kubrick's work occurs at the end of *2001: A Space Odyssey*, when Dave Bowman is trapped in a room outside of time and space, a room that contains an antiseptic bathroom of which Alfred Hitchcock would approve. Dave is trying to eat a proper meal; he breaks a glass and, bending down to pick up the pieces, turns to see himself aging before his eyes, until, an ancient man upon a bed, he sees the monolith and passes through it, becoming a fetus encircling Earth.

Filmmakers often use dinner scenes to open up conflicts, and the eating scenes of these three filmmakers are fraught with threat and the promise of change that is not for the better. Uncle Charlie, in *Shadow of a Doubt*, is a serial killer, but, more important, he is the darkness that lurks beneath the bland surface of a middle-class family. When Mr. Alexander feeds a bowl of spaghetti and spiked wine to a beaten and lost Alex, he is involved in a torturous plot of revenge against the rape and beating of his late wife, committed by Alex and his droogs. He is attempting as well to destroy the government that had castrated Alex of his violent tendencies. Here food becomes a political weapon.

"Leave gormandizing," Prince Hal tells Falstaff. But Falstaff is a creature of food and drink, to be given up only with banishment and death. He is the old paradise lost and the Lord of Misrule, who is finally ruled out of order. Welles's films are almost always structured on a dialectic of gain and loss, metaphors for the greater dialectic of modernism and sentimentality. Appetite for the new and reluctance to give up the past. "Mr. Kane was a man that lost almost everything he had," Mr. Bernstein says in a film that, formally, is full of cinematic energy and tremendous imaginative drive but is about a man who fails.

A modernist story of a lonely narcissist. A film that gained in reputation as it made it harder for Welles to move forward.

"He was some kind of man. What does it matter what you say about people?" So says Tana, played by Marlene Dietrich (whom Welles liked to saw in half in his magic act in the 1940s), about a character, Hank Quinlan, who is Welles's version of Joe McCarthy in *Touch of Evil*. Earlier in the film Hank visits Tana in her brothel. "You're a mess, Honey," she tells him, as if Dietrich herself were amazed at the change in girth of her old friend Orson, who had been out of the country for nearly a decade. "It's either the candy or the hooch," Hank says. "I wish it was your chili I was getting fat on."

Apollo, Dionysus, and Nemesis

Food and weight and some kind of man. Welles and Hitchcock were portly men. They carried their lives in their bellies as well as in their films and into their celebrity. Stanley Kubrick, maker of hamburgers, defied celebrity throughout his career and therefore became the most intriguing—because the most hidden of the three directors. Welles's exuberance is on the screen as it was in his life. He is a Dionysian filmmaker. Hitchcock's careful control of his public image is met by the careful control of the images he puts on the screen. He is Nemesis, his films cautionary, violent, threatening chaos and harm. Kubrick, the invisible man, the Apollonian, maker of dreams and nightmares, will be known only by the films he made, even as researchers penetrate his archives. But the paper trail does not entirely reveal the man, so thoroughly is his imagination realized in his films, so thoroughly did he remain out of the public eye. In fact, in the few interviews he gave and the various insights into his filmmaking process, there is the notion that he himself didn't quite know what his imagination would create until it was revealed to him in the process of shooting. The famous sto-

ries of his multiple takes of a given scene indicate a number of things: he said that actors were simply unprepared when they came in front of his cameras, that he needed to see what the actor had to offer by causing the actor to repeat the scene until the right reading occurred, or, conjointly, that he wanted to break the actor down until nothing came between the actor's personality and the persona being created. In the few behind-the-scenes images of Kubrick at work (the most thorough is a "making of" *The Shining* by his daughter, Vivian), Kubrick seems even to be improvising camera setups, down to the lenses he would use, information that is entirely baffling given the detailed production design of his sets—which require a knowledge of camera setups beforehand—and the complex compositions that make up his films.

Hitchcock was the opposite. He was fond of saying that the most boring part of filmmaking was the actual making of the shots because he had all of these in his head and on storyboards before shooting began. Welles often had to shoot on the fly, as money became available, though this did not prevent him from using his camera as a dynamic probe and creator of space. Kubrick's camera, no matter where or when he chose to put it, or what lens he used, is almost always at a cool distance from his characters, unless they are going mad, in which case a close-up of a grimacing face, the Kubrick mask, usually taken with a wide-angle distorting lens, fills the screen. Otherwise, his compositions tend to be symmetrical, antirealist, brightly lit with a fluorescent gleam, and filled with dread. When dread occurs in Hitchcock's films, his camera usually moves to a high angle, as if he didn't have the stomach to look at it straight-on. This is not a constant: a big close-up or a graphic montage of murder in the shower may serve to bring the viewer close and frighten her away at the same time. But high or close, Hitchcock's compositions create a closed, exclusive narrative space, calculated as part of the larger scheme that is the film itself, attractive and threatening all at once.

Not so with Welles. The camera for him is a tool to batter and con-

quer space. Master of the long take and, in his later films, of a peculiar arrhythmic editing style, Welles wants to own the cinematic universe he creates. There is less sense of dread in Welles's films compared to Kubrick's and Hitchcock's precisely because of the fascination with the visual worlds he creates. Even in a late modernist work, his adaptation of Kafka's *The Trial* (which bears close relation to Hitchcock's more formally restrained *The Wrong Man* and shares an ironic sense of individual impotence with much of Kubrick), visual wonder almost overcomes the pathetic state of Josef K. Here Welles turns an abandoned Parisian train station into a labyrinthine world of smothering illogic where Josef K. (played by Anthony Perkins, who had played Norman Bates in *Psycho* just a few years earlier) wanders and is finally crushed—blown up, actually. There is, to continue our food metaphor for just a moment, no sustenance for the character in this or any other Welles film. They are not sustained; they are hunger artists (Falstaff is banished, and his weight falls away) and, like Kubrick's characters, most often die. They are unsustainable within the worlds the directors build for them, worlds that they try to conquer to no avail.

Embodiment and Performance

Welles's characters and Kubrick's are hungry strivers. Charles Foster Kane seeks to fill his life with food and objects, including the people and things he collects, stores, and forgets, even as he himself recedes from the public eye into his own sinking ego. Thompson, sent by *News on the March* to find out what "Rosebud," Kane's dying word, means, confronts Kane's former friends and wife, and the more he seeks, the less he finds. The stories told by each—Mr. Thatcher by means of his diary, Mr. Bernstein, Jed Leland, Susan Alexander, Raymond the butler—create multiple characters, versions of a man who is beyond reach (multiple characters like the multiple Orson Welleses created by

each of his various biographers). For Thatcher, Kane is the wayward child who turns on his guardian after his mother and father have sold him for the deed to a copper mine. We are privy to the scene taking place in the space of a small cabin; young Kane remains outside the window as his parents and Thatcher seal a contract that, given the way Welles handles the spatial relationship of the participants, seals off the child out in the snow. Charlie plays a game in which he shouts, "The Union forever," as the domestic union is broken. We will look at this scene in detail further on.

Mr. Bernstein's Kane is a story of Bernstein's own diminishment, a lost Jewish soul who remembers a girl in white he saw once many years ago. He lives in the shadows of his boss (we see him sitting under a gigantic portrait of Kane) and remembers the beginnings and the endings, Kane's political gains and losses, which are also his own. Jed Leland, a gay man (though this is unstated), tells us of things he could never have seen: the dissolution of Kane's marriage, told by the rapidly increasing chasm of the domestic space at the breakfast table (another place of eating), envisioned by the increasing space between husband and wife as time expands to separate them.

Susan's Kane is a controlling narcissist, a domineering figure whose shadow looms over her, who causes her suicide attempt. But Welles plays a plasticity with this character. Susan's body is Kane's tool for his own ambition. Her whining after her dismal opera performance annoys him and us. Physical abuse occurs during their outlandish "camping trip" to the Florida coast with dozens of guests in tow. The musical accompaniment is a song: "It Can't Be Love." Kane stares down at Susan, and, in the reverse shot, she looks up, not quite cowed and with the beginnings of defiance in her eyes. When she calls out his self-centeredness, his insatiable need for the love of others, he slaps her. A woman's scream is heard offscreen, an indication that Susan is repressing her own pain and finding a way to counter her master. She does this when she prepares to leave Xanadu and Kane. There is a

telling composition, shot from a typical Wellesian low angle and deep focus. In the foreground, on the bed, is a large doll. Susan and Kane confront each other in the middle ground. He is in shadow. The composition is reminiscent of Susan in bed after her suicide attempt, but now an inanimate object takes her place while she herself has become animated. She seems to soften when Kane promises to stop controlling her until Kane says, "You can't do this to me." This hardens Susan to her task: "I see. It's you this is being done to. It's not me at all. Not what it means to me. I can't do this to you? Oh, yes, I can." She walks out.

Susan's strength was not long-lasting, because when Thompson first interviews her in the nightclub where she performs after Kane's death, she has become a sullen drunk. But she endures, and in the second interview she is able to voice the strength of her leaving Kane, which is more than can be said for Charlie Kane, who—as Raymond the butler tells the story—rages after her departure, destroys her room, grabs a snow globe, whispers "Rosebud," and walks past a mirror reflecting his image into infinity. But his ego can no longer be fed. The last images we see of him actually occur early in the film, in the *News on the March* newsreel: a frail Kane being pushed in a wheelchair by Raymond the butler.

Kane follows his character to the end. He can't do otherwise, and this is something Welles has his characters talk about in his films. "One who follows his nature keeps his original nature in the end," Michael O'Hara says to Elsa Bannister—words she had spoken to him earlier—their images, like Kane's, reflected into infinity in the crazy house climax of *The Lady from Shanghai*. The two lovers are swallowed and shattered by their own blindness to each other's flaws: Michael's innocent bravura and Elsa's dark murderousness. Gregory Arkadin in the film that carries his name tells the famous tale of the frog and the scorpion:

> "This scorpion wanted to cross a river, so he asked the frog to carry him.

'No,' said the frog. 'No, thank you. If I let you on my back, you may sting me, and the sting of a scorpion is death.'

'Now, where,' asked the scorpion, 'is the logic of that?' for scorpions always try to be logical. 'If I sting you, you will die, I will drown.'

So the frog was convinced and allowed the scorpion on his back. But just in the middle of the river, he felt a terrible pain and realized that, after all, the scorpion had stung him.

'Logic,' cried the dying frog as he started under, bearing the scorpion down with him. 'There is no logic in this.'

'I know,' said the scorpion, 'but I can't help it. It's my character.'

Let's drink to character."

Arkadin tells his story to his party guests, and is shot from the usual low angle, so he towers over them. He is the anti-Kane, sending out the dimwitted Van Stratten to dig up Arkadin's past as a petty international racketeer and sex trafficker so that he can destroy those involved. He devours his past until it turns on him. But like so much of post-*Kane* Welles, the plot is confused and tortured (partly because of the vicious editing done on the film when it left Welles's hands), and instead the composition and rhythm of the shots, which remain powerful despite the editing done by others, propel the film with a sense of hysteria put in motion by this larger-than-life figure that his daughter calls "the ogre." In the role of Arkadin, Welles's makeup is like a mask. Welles loved to apply makeup and especially liked to do his nose, sometimes, as in *Touch of Evil* and *Chimes at Midnight*, his face and whole body. Arkadin, like some other Welles characters, remains hidden from the world and wishes to be hidden from himself even as he sends his agent out to rediscover it so he can destroy it once again.

So many of the characters that Welles plays in the films he directs are ogres. They threaten and devour and are devoured in turn; the scorpion's sting is usually in their own tail and inflicted on themselves.

They get their comeuppance but not before they damage other people. The characters that surround them, like those in *Citizen Kane*, are hurt and hurtful in turn. Vargas, the Mexican antidrug official in *Touch of Evil*, becomes the subject of Welles's Hank Quinlan's wrath. Quinlan is an Arkadin-sized ogre on American soil. He is a corrupt, nasty sheriff of a border town, Welles's version of Joe McCarthy and a foreshadowing of Arizona's real-life Quinlan, Joe Arpaio, who flouts the law and despises Hispanics. Vargas, played by Charlton Heston in brownface, is a self-righteous official who becomes the very thing he hates. He presumes his superiority to his nemesis before taking on his traits and planting evidence on him.

Touch of Evil is a magnificently dark film, creating a nightmare, garbage-strewn landscape in which the borders between the United States and Mexico are fluid and unrecognizable, as are the characters who inhabit it. Vargas is a righteous prig and Quinlan a pitiable wreck of a racist. He is the subject of that most memorable line in a Welles film. Shot by his deputy and obsequious friend, Menzies, he falls like a drunken whale into the swamp, rolling around in the garbage. Marlene Dietrich's Tana, a Mexican madam who may have once been Quinlan's lover, looks on and delivers her verdict: "He was some kind of man. What does it matter what you say about people?" Jean Renoir has a character in *Rules of the Game* say, "The awful thing about life is this: Everyone has their reasons." For both Welles and Renoir, character cannot be rationalized precisely because everyone has reasons, no matter how wrong those reasons are and how much trouble their reasons get them into. Josef K. in *The Trial*, trying to maintain his humanity, is destroyed by an irrational system that works by its own illogic and that he fights though he knows he has lost. Falstaff is the memory of youth in old age who cannot survive maturity; he is the image of loss even as he plays to the vitality of youth that will, when grown, destroy him. His reasons and those of Prince Hal are both sound. They can't coexist. Charles Foster Kane bulldogs himself through the world that he leaves in ruins in

his wake. Othello is undone by the irrational hatred of the man closest to him. Iago has his reasons—"I hate the Moor." He is devoured by his hatred and infects Othello with the disease of jealousy.

This is the delirium of the Wellesian character: a confusion of ill-considered desire and misplaced reason set in a visual frenzy that pulls us away from even attempting to understand him. *Touch of Evil* has a plot in which Quinlan frames a shoe clerk for blowing up someone's car. But I'll be damned if, after watching this film dozens and dozens of times, I can tell you exactly who does what to whom and why. Yes, the antagonism between Quinlan and Vargas is clear, as is the transfer of guilt from one to the other: Vargas, the upright Mexican official, becomes a planter of evidence just like Quinlan. Beyond that, I am lost in the vertiginous fury of the film, the sheer pleasure of its mad, hectic imagery. There is a plot buried deep inside *The Lady from Shanghai*, as well, but you need to close your eyes to the visuals of the crazy house sequence and listen to Mike O'Hara's voice-over to understand it.

Welles devours—food for his body, space in his cinema. His characters devour the space that enfolds them, even when they attempt at the same time to corrupt that space and are finally devoured by it. Franz Kindler, the Nazi masquerading as Charles Rankin, American college professor, in *The Stranger*, infiltrates a movie-perfect Connecticut town (which was built specifically for the movie). The premise is ridiculous on the face of it; beneath the face, however, Welles is probing and indeed inciting postwar anxieties. *The Stranger*, as I noted earlier, was the first theatrical film to show footage of the concentration camps. Similar footage was, at about the same time, being viewed and unsuccessfully edited by Alfred Hitchcock. In *The Stranger* these images are projected by the Nazi hunter Wilson (played by Edward G. Robinson) on a screen in the home of a judge and his daughter, who has married Kindler. The setup is similar to the screening room at the beginning of *Citizen Kane* and the screen that appears near the end of *The Trial*, where the Advocate Hastler (played by Welles) tries to pres-

ent Kafka's parable "Before the Law" to a rebellious Josef K. Display and observation are folded back into the performative space. Character and viewer are reflected back and forth as we are asked to see the screen as we are seeing through the larger screen of the projected image. The screen is Welles's canvas on which he paints his characters in shadow and light, allows them to perform, allows them their reasons, permits them to fall.

Like Alex in *A Clockwork Orange* Welles's characters are always conscious of their performance, of their being seen and acknowledged. This may be a result of Welles's stage origins, where characters are thrust forward from the background to the audience and declaim as much as they converse. "When I start out to make a fool of myself," declaims Mike O'Hara, the Welles character in *The Lady from Shanghai,* "there's very little can stop me. If I'd known where it would end, I'd have never let anything start. If I'd been in my right mind, that is. But once I'd seen her, I was not in my right mind for quite some time." Neither is the film in which O'Hara appears quite in its right mind. The fact that Welles himself plays the major characters in every film save *The Magnificent Ambersons* and *The Trial* (where he has a relatively minor role) also contributes to this performative presence. He is the center around which the other characters coalesce. He pushes outward against them.

Even in films that he did not direct, he becomes the center point of our gaze, the figure who devours all others. He has a relatively small role as Harry Lime in Carol Reed's *The Third Man,* but that role is central to the film, and Welles's appearances are remarkable in the way they dominate everything and everyone else. His first appearance, some way into the film, is wordless, standing in a doorway, dressed in black, his face lighted as he might be on the stage, a cat playing with his shoelaces. The Ferris wheel sequence is a tour de force and a summary of the kinds of characters (save Falstaff) Welles likes to create: simultaneously distant and prominent, blustery and vulnerable, loquacious

and reticent, and deeply corrupt. While telling his American innocent friend, Holly Martins (Joseph Cotten again), that the people he has caused to die because of his tainted penicillin are like the dots moving beneath them, he draws a heart with his lover's name. Sentimentality in the midst of murderousness. The cuckoo clock speech that follows (which Welles wrote himself) apparently dismisses the guilt that this postwar racketeer might carry:

> Don't be so gloomy. After all, it's not that awful. Remember what the fellow said. In Italy, for thirty years under the Borgias they had warfare, terror, murder, bloodshed, but they produced Michelangelo, Leonardo da Vinci, and the Renaissance. In Switzerland they had brotherly love. They had five hundred years of democracy and peace, and what did that produce? The cuckoo clock. So long, Holly.

The final appearance of Harry Lime is in the dark dankness of the Vienna sewers, where he is chased to his death. The sequence is echoed forward to the death of Hank Quinlan in *Touch of Evil*, shot and falling dead in an open sewer, and the pursuit of Josef K. through a weirdly slotted corridor in *The Trial* (see figure 5). Welles insisted that he had nothing to do with the direction of *The Third Man*, but if so, Carol Reed learned much from his star. The film's chiaroscuro owes much to Welles and to Reed's cinematographer, Robert Krasker, as does the sentimental monster of Lime's character.

The gallery of Wellesian characters—Kane, Haki (in *Journey into Fear*, the third film contracted by RKO and largely directed by Norman Foster), Kindler, Mike O'Hara, Macbeth, Othello, Gregory Arkadin, Hank Quinlan, Advocate Hastler, Falstaff, and Mr. Clay (in *The Immortal Story*)—comprises figures that might break out of the frame Welles creates for them were it not for the fact that the frame threatens to absorb them into the crazed mise-en-scène, the totality of the cinematic space, through which they careen. (*The Immortal*

FIGURE 9-12 Some incarnations of Orson Welles: Figure 9 Harry Lime in Carol Reed's *The Third Man*.

Story is a major exception, where Welles's character is insidious but still, unmoving.) These are characters with a hunger for life, no matter how corrupt or wrongheaded, and no concern for those they devour in the process of living.

The careening stops—visually, at least—in *F for Fake*, a film made in 1973, which Welles hoped might bring him back into the fold. It did not. This is an odd film, a film within a film actually, using large amounts of footage about the art forger Elmyr de Hory and another forger, Clifford Irving, made by the documentarist François Reichenbach. Welles weaves this footage with original material, acting as master of ceremonies in what becomes a ceremony of fraud. Welles plays himself—or at least a character named Orson Welles—as the bemused and cautioning voice of a filmmaker who wants to negate or expose the

FIGURE 10 *Mr. Arkadin.*

"magic" of filmmaking. *F for Fake* is Welles's trompe l'oeil, his assurance that in film nothing is what it seems, and his kindly warning that the viewer is always the butt of the joke. The Welles of *F for Fake* (in French it was called *Vérités et mensonges* [Truths and lies], and I must admit that I have always thought the English title, presumably made up by Welles's companion, Oja Kodar, really stands for "F for Fuck You") is the earnest, somewhat cajoling would-be charlatan speaking in good faith about bad faith.

F for Fake is Welles channeling his pain and anger over the way his films have been received by creating a film of denial. He must have had in mind Pauline Kael's appalling attempt to take down *Citizen Kane* in her 1971 *New Yorker* essays and subsequent book, which claimed that authorship of the film belonged to its cowriter Herman J. Mankiewicz.

FIGURE 11 Hank Quinlan in *Touch of Evil.*

If Welles faked *Kane*, then perhaps cinema and Welles himself are fakes. And if so, he is in the company of those two forgers, de Hory and Irving. In making this film, he implies that authenticity lies only in the desire of the beholder. We see what we want to see and what the filmmaker wants us to see, and the filmmaker cannot be trusted. No one can be trusted. Everyone has their reasons. Welles fooled us with his *War of the Worlds* broadcast in 1938 and by implication has been fooling us, or himself, ever since. I am a magician, he assures us from the very opening of the film, and the job of magicians is to create illusions. He performs some sleight of hand for a few children and then a levitation—corny gags from the amateur magician's simple bag of tricks—and then launches into eighty-eight minutes of sophisticated editing as if to prove that we will see what we want if the filmmaker wants us to.

Only once does Welles assume a tone of somber seriousness, the character of a serious artist contemplating a serious work of art. Over beautifully photographed images of Chartres cathedral, covered in mist (was it covered in mist or was the film fogged in postproduction?

FIGURE 12 Falstaff in *Chimes at Midnight*.

Were the images of Welles apparently gazing at the cathedral real, or are they images of him gazing at something, somewhere else and then cut in with the images of Chartres?), Welles talks about the beauty of anonymous craftsmanship made for the celebration of "God's glory and the dignity of Man." Today, he says, everything is made only for man alone—he paraphrases Falstaff from *Henry IV, Part 2*: the "naked, poor, forked radish." In the midst of his lyrical elegy for the authenticity of anonymity, he takes a Beckettian turn: "The triumphs and the frauds, the treasures and the fakes," he says. "A fact of life: we're going to die. Be of good heart, pry the dead artists out of the living past. Our songs will all be silent. But what of it? Go on singing. . . ."

This is an unexpected burst of lyricism coming from Welles, whose persona in *F for Fake* is the playful realist, poking holes in the illusionist's game. It is unusual in comparison with the entire run of Wellesian characters, even the Shakespearian ones, all of whom are given to bluster, aggression, or a certain self-pity. Perhaps only Welles's own voice-

over at the beginning of *The Magnificent Ambersons* matches the depth of feeling of the Chartres sequence of *F for Fake*. But there it was the voice of nostalgia; here it is the voice of the artist's longing for a voice to be remembered, a work, even a movie that will be evoked, that will not be a fake and fraud. Welles's movies are that, though perhaps he would not admit it, preferring to go on singing.

Like Welles's, Kubrick's characters have their reasons, and they are always wrong, inevitably undone by their attempts to insert their reasons and their desires into an unwelcoming world, which, it turns out, they are responsible for creating. But these characters are less than characters. They are Kubrickian ideas placed in or delivered by his actors' bodies, worn down in take after take until they embody Kubrick's ideas. His actors perform for their audience in their particular film, for their director, and for us. This is illustrated no better than in *A Clockwork Orange*, which is a huge, garish platform for Alex to act out his violence, to have violence committed on him, to be put on display. Alex speaks to us throughout the film, the moderator and ringmaster of his own character and its exploits. A narrator is hardly unusual in a Kubrick film: Humbert Humbert narrates *Lolita*; a third-person narrator supplies ironic counterpoint to what we see in *Barry Lyndon*; an anonymous voice-over sets the tone for *Paths of Glory* and *Dr. Strangelove*. But Alex's voice-over guides us toward how he would like us to think about him and what his hyperactive, hyperviolent, hypersexualized body is doing or having done to it. The latter is important, because in Kubrick's films, as in Hitchcock's, the body is acted upon as much as it acts upon others.

Alex is a rapist and killer, pleased to display his acts in words and images. He begs our assent; he wants our approval and gets it because of all the characters in his dystopic universe, he is the most energetic, the most in control, the most self-aware. And he stages or has staged what he does. Billy Boy's gang is about to rape a young girl on the stage of the derelict casino. Alex arrives as part of his evening of ultravio-

lence and announces his presence in voice-over, tells us that Billy Boy's gang was preparing "to perform a little of the old in-out, in-out" on the naked young lady they are violently passing between them. Alex and his droogs emerge from the shadows, and he directly throws down the gauntlet with a typical bravura performance: "Ho, Ho, Ho . . . Well, if it isn't fat stinking Billygoat Billyboy in poison. How are thou, thou globby bottle of cheap stinking chip oil? Come and get one in the yarbles, if you have any yarbles, ya eunuch jelly thou." Alex's near Shakespearean monologue, called Nadsat, borrowed from Anthony Burgess's novel, is a mixture of cockney and Russian. The fight that ensues is a ballet of bodies sailing through the air, crashing through windows and tables, synchronized to Rossini's *Thieving Magpie* overture.

Alex behaves, for a while, like a malevolent, joyous force of nature, wrapped in his confidence and the power of his words. When he comes to his fall, he narrates the low point of his life, and we feel sorry. He speaks, over images of prison:

> This is the real weepy and like tragic part of the story beginning, O my brothers and only friends. After a trial with judges and a jury, and some very hard words spoken against your friend and humble narrator, he was sentenced to fourteen years in Staja No. 84F among smelly perverts and hardened prestoopnicks, the shock sending my dadda beating his bruised and kroovy rookas against unfair Bog in his Heaven, and my mom, boohoohooing in her mother's grief as her only child and son of her bosom, like letting everybody down real horrorshow.

Alex is turned from a force of nature to a cyborg, having implanted in him through the "Ludovico Treatment" a violent reaction against violence. Straitjacketed, eyes clamped open, he is forced to watch violent movies while listening to his favorite Ludwig van. Afterward, he is put on a stage to demonstrate to all his changed nature. He is made to perform a humiliation ritual, overseen by the Minister of the

Interior, who acts as Master of Ceremonies:

> Ladies and Gentlemen, at this stage, we introduce the sub-
> ject himself. He is, as you will perceive, fit and well nourished.
> He comes straight from a night's sleep and a good breakfast,
> undrugged, unhypnotized. Tomorrow, we send him out with con-
> fidence into the world again, as decent a lad as you would meet on
> a May morning. What a change is here, Ladies and Gentlemen,
> from the wretched hoodlum the state committed to unprofit-
> able punishment some two years ago, unchanged after two years.
> Unchanged, do I say?—not quite. Prison taught him the false
> smile, the rubbed hands of hypocrisy, the fawning, greased, obse-
> quious leer. Other vices it taught him as well as confirming him in
> those he had long practiced before. Our party promised to restore
> law and order and to make the streets safe again for the ordinary
> peace-loving citizen. This pledge is now about to become a reality.
> Ladies and Gentlemen, today is an historic moment. The problem
> of criminal violence is soon to be a thing of the past. But enough
> of words, actions speak louder than. Action now. Observe all.

The performance is disgusting. Alex is made to lick someone's shoe
and gag when presented with a naked lady. But it's all part of the joke
that Kubrick is playing on us, himself performing, like Welles in *F for
Fake*, a sleight of hand.

My initial viewings of *A Clockwork Orange* left me feeling that
Kubrick was presenting me with a false set of choices: accept Alex's
brutality because it is infectious, because he is the only vital character
in a deadened landscape, condemn the Ludovico Treatment because
it is inhumane and politically expedient, and then conclude, with the
words of the priest who takes Alex under his wing, that free will—
even if expressed as rape and murder—is better than no will at all. No
wonder the film was banned in England until after Kubrick's death (in
fact, Kubrick and Warner Bros. pulled it from British distribution after

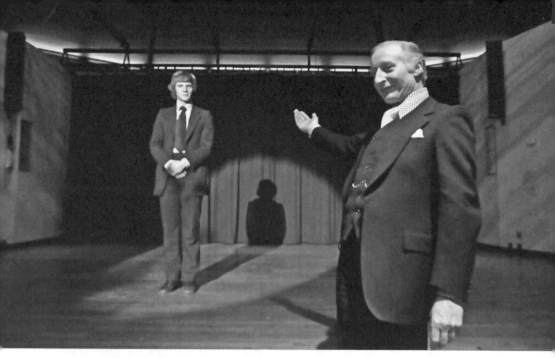

FIGURE 13　Alex on display in *A Clockwork Orange*.

two years for fear of lawsuits coming from copycat crimes and because of personal threats against Kubrick himself). But the joke was on me. In these great flourishes of word and image Kubrick is indeed creating false dichotomies. For one thing, we are watching a carefully crafted movie, not an ethical tract. In so doing, we need to ask about our own response to filmed violence, the representations of assault on the body. "It's funny how the colors of the real world only seem really real when you viddy them on the screen," says Alex in voice-over as he is forced to watch a movie of a violent fight as part of his treatment. So perhaps the film is asking us not to judge Alex but our own propensities. Why not just walk out of the film rather than give over to it? We are hardly given our choice.

Alex does not present us with a choice between free will and the coercion of the state precisely because his is the *only* alternative we are allowed to see. In the narrowly, if expressively, drawn world of *A Clockwork Orange* it is we who are not allowed free will. In a Hitchcockian mode this might be called the transfer of guilt from a character to our

own perception of the character and his or her actions. (Think about how we are made anxious when Bruno can barely reach Guy's cigarette lighter dropped in the sewer in *Strangers on a Train*, or in *Psycho*, when the car with Marion's body seems not to sink in the swamp as Norman looks nervously on.) But Kubrick is rarely as programmatic as Hitchcock. He works by indirection and, as clear as the unescapable failure of his characters is, there is always an ironic penumbra surrounding that failure. But, you might say, Alex is the one character who does not fail. The state, in response to popular outrage, reacting to the machinations of the political opposition figured through the chattering mad Mr. Alexander, restores Alex to his original state. As Alex's beloved Beethoven's Ninth comes to a close, there are his chilling words: "I was cured all right!" and the last images are of Alex having sex in the snow as people in Edwardian dress applaud. A masturbatory daydream from a pornographic *My Fair Lady*.

Cured, all right? Back to his murderous, rapist self, though now in service to the government. When he rises from his wheelchair, the reborn Nazi Dr. Strangelove cries, "Mein Führer, I can walk!" He, too, is cured all right as the world explodes around him. Kubrick's characters are, of course, never all right, even when they are morally righteous like Colonel Dax in *Paths of Glory*. *Paths of Glory* might be considered the first thoroughly Kubrickian film. *The Killing* contains the seeds of the devices that would be sprung in all the films to come. In this gangster/heist film a complex time scheme is put in place for a racetrack robbery that depends on everyone hitting his mark at an exact moment. It leaves no room for contingency, but everything in the Kubrick universe is contingent. Johnny Clay, the depressed, angst-ridden head of the heist, is undone by a jealous woman and a yapping dog. His failure is foretold. Dax, however, is on the winning side of humanity and rationality. Dax, after all, is played by Kirk Douglas, the film's producer and the first major star Kubrick directed. His character had to succeed, and his failure—as the movie proceeds—seems

untenable and not inevitable. Every convention of moviemaking stirs us to believe that he will save his men. We need him to succeed in the face of the generals who want to execute their own men because of the generals' impossible attempt at battlefield glory. They choose three at random. And Dax fails to save them because the machinery of military injustice overwhelms him. The three soldiers are executed, one already half dead from being knocked down for attacking a priest, another a half-wit, the third stoically accepting his fate. Dax is left with nothing. The troops are left weeping over a sentimental song sung by a German prisoner. Then they return to the front.

Most of Kubrick's characters have boundless energy. They keep provoking the world they inhabit, oblivious to the fact that it will fall around their ears because of their provocation. Their desire is boundless and usually misdirected. Bill Harford in *Eyes Wide Shut* is driven by desire, bonded to his wife, living a sexually and materially privileged life until his sexuality is threatened by his wife's telling him that he is not the only one she has found sexually attractive. Her simple admission of being aroused by a naval officer she saw briefly when on vacation the previous year sends Bill into a frenzy of activity to prove that he, too, can be attracted to someone else. He walks directly into a dreamscape of women who welcome him but are, for a variety of reasons, unavailable, and into a nightmare of an orgy where sexuality has become sport, ceremony, and a threat to his life.

Jealousy and inquisitiveness become self-cancelling, and Bill goes around in circles, tracing and retracing his steps, trapped in the inner circle of the orgy, saved by a prostitute, frightened by Ziegler's warning that he's in well over his head, and returning finally to his wife, who, stunned by her own bad dreams, tries a reconciliation. Her self-possession is intact; his is in shambles. Alice Harford is the only self-possessed woman in a Kubrick film, the only figure of female strength. Compared to Kubrick's male characters, she survives. Wendy, in *The Shining*, also survives but not out of a thoughtful attempt to under-

stand dream and reality as does Alice. She escapes Jack's murderous pursuit in order to save her son. A female sniper decimates the platoon in *Full Metal Jacket*, but she is more a psychological and political force than a character. The other women who populate Kubrick's films, when they are present at all, cringe under the weight of the male characters as they implode: Johnny Clay and his fiancée watch helplessly as the take from the heist blows away on an airport runway; Jack Torrance falls into madness and frost, Barry Lyndon into castration and exile, Dave Bowman into a dream of alien captivity and finally an encapsulated fetus circling the cosmos. Private Joker kills a woman, the enemy, and is lauded by his comrades. He becomes encapsulated within the sexualized, infantilized all-male world of the military, singing the Mickey Mouse Club song. The all male world of *Dr. Strangelove* simply manages to blow itself into oblivion. The only woman in that film is Buck Turgidson's girlfriend, the nude centerfold, "Miss Foreign Affairs." The rest of the female race exist as fantasies of sexual stimulation as Strangelove, Turgidson, Ambassador de Sadesky, and President Muffley plan on living and reproducing in mineshafts as the world explodes. Kubrick's characters cannot help but squirm in their own bodies, pushing, pushed upon, trying to act, to have agency but never to grow, never to change unless the change is a downward spiral into madness and self-destruction or, in the case of Dave in *2001*, into an embryonic wanderer of the universe, moved by unknown forces.

It is possible to imagine a similarity between Hitchcock's characters and Kubrick's. While Kubrick's are ideas given embodiment, on the surface Hitchcock's seem to fit the conventions of psychological realism. They are provided with something of a past; they have distinguishing characteristics, gestures, and vocal traits that seem familiar. But those elements of familiarity are only a baseline. Hitchcock was a sworn enemy of the Method school of acting, said that actors were cattle, and more appropriately saw them as one element of the film's mise-en-scène, the active component in the spatial construction

of a Hitchcock film. The result is that Hitchcock's characters seem to inhabit their world, are even comfortable in it, until something awful happens. They are primed for disaster or the cause of disaster to others, pawns of their own psychopathology or the world's. Like Kubrick's characters they are acted upon, even though they seem to be, or think they are, moving under their own power.

Cary Grant's Devlin in *Notorious* and James Stewart's Scottie Ferguson in *Vertigo* strike me as distant relatives of Bill Harford in *Eyes Wide Shut*. The three of them suffer from erotic displacement. Devlin is forced by his government to turn his lover into a prostitute and eventually wife of a Nazi, who, along with his mother, tries to poison her. Scottie suffers from a narcissism so severe that he can only become aroused by a woman who reflects an ideal image he has of what the woman he loved should look like, despite the fact that the image he has of his perfect love object never existed. None of these characters can exist in the here and now of their sexuality, and all are driven to deny, deflect, or destroy their objects of desire. Kubrick asks a great deal of his characters (and the actors who create them). They strain against the spaces that contain them, against the world that bears down on them. Hitchcock's characters work within their constraints, until those constraints close in on them. Norman Bates becomes his mother. James Stewart's Jeffries in *Rear Window* tries to possess his neighbors across the courtyard from his apartment, where he is restricted to a wheelchair. He turns them, like a filmmaker, into creatures of his imagination. Jeffries tries to control perception—his and ours, provoking anonymously, looking but not looked at (except by us). He remains invisible until his gaze is returned by a neighbor who may be a wife murderer. Once his safe space is invaded, there is nothing to be done other than being tossed out of his window by the presumed murderer.

There is a touch of cuteness about *Rear Window* and a lack of total commitment to the problems driving Jeffries to hide behind the telephoto lens of his camera. Like Scottie in *Vertigo*, Jeffries is a fantasist,

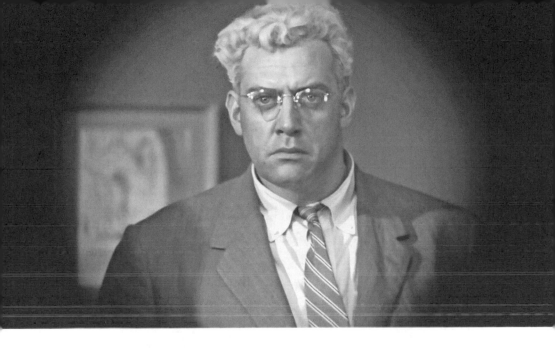

FIGURE 14 The return of the gaze. Lars Thorwald sees Jeffries (and, by implication, the audience) in Hitchcock's *Rear Window*.

but unlike his descendant, he does not suffer consequences for his behavior save another broken leg. Perhaps this displaced castration is enough for his having ignored his gorgeous fiancée, but the film as a whole is played rather too lightly. It took another year and *The Wrong Man* for Hitchcock to rediscover his gravitas. Manny Balestrero in that film is a naïf, an ordinary middle-class man of modest means. He has no pretentions; in fact, he seems a bit neurasthenic, riding the subway each night to the glamorous Stork Club, where he plays bass in the house band. Manny is a person of the night, though without the sinister connotations that would hold for a figure plying the dark in a film noir. That's because *The Wrong Man* is a noir manqué, and what is lacking is a sense of dread (a quality that pervades Welles's *The Trial*, which also concerns a man here charged with an unnamed crime he didn't, or maybe did, commit). Instead, there is a sense of inevitability, that this ordinary man will face extraordinary circumstance, as happens when he is arrested for robbery. Manny has only one outburst under the first grilling he gets by the cops. The scene starts with close-ups

of Manny and his two interrogators, who ask him how much money he owes on his bills. They push and push, and Manny finally shouts: "Am I being accused of something? Who says I'm a holdup man?" The camera cranes up to that high angle that in a Hitchcock film is always a sign of some sort of distress. Manny resumes his calm demeanor as he continues to be demeaned by the cops and his accusers. His anger and anxiety are stunningly expressed when he is placed in a cell. Hitchcock's camera moves first slowly and then more quickly in vertiginous circles around him. Manny's wife absorbs her husband's anxiety and goes mad under the strain.

In *The Wrong Man* domesticity is under siege, not an uncommon event in 1950s cinema that reflected postwar fears of disruption and invasion. But it's not that common in Hitchcock, whose characters— with some important exceptions, *Shadow of a Doubt* and the 1956 remake of *The Man Who Knew Too Much*, for example—live outside of the domestic sphere and within their own worlds of frustration and sexual pain. Sexual dysfunction is a mark of many film characters, and I want to discuss that more fully later on, but Hitchcock's males suffer to a degree that renders them either totally passive (like Manny or Jeffries) or horrendously active like Verloc in *Sabotage*, who sends his wife's young brother on an errand in London with a bomb hidden in film cans. Kubrick's males are always active in their pursuit of oblivion. Welles's are battered by their love of life, their absurd situations, the very vast darkness of their world. Hitchcock's males, even more than Kubrick's, cause no end of trouble. They are either mad or distracted, or pursued, or have a false identity foisted on them (in which case they eventually triumph). They are mama's boys or victims of spies. They always disrupt or are disrupted.

Uncle Charlie, the killer of widows in *Shadow of a Doubt*, is played by Joseph Cotten, who played Jed Leland in *Citizen Kane* and the automobile inventor Eugene Morgan in *The Magnificent Ambersons*. Jed is a passive figure, living in Kane's shadow until he leaves it after Kane's

FIGURE 15 *Shadow of a Doubt*: Young Charlie and Uncle Charlie in a film noir bar— "And I brought you nightmares."

electoral defeat. He plays the calming influence on his friend, his quiet double until Kane's voluble narcissism drives him away. Eugene is a bright-eyed figure of the future, of progress. Uncle Charlie is quiet as well, but his role is that of dark shadow, the evil double of his niece, who bears his first name. He is the snake in the garden, entering the pristine town on a train billowing black smoke. He uncoils himself like an adder and later, taking his niece into a dark film noir bar in the middle of the day, he announces his purpose:

> There's so much you don't know. So much. What do you know, really?
>
> You're just an ordinary little girl living in an ordinary little town. You wake up every morning in your life and know perfectly well there's nothing in the world to trouble you. You go through

FIGURES 16–17 Tony Perkins in *Psycho* (above) and *The Trial* (right).

your ordinary little day, and at night, you sleep your untroubled ordinary little sleep filled with peaceful, stupid dreams.

And I brought you nightmares.

The darkness in the light. Many of Hitchcock's characters insinuate themselves and cause chaos or worse. Devlin in *Notorious* is first seen in silhouette from behind, sitting upright, watching Alicia, whom he will manipulate into Nazi hands. The terrors of *Psycho* are hidden in the old dark house and in the further darkness of Norman's mind. In the only truly unnerving moment in *Strangers on a Train* Bruno beckons to Guy from inside the darkness, the evil double of the not-too-bright tennis player, reminding him that he owes Bruno a murder.

Of course it is difficult to talk about characters as if they existed. As Hitchcock pointed out, characters are elements in the total design of the film. For all three directors, characters function as a humanizing or dehumanizing aspect of the film's totality; they are the mobile, active and reactive components of story and space. The actors who portray them yield to what their directors want. There are few star turns in

their films. Perhaps Jack Nicholson in *The Shining* stands out for the looniness of his performance. Cary Grant cannot help but dominate the screen space and the story he is part of in Hitchcock's films. Otherwise, the characters become either absorbed into or detached from everything that goes on around and through them. Consider Anthony Perkins's role in *Psycho* and, two years later, in Welles's *The Trial*. The fundamentals of his acting are the same in both: a halting, stuttering delivery from a lanky, recessive body, easily put upon, slow to respond. But in Hitchcock's film he plays a maniac killer, and his recessiveness is the anchor of his violence. It erupts as mother resumes her hold on his psyche. But more important, Norman is the figure of the old dark house; he is the house's basement, the motel's parlor where he entertains Marion, the bathroom where he stabs her. The horizontal, vertical, and circular forms that make up the design of Hitchcock's images both constrain and release him. He is seen and not seen, known and unknown—a function of the darkness Hitchcock knows is always already about to erupt. Perkins's Josef K. in *The Trial* is no less

constrained, perhaps more so, by the gigantic structures of the courts that oppress him (in reality, the amazing skeleton of the then abandoned Gare d'Orsay railway station in Paris). But in Welles's film Perkins is more active, more mobile and aggressive even under the burden of his predetermined guilt. No matter what their situation, their morality, their standing, Welles's characters fight against their restraints.

The body of the actor, Perkins in this instance, is the puppet of the master and the worlds he creates for him. With James Stewart, who plays in four of Hitchcock's films—*Rope, Rear Window, The Man Who Knew Too Much*, and *Vertigo*—there is an evolution as Hitchcock exercises his control over him and Stewart deepens his range, allowing an evolution from the uneasy innocence that marked his roles in other people's films to become, in *Vertigo*, the ultimate Hitchcockian male—tormented, obsessive, self-destructive.

Hitchcock's female characters are too often seen as helpless tools in the face of their male manipulators. But often enough, they break through their passivity and prevail. In some of Hitchcock's British films they become helpmates (after a struggle with their male counterparts). Pamela holds her own even while handcuffed to Hannay in *The 39 Steps*, as does Iris with Gilbert (not handcuffed) in *The Lady Vanishes*. Mrs. Verloc stabs her wretched husband, who was responsible for blowing up her young brother in a terrorist attack in *Sabotage*. Jo Conway in the 1956 remake of *The Man Who Knew Too Much* saves a foreign ambassador from assassination with a scream and her son from captivity with a song. Eve Kendall turns out to be a spy for the good guys, though not before—like Alicia in *Notorious*—she is whored out to the enemy. Even though Sam Loomis grabs and restrains the howling Norman Bates in *Psycho*, it is Lila Crane who braves the old dark house and discovers Norman's stuffed mother in the fruit cellar. Marnie survives marital rape and maintains a modicum of damaged dignity at film's end.

Marnie is one of the famous "Hitchcock Blondes," though with-

out the air of mystery that hovers over Madeleine/Judy in *Vertigo*. She represents lonely, naked fear and exhibits a profound repression of her sexuality. Her performer, Tippi Hedren, or "Tippi" Hedren as Hitchcock and Universal Picture's publicity liked to present her name, may have, as I have noted, been the object of Hitchcock's wrath. It is said he developed a distasteful lust for her and punished her for not returning the favor. "Torture the women," he once famously said. So, in *The Birds* he hurled birds at her and in *Marnie* had her create an affectless, frightened woman at the mercy of her childhood trauma and a husband who rapes her and then tries to cure her.

Marnie stands at the end of this particular line of development of women in Hitchcock's films. But for all the endangered women and all the evil mothers the latter in *Notorious*, *Psycho*, *Marnie*—there are some interesting variations, women still at the receiving end of pain and abuse, but handled by Hitchcock quite differently than the more famous gray-suited blondes of his later films. Mitch Brenner's mother, Lydia, in *The Birds* starts off as a stern, threatening figure. Hitchcock is drawing on his audience's memory of *Psycho* to prime us with yet another destructive, controlling maternal figure. But as the film proceeds, Lydia becomes a frightened, unthreatening presence, protective of her son and of Melanie Daniels as well. The schoolteacher Annie Hayworth, in the same film, is a lost soul, forever pining over her love for Mitch, unrequited, unrecognized. These women, including Mitch's young sister, become, like Mitch himself, diminished figures in the revolt of nature, the reign of chaos that Hitchcock's film creates.

But if we look further back, we find one of the most interesting women in Hitchcock's films. I've mentioned how young Charlie in *Shadow of a Doubt* is taken by the force of darkness when her double, her uncle, comes into Eden bringing nightmares. She fights back and overcomes, at the cost of her innocence. But even more interesting, more full of pathos and despair, is her mother, Uncle Charlie's sister, Emma. In this early film from the American half of his career, Hitch-

cock (and perhaps his screenwriter, Thornton Wilder) takes note of the empty burden borne by the small-town housewife. Emma comes alive when her brother comes to visit; he brings with him her past and gives her joy. While she never fully realizes the evil represented by her brother, it does slowly dawn on her that there is something seriously wrong.

After Uncle Charlie's second attempt on his niece's life (first he sawed a step off the back stairs, causing her to fall; then he locked her in an exhaust-filled garage), Emma, in a cab with the rest of the family, on their way to Uncle Charlie's lecture to the local women's club, begins to wonder what exactly is going on. Observed in close-up, against a dark background, she can only manage a few words: "I just don't understand it . . . first the stairs, then . . ." She trails off as the cab pulls away. The power is in actress Patricia Collinge's reading. Pained, confused, sorrowful. It gets worse. After the lecture, guests gathered at the Newton house for a reception, Uncle Charlie, the Feds on his heels and his niece onto him, announces that he is leaving. Emma sits, her saddened face interrupted by shots of Uncle Charlie and young Charlie. "But I can't bear it if you go, Charlie . . . I know . . . It isn't any of this . . . it's . . . it's just the idea that we were together again." She is in tears, rubbing her face with her hand. "I'm sorry . . . you see, we were so close growing up. Then Charlie went away and I got married and then you know how it is." There are shots of the slightly embarrassed guests and a slow track in on a sad young Charlie. Emma goes on. "You sort of forget that you're you . . . you're your husband's wife. . . ." On these words, gazing at young Charlie's tear-stained face, Hitchcock does something that is common in his films when he needs to close off a sequence without sufficient closure: he fades to black, in effect squelching off the action. But at this moment, the fade represents our own and perhaps his discomfort and uneasy embarrassment at the outpouring of grief and quiet despair of this lovely woman.

Emma's identity has been stolen twice, by marriage and then by

FIGURE 18 The sad, lost woman: Emma in *Shadow of a Doubt*.

her beloved brother's arrival and departure. It's not made clear that she ever realizes who her brother is. After he falls from the train trying to kill his niece, Hitchcock's coda presents young Charlie and her FBI romantic interest telling her that the world goes crazy now and then. They are outside the church where, in counterpoint, we hear the priest praising Uncle Charlie's virtues. Emma (whom we no longer see in the film) is left with her grief, Charlie with her knowledge of evil. One can only imagine the response of a viewer in 1942, the war raging, the world having gone crazy once again. Women joining the workforce, beginning to reclaim themselves, beginning to remember again that "you're you."

There is an interesting variation in the female characters in Hitchcock, more so than in the films of Welles and Kubrick. He shows an

unusual sensitivity to them, a willingness to allow them to show their pain and their ability to overcome it, albeit with the help of their male counterparts. This is a complex issue for Hitchcock, and I'll need to return to it again when I discuss images of sex and power in his films. But let me say here, when the women fall—quite literally in *Vertigo*—their misery is always caused by the men who use or abuse them. Those men are deeply needy—they want recognition; they want to perform their madness, or obsessions for themselves, for us as viewers. Like the characters created by Welles and Kubrick, they embody desire and suffer the failures that desire ultimately brings. They rarely triumph; many of them fail gracelessly, many remain deeply traumatized, and some wind up dead.

FORM, TIME, AND SPACE

Looking closely at a film's characters is an interesting exercise for me because I tend to see characters as part of the spatial totality of the film. They speak the director's narrative intentions; thus, they are his mouthpiece. Attractive, comic, repulsive, they all act as one focus of my attention. In other words, the actors, the bodies in the film, do not exist apart from the spaces in and through which the director moves them. Those spaces, unique and uniquely different for our three filmmakers, deserve our close examination. They are the spaces that engulf us, that take over our own awareness of time, that speak to the ways Welles, Hitchcock, and Kubrick reimagine cinema.

Spatial Illusions

Welles begins *F for Fake* in a train station, where he shows children some magic tricks—well, perhaps the tricks are shown in the train station, perhaps somewhere else. No place in this film is where it seems. Welles proceeds to create a film that is itself something of a magic show. Some assistants hold up a white screen on the station platform (there is that screen again), and the camera zooms in on Welles standing in

front of it. When he moves away, he is in a different space altogether, talking about the film we're about to see, a film about trickery, fraud, and lies. "Almost any story is almost certainly some kind of lie. But not this time," he lies. "This is a promise: during the next hour everything you hear from us is really true and based on solid facts."

What occurs during the next hour are stories of lies and trickeries edited as if of a single piece, though coming from diverse films and diverse moments. Welles, the master of deep focus cinematography, where everything, front to back, is seen at once, has here become the master of editing, that fundamental cinematic tool that turns asynchronous fragments into an illusion of an ongoing whole. The pieces woven together are from a different documentary about the fakers Elmyr de Hory and Clifford Irving. Near the end of the film Welles tells a "true" story, of Picasso and Oja Kodar, Welles's lover, a story that plays on the oldest cinematic trick of shot/reverse shot: look at someone looking, and cut to the object or person presumably being looked at. Done well, the two appear to be in the same place and time. Using this technique, Welles intercuts still black-and-white images of Picasso, who seems to be looking. He edits in the eyes of Picasso's paintings. Eyes looking, all intercut with Oja, in various states of dress and undress, walking by. With this common trickery of filmmaking Welles visually implies that Oja poses for Picasso. The story is further enlarged and exaggerated. Oja, we are told, spirits away the paintings Picasso made of her, and, what's more, the paintings were in fact not by Picasso but forged by her grandfather. It's a grand tale of forgery and fakery, and it's all utter nonsense, which Welles admits.

F for Fake is a game Welles is playing with his viewers. He had warned that the "next hour" of the film would be true; but the film is close to an hour and a half long. He hoped the game would be a pleasure (which it is); but few decided to play, and the film was a commercial failure. It would be the last hand Welles would play. With the exception of *Filming "Othello,"* no other Welles film would be com-

pleted and released. In a way *F for Fake* is a fitting climax to an extraordinary career, and it is, as well, a critical commentary on that career, seemingly mocking it. And the mockery seems to be based on Welles's debunking his own cinematic form. Welles was a master of spatial construction, and his right turn into a film that depends entirely on, and is indeed *about*, editing serves to set up a contrast with all the films that preceded it. Maybe not such a contrast. Viewers familiar with the whole of Welles's output would have known that he had more and more come to depend on editing. Therefore, I don't think *F for Fake* is a repudiation. Rather, Welles is creating a complex response that does not negate his previous work but disavows his many critics by showing that work in mirror reflection. And within the disavowal is an affirmation. Welles *was* a master illusionist of space—so are all filmmakers—and he had already made that clear in his first and best-known film.

Citizen Kane is a game of mirrors, and its much admired depth-of-field cinematography is a two way illusion. Depth of field or deep focus is a product of lighting, lens, and production design. Welles and his cinematographer, Gregg Toland, wanted to have everything in the frame, from close-up to far distance in sharp detail. Screen space would be staged to reveal everything to the viewer. But not every shot could be composed with everything in the frame at the same time. The famous shot of Susan Alexander Kane in bed after having tried suicide is, in fact, a composite: the table with a bottle of sleeping pills and a glass of water up front in the frame, Susan lying asleep in bed in the middle, and Kane breaking through the bedroom door in the rear were put together in an optical printer. The film is replete with trick shots like this. "There were so many trick shots," Welles told Peter Bogdanovich in the late 1960s; "it was a big fake, full of hanging miniatures and glass shots and everything." And that is what Welles is talking about in *F for Fake*. All art is an illusion and all artists illusionists, with filmmakers especially creating illusions for the eye. The two-dimensional space that makes up the screen image can be molded and

tricked out and yet seem "real," at least within the conventions of what we accept as real in film.

But there is a second illusion going on in the spaces of *Kane*. Deep-focus cinematography is meant to show us everything the director has composed in the frame. But the thrust of this film is that its subject can't be seen or, more accurately, is only seen through the filter of the five people who knew him best and are interviewed by the journalist Thompson in his quest for the meaning of *Rosebud*. "No Trespassing" is the sign that begins and ends the film. We are warned at the beginning, and the warning is confirmed at the end. What trespasses occur, what happens when the camera pierces the veil, are bursts of vision that show us much and tell us little. We know, for example, in the sequence that grows out of a reading of Thatcher's diary, that Kane's mother and father sold him off to Thatcher for a deed to the copper mine the family shack sits on. What we see is an elaborate almost two-minute take in which Welles's camera extends the space of the small interior like it was a rubber band. Young Kane plays outside the window, crying "The Union forever." Within the house the union is dissolved. Mrs. Kane dominates the space, even as she and the two men, Kane's father and Mr. Thatcher, move into the foreground when she comes to the table to sign the papers. Young Kane, outside, remains in focus throughout, except for a moment when he is blocked by the three adults.

This is one of the most remarkable sequences in the film; it never fails to impress me with its visual eloquence, and I will return to it again in a moment. There seems to be no special-effects trickery involved in the sequence, just the actors and Welles's and Toland's camera making space. It tells part of Kane's story in which Mr. Thatcher takes control of Kane away from mother and father despite Mrs. Kane's control of the space (she is, after all, responsible for signing the papers). Narrative meaning is contained within the movement of the camera and the changing positions of the characters. We are not told a great deal—who is the defaulting boarder who left the deed to the copper mine?

how did Thatcher get involved?—we need to read space, and spatial reading is as informative as what we get from the dialogue. Let's read.

Citizen Kane is about memory, what various people recall of Charles Foster Kane, a figure we see and know only through the eyes of others. This is the paradox of Wellesian deep focus: we think we see a lot across and within the composition of each shot, but the more we see, the less we know. What's more, Welles keeps jolting our attention with startling transitions as we move from one witness of Kane's life to another, further diverting and distracting us. It's as if the film were intent on throwing us off course—No Trespassing! The eerie montage of Xanadu, the giant close-up of Kane's lips, the shattering of the globe, the shrouding of the body, and the darkened window at the opening of the film give way suddenly to the raucous hectoring of *News on the March* (a parody of the popular newsreel *The March of Time*, produced by William Randolph Hearst's competitor Henry Luce). The newsreel ends abruptly by wrenching us out of its flow and suddenly flipping the screen diagonally into the frame so that we are no longer looking directly at it but looking, somehow, at the screen on which the newsreel is being projected, while its images and soundtrack wind down. We are now looking at another screen, which contains the main action.

That screen is the *News on the March* projection room, which Welles creates as an abstract play of black and white, light and shadow. Here the hunt for *Rosebud* begins, and the visual display emphasizes people in the dark, illuminated by two shafts of light from the projection booth, a desk lamp, and the lighting of cigarettes. The editor thrashes the light with his arms in hopes of enlightenment. The shadows keep all the reporters in the dark, literally and metaphorically because they will never find the real meaning of *Rosebud*. (If we look closely, however, we can recognize many of the film's actors, like Joseph Cotten, playing the roles of reporters in the dark—another illusion.) But the display does more, reminding us of the visual material of film, affirming that the director is in charge. He owns the light and can withhold it at his pleasure.

"Rosebud, dead or alive. It'll probably turn out to be a very simple thing," says the editor, in silhouette against a bright screen. There is a crash of thunder. Lightning illuminates a giant billboard with Susan Alexander's face. The camera cranes up to a neon sign flashing:

EL RANCHO
Floor Show
SUSAN ALEXANDER KANE
Twice Nightly

("Grandi's Rancho Grandi" is the name Welles will give to a nightclub in *Touch of Evil*.) The camera pushes through the sign, and, if you look closely, you can see the gaps in the model of the neon sign, indicating where stagehands will pull it apart as the camera approaches. As Welles said, *Citizen Kane* is a film of optical tricks and models and forced perspective. The camera forces our gaze to and then through the skylight over the club, complete with a stopped-up hole in it. We can make out a figure sitting at a table as a flash of lightning hides the dissolve from the model to a crane down through the actual set to Susan, drunk and dissolute, at the table.

The only thing we know about Susan Alexander Kane at this point is what we were told in the newsreel: she is the one-time opera singer for whom Kane built an opera house and the still unfinished Xanadu. What we see in the nightclub is a ruined person, drunk, depressed, unwilling to talk. She is all but slumped over a table at the back of the club, sobbing. The headwaiter brings the reporter, Thompson, to her table. Thompson is our "eye" throughout the film as he interviews (or, in the case of Mr. Thatcher, reads about) five people who knew Kane. The narrative function of Thompson is a holdover from Welles's choice for his first film, Joseph Conrad's *Heart of Darkness*, which he had planned to shoot as a first-person narrative, told through the eyes of Marlow, Conrad's own narrator in his novella. It was a bold experiment that proved to be too expensive for RKO, which cancelled it, an action

that allowed Welles to move forward on *Citizen Kane*. But Welles remained intrigued by the idea and translated it, in a much diminished form, by using Thompson as the interrogator. I think Welles realized that a strict first-person narration was not possible in film. (Actor Robert Montgomery tried it when he directed a Raymond Chandler adaptation, *Lady in the Lake*, in 1947. The result, in which we only see what Chandler's Marlowe sees, and only see Marlowe when he looks in a mirror, is risible.) Thompson becomes at best a filter through which the perspectives, memories, and surmises of his interviewees pass. We see what he hears or sees from Susan, Mr. Thatcher's diary, Mr. Bernstein, Jed Leland, Susan again, and Raymond the butler, though each of these sources tells us much more than what Thompson could hear and in some instances more than the interviewee could have seen.

The first interview with Susan is a bust. In response to his request to talk, she says, "I'm minding my own business, why don't you mind yours?" No Trespassing! She yells at him to get out. Thompson moves off with the waiter, and there is a cut as he enters a phone booth in the club. What results is one of the most remarkable compositions in the film. Thompson is in shadow in the phone booth—he is always either in shadow or seen in profile—the waiter is outside the closed door of the booth, Susan in a pool of light in the left of the frame, drinking, the whole setup looking like a triptych of despair and frustration. But it is also a painterly display of mixed perspective. There are no stable lines in this setup, so our eye is confused as we try to pick out the points of visual interest—Thompson in the phone both, the waiter outside, Susan left rear. The sequence closes with the waiter telling Thompson that, when he asked Susan if she knew what *Rosebud* was, she said she never heard of it. Susan remains in focus in the background, deeply in her cups.

Thompson's next visit is to find the body of the past in the diaries held in the Thatcher library, all mock grandeur in shadow and streaming light so harsh that it looks like an image from Leni Riefenstahl's

FIGURE 19 A tryptich of despair and frustration. The end of Thompson's first visit to Susan Alexander in *Citizen Kane*.

Triumph of the Will. Given strict orders about what he can read in the diary, Thompson sits alone, in shadow and light, vault and library doors slamming (one slams in our face, but there is a dissolve to the other side—a trespass grudgingly allowed). The camera tracks in and over Thompson's shoulder and into the diary itself, moving across the black lines on white paper: "I first encountered Mr. Kane in 1871." Bernard Herrmann's music shifts to a brighter register as snowflakes appear over the white pages, which dissolve to young Charlie Kane, dressed in black against the white snow—the inscription in black ink on white paper becomes the body the writing is about. He is sledding on *Rosebud*, which we don't discover until the end of the film, because at the end of this sequence it is covered by snow, its name obscured.

Charlie throws a snowball at the sign, "Mrs. Kane's Boarding House," hanging over the shack. It makes a white period on the sign

FIGURE 20 Deep focus in *Citizen Kane*. Young Charlie's mother signs him over to Mr. Thatcher.

matching the black period on the document that Thompson is reading. It is also the period placed at the end of Charlie Kane's childhood. His parents are about to sell him to Mr. Thatcher in return for money received from the deed to a copper mine. And here we can look at that sequence again in greater detail. "Come on, boys, the Union forever," Charlie shouts as Welles cuts to inside the Kane house, his mother leaning out the window, calling to Charlie to pull his muffler around his neck. What follows is that long take, almost two minutes, in which Welles's camera tracks backward through a room of the Kane's boardinghouse, during which lines of sight shift, from Mrs. Kane looking at her son out the window to Mrs. Kane looking at Thatcher. Kane's father enters from the left, and he momentarily gains attention by claiming he has a right to decide his son's fate. As the trio proceed inexorably toward the table where Mrs. Kane will sign away her son, a series of

interlocking triangles form: Mrs. Kane, Thatcher, Kane's father, and Charlie, outside the window, in sharp focus, eclipsed only briefly by his father, who complains until Mr. Thatcher reminds him that they will receive $50,000 a year for the deed.

The sequence is a kind of oedipal ballet of shifting gazes and shifting allegiances. Its narrative function is to tease us with some knowledge of Kane's boyhood. After the sequence in the cabin, we are back outside, where young Kane knocks down Mr. Thatcher with his sled. His father threatens Charlie with "a good thrashing." There is a huge close-up of Mrs. Kane and her son, one of the few such close-ups in the film: "That's why he'll be brought up where you can't get at him," his mother says. And we are left, on first viewing at least, with the enigma of *Rosebud*. And with a sense of Kane's loss. A transition is made from the snow-covered sled to white wrapping paper, torn open to reveal Thatcher's present to young Kane of a sled named *The Crusader*.

The characters in *Citizen Kane* talk a great deal, often over one another, but their talk tells us a lot about them, more than it does about Kane himself. Mr. Bernstein's touching story about the girl in white lets us know about this small retainer's memories and longings. Jed Leland bespeaks a character dependent on his friend, Charlie, while understanding that his friend and his friendship have limits—limits set by Charlie himself. "Well, I suppose he had some private sort of greatness," Jed tells Thompson. "But he kept it to himself. He never gave himself away. He never gave anything away. . . . He never believed in anything except Charlie Kane." Leland's narration of Susan Alexander's opera career is something he has seen; his story about the decay of the Kane's marriage is something he could not have seen. What *we* see is a justly famous sequence in which, by means of a series of dizzyingly accelerated pan shots, Kane and his first wife, Emily, move physically apart. The failing marriage is told almost entirely through visual description. We read the growing distance across the breakfast table and hear the ever more bitter dialogue between the couple. There is

no explanation of what is happening. We know only what we see here and throughout the film: a narcissistic personality whose friends and lovers drop away, leaving him alone in an absurd castle filled with junk.

Thompson's second visit to Susan Alexander reveals more information—about her and her growing independence. "Everything was his idea, except my leaving him." Susan's flashback covers the time of her oppression by Kane, his forcing her to sing opera, her attempted suicide, the couple's self-banishment to the yawning black spaces of Xanadu. "Throw that junk," cries Raymond the butler as *Rosebud* the sled is tossed into the furnace during Thompson's visit to the last witness on his list. We see the veneer peel off as it begins to go up in flames. The camera follows the smoke outside of Xanadu and comes back to rest where it began, on the sign reading "No Trespassing." "I don't think any words can explain a man's life," says Thompson as he and his colleagues wander through Xanadu's basement. The visual jigsaw puzzle that is *Citizen Kane* allows us to see more detail within any given frame than most films up to that time, but Charles Foster Kane remains unknown, a fiction in a film, which is itself a fiction that has become a cultural marker.

Going through these sequences, as I have so many times, and thinking once again about *Citizen Kane* as a whole, I'm struck how, compared to Welles's later work, just how *polite* the film is. So full of various experiments with form and content, making amazing transitions, defying us to understand the meaning of *Rosebud* when in fact the meaning of the film is precisely the denial of stable meaning, the film still shows remarkable restraint. "I don't know how to run a newspaper, Mr. Thatcher. I just try everything I can think of," Kane tells his guardian. Substitute "make a movie" for "run a newspaper," and you have Welles's approach. But there still is a holding back, a young man's reticence in an old man's business. Kane grows old in the course of the film, but never as old as William Randolph Hearst or the studio heads who became maddened by Welles's attempt to parody Hearst's

life. Welles was a newcomer, and despite his reputation as a "genius," he trod relatively carefully. *Kane* is full of surprises and youthful energy—it reimagines cinematic space—but it also remains a Hollywood studio film, albeit one that changed Hollywood studio filmmaking.

Or did it? The Academy Award for 1942's Best Picture went to John Ford's *How Green Was My Valley*. Director of photography Arthur Miller won for Best Cinematography for that film. The only award *Kane* received was for screenwriting, which Welles shared with Herman J. Mankiewicz. Ford's sentimental melodrama about the decay of a Welsh mining town is richly photographed, with a temperate use of shadows and, while using deep focus sparingly (Ford and Gregg Toland had already experimented with this in *The Long Voyage Home* in 1940), still creating carefully detailed compositions. Ford's film is the anti-*Kane*. Though told as a flashback, it creates a fairly straightforward narrative exposition. There is nothing demanded of audiences but their emotions, unearned or not. *Citizen Kane* demands not emotion but attention. It is not sentimental—save for that close-up of Mrs. Kane holding her son—but rather coldly calculated in the kinds of effects it might have on the audience. But this does not contradict my notion that *Kane* is a "polite" film. The demands it makes are easy to take, compared to, for example, Welles's *The Lady from Shanghai*, which, as we will see, so troubled Harry Cohn's rear end. *Kane* is both within and without the general studio output of the early 1940s. It is extraordinary for the amount of push it gives to that output and the conventions of 1930s studio film as a whole.

I need to be very careful. I've mentioned Pauline Kael's destructive 1971 *Raising Kane* articles in the *New Yorker* and a subsequent book, and I'm not about to repeat her claim that *Kane* is not the original work of cinema for which it has been rightly revered. Perhaps James Naremore has the more useful take when he says that *Kane's* "canonicity has become a burden." In this light it might be helpful to see *Kane* as Welles's first and last studio production in which he had

total control and understand it *as* a studio production in order to more clearly understand how extraordinary it is. Michael Anderegg puts it well. *Citizen Kane,* he writes, is "the one Wellesian film that stands as a textually stable, finished work, as opposed to the provisional, improvisational nature of virtually all his other films." Surely Welles could have continued as a studio director had the studios not trammeled the few films he made for them and had he the temperament to work under studio conditions during the 1940s. But what happened to *The Magnificent Ambersons* indicates that the proposition is impossible. Welles, therefore, *gains* from the commercial failure of *Kane* and the butchering of *Ambersons.* This may have crippled him financially for the rest of his life, but it allowed his imagination to work untrammeled when he did get funding for a film. He was given room—space—to further explore the space of his medium.

Conventional Spaces

Welles's most conventional film, *The Stranger,* a film he consciously made to prove he could make an "ordinary" film, is extraordinary in its use of concentration camp footage, a provocation of contemporary history for an audience that might have wished to forget what the world had just been through. The film examines the acts of forgetting and remembering over the course of time—a small slice of time, since *The Stranger* takes place only a few years after the war, but, in that concentrated period, it opens up larger questions of innocence corrupted and historical evils played out within a setting of American innocence. Charles Rankin, née Franz Kindler, has a hobby outside of his task of regenerating the Third Reich in a small Connecticut town. He loves clocks and sets out to fix the clock in the town square of Harper, where he marries the blithely, ridiculously innocent daughter of a Supreme Court judge. He is exposed by a Nazi hunter and meets a grisly death,

skewered on the sword of the statue of a medieval knight that circles the clock.

Such is the plot, and now that I have given it to you, this might be the appropriate place to explore what an "ordinary" film is. What did Welles mean when he said that *The Stranger* would prove he could make a film like anyone else, that he could say "action" and "cut" like any other director? On the level of the production itself it meant that Welles willingly gave over control of the film to his producers. He had a less-than-usual hand in the script. He had little involvement in the editing of the finished film. Throughout his post-*Kane* career, at least until *The Trial* and *Chimes at Midnight,* this control was taken from him rather than given up voluntarily before or after filming. For *The Stranger* it was more or less voluntary.

But "ordinary" or "conventional" refer to more than the production of the film; they refer to the film's construction itself, the way it is made and how it is meant to be received. Conventional filmmaking strategies suppress any conspicuous visual and editing techniques that might interfere with the story the film is telling. In other words we are urged by the form of the film to ignore the form of the film. Emphasis is on dialogue with the camera at eye level and moving as little and as unobtrusively as possible. Focus is shallow, the figures in the foreground in sharp focus, those in the background in soft focus. Editing is largely invisible, cutting propelled by dialogue or change of place. A dialogue sequence—two people talking to each other—will be cut with a series of over-the-shoulder shots from the position of one of the participants to the other and back again.

Construction of a conventional film produces stories that are conventional themselves: clear demarcations of good and evil, rescues of women in distress, redemption of wayward male characters, punishment of the unredeemable, resolution. Always resolution. The Hollywood classical style, as film scholars call it, is based on the notion of easy assimilation and instant forgetting. Gratification is spread out

during the course of the film by means of scenes that propel the action forward to an ultimately satisfying, morally defensible conclusion. I can't be dismissive of all this. Most of our favorite films are made with the various small variations allowable within the confines of the Hollywood classical style. Whether we watch *Casablanca*, the latest Judd Apatow comedy, or a digital-effects-laden Marvel comic superhero film, we are seeing the style in action. Its strength and longevity lie precisely in its malleability and flexibility, its ability to mold a story and be molded in return, to render itself invisible and make us excited, terrified, happy.

The films of Welles and Kubrick never render themselves invisible. They are carefully styled and demand attention to form and the way form makes content. Hitchcock can play a double game, making form invisible yet allowing us to be conscious of it if we want to watch closely. So, what then happens when Welles tries to make a conventional film in which content must envelop the form that makes it? The opening minutes of the film, in which the Nazi, now religious zealot, Meinike leaves South America to find Kindler in Connecticut seem Wellesian enough in their use of shadow and huge close-ups. These scenes foreshadow the work of director Anthony Mann in the late 1940s, whose films noirs push their characters further into darkness and the distortion of screen space. Once again, Welles is leading the way. But when the film settles down in the town of Harper, the formal bravura itself settles down. There is a long tracking shot in the woods early on when Rankin strangles Meinike. (The film was photographed by Russell Metty, who would work with Welles again on *Touch of Evil*, a film of nimble and amazing long crane shots. Metty also photographed *Spartacus*.) There is one Wellesian grotesque: Potter, the proprietor of the local drugstore, a huge man who never gets up from his seat to help his customers. And there is an extraordinary image when Rankin comes to his wife's bed after kicking the family dog (who attempted to dig up Meinike's body). The camera is high and tilted down,

making the room seem small. The door opens, casting light and Rankin's shadow, huge, hovering over his sleeping wife. The camera tracks forward with the shadow, and Mary awakes and tells of dreaming of shadows. Much of the action is bathed in shadow, and there is a carefully composed scene in which Wilson and the Longstreet family talk to Mary's maid about Mary's breakdown in the face of the knowledge about her husband. The characters are carefully arranged about the set, and the camera is at almost a Wellesian low angle. The scene is done in one brief take. Otherwise, the film settles into standard shot/reverse shots as Wilson, the Nazi hunter, zeros in on his target. There is a classic dinner table scene, conventionally edited with shot/reaction shots, where Rankin reveals himself by referring to Karl Marx as a Jew, not a German. And there is the film of the concentration camps— unconventionally cracking the film open.

Welles plays Kindler/Rankin with much eyebrow furrowing and eyeball bulging. It is not a subtle performance, no more than his wife's, played by a star of the period, Loretta Young, who stays cloyingly by her man until the bitter end. *The Stranger* is political melodrama— Welles was personally involved with progressive politics during the 1940s—without subtlety and, much more than most melodramas, without an internal logic, namely, how Kindler could so easily pass himself off as an American. Even if this narrative fact is taken as a given, it remains a matter of faith, which the film barely holds on to. But when it holds, the film moves quickly in a linear pattern that admits of just a few compositions that tend to stop the flow by drawing attention to themselves.

"Establish time," Rankin writes in a note to himself as he plans to kill his wife by sawing off a rung of the ladder leading up to the town clock he has been fixing. He fails in his attempt, and his wife, having come to her senses, winds up shooting him. And of course time does him in, skewered on the sword of the knight that rotates around the clock. "It's only a matter of time," the film seems to be saying. In that brief period

after the war, when finding Nazis was important and communism had not yet become a cultural and political obsession, *The Stranger*, along with Hitchcock's *Notorious* and a few other films, spoke to the pre-anticommunist postwar condition. *The Stranger* is an earnest and urgent appeal done up in high melodramatic fashion. Is it finally Welles's most ordinary, conventional film? The answer is almost but not quite. It is Welles restrained, Welles lite, but all the same, Welles unable to entirely remove himself from using his camera and lighting to create something new to and for the eye. Try as he might, Welles was addicted to the unusual, to the construction of screen space that would make the most banal film extraordinary, only if even for a moment of time.

Against Realism

The Stranger is a "realist" work as realism is defined by the classical Hollywood style. But this alleged realism is real only because it follows the traditions that well before 1946 had normalized film production and film form across the studios. In other words *realism* becomes "real" through the conventions of filmmaking that meet the expectations based on our accepting those conventions in film after film. Watching *The Stranger*, with a knowledge of what Welles can do, can be frustrating. I want the images to break free and open, the camera to move aggressively, the characters to stop their eye rolling. To be *unreal*. That desire is satisfied with the film Welles made next, under what would become the usual circumstances for a Wellesian production. Welles had gone broke trying to mount a stage production of *Around the World in Eighty Days* in 1946. He turned to Harry Cohn, the crude, mean-minded head of Columbia Pictures, with a proposal to make a film from a pulp novel that would star Rita Hayworth, Cohn's biggest and only star and Welles's soon to be ex-wife. He would do it for very little money.

The Lady from Shanghai was a major production, with location shooting in San Francisco and Mexico. Welles hoped that he once again had a movie under his control. He didn't reckon with Cohn, who once famously said that he could tell whether a movie was good or not depending on how often he twitched in his seat. Legend has it that Herman J. Mankiewicz (coauthor of *Citizen Kane*) responded, "Imagine, the whole world wired to Harry Cohn's ass." Cohn's ass must have twitched a lot during the screening of rushes and rough cuts of Welles's film. Welles wasn't creating enough close-ups of his star. Even worse, Cohn couldn't understand the film. He demanded retakes and turned the footage over to his editor, Viola Lawrence, to make Harry Cohn sense out of the material Welles shot. The result is an even loonier film than the one Welles most likely turned in. Where *The Stranger* hews closely to the norms of cinematic space and time, *The Lady from Shanghai* triggers a fracturing of both.

The film's most famous sequence is the hall of mirrors, where Elsa Bannister (Hayworth) confronts her crippled husband in a shootout that bursts the screen into fragments. It is a suitable metaphor for a film whose angularity, its mix of bulbous close-ups of masklike faces, mocks any simple desire for continuity or clear exposition. The film's story is impossible: Welles as Michael O'Hara, the tough Irishman who fought with anti-Franco Republicans in Spain, summarizes the plot under the funhouse sequence, but the dizzying visuals disallow the possibility of paying any attention to his words. What *The Lady from Shanghai* is *about* is Welles's style changing, becoming more assertive, more concerned with the ways in which film makes time and space malleable, the ways these components of narrative perception can be distorted or righted in the cause of shaking us out of our visual complacency. Now this just happens to be an element of this film's story as well. Michael O'Hara is shaken out of his world-weariness, his innocence and self-assured incorruptibility. He faces a perfectly banal corruption in the guise of a criminal lawyer, his loony partner, and his voracious wife,

who manipulate him just as Welles the director manipulates us out of easy comprehension of their motives and means.

The gaze, thanks to Cohn's insistence on close-ups, is intense and discomfiting. It breaks narrative continuity and jars us. Bannister's partner, Grisby, looks like a gargoyle as he ogles Elsa through a spyglass or, teetering on the edge of a precipice, convinces the gullible O'Hara to fake Grisby's murder so he can escape the civilized world. The A-bomb, he believes, will destroy everything anyway (Grisby's faked murder turns out to be part of a torturous plot that, of course, goes awry, flies and breaks apart—Grisby is killed). "It's a bright, guilty world," O'Hara says at one point. Light and dark; the darkness beyond the light. A universal guilt. Let me extend a metaphor for a moment: Welles is creating a kind of black hole down which all his characters fall. This is what the funhouse sequence represents, with its set design mimicking the distorted lines of German expressionism and Mike O'Hara sliding uncontrollably down a long chute into the hall of mirrors; this is the story he tells of the sharks that, in their blood frenzy, took to eating each other.

That story is remarkable because, telling about the sharks in the ocean "off the hump of Brazil," it draws, in part, on Welles's own experience in Brazil when shooting the aborted *It's All True*. But it is also part of the animal imagery of *The Lady from Shanghai* itself, playing off the aquarium sequence in which Mike and Elsa are set against giant images of voracious fish. The shark tale is told by Mike, looking down at the trio of Grisby, Bannister, and Elsa, lying supine during their picnic in the Mexican swamps. They lie drunk and unmoved, even as Mike's story becomes prophetic: "I never saw anything worse until this little picnic tonight. And you know there wasn't one of them sharks in the whole crazy pack that survived." Bannister can only rouse himself enough to say, "George, that's the first time anyone ever thought enough of you to call you a shark." The human omnivores of this film do, figuratively, eat themselves alive. Michael is, in a sense, thrown up

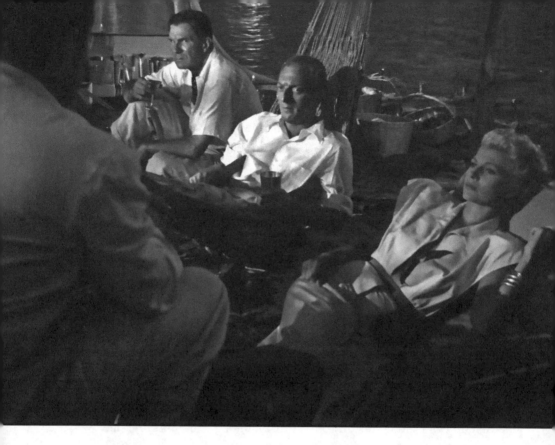

FIGURE 21 Mike O'Hara tells his story about the sharks—to the sharks, in *The Lady from Shanghai*.

on the beach, safe for the moment, his tormentors dead, he "innocent." "But that's a big word, *innocent*," he says, as he walks toward the sunrise and the ocean in a striking location shot, the camera craning up. "Stupid's more like it."

The Lady from Shanghai, held up from distribution for a year until Cohn could understand it (I doubt he ever did), marked the beginning of the end of Welles's Hollywood career. He left the United States after he made *Macbeth* for Republic in 1948. He left for a number of reasons—as I noted, Welles was very active in liberal causes during the 1940s, and J. Edgar Hoover had a file on him. He knew that HUAC was on his tail, and he was fed up with the ill treatment he was receiving from the studios. The promise of control over his work so tantalizingly held out to him when he arrived in 1939 had become an ongoing

FIGURE 22 Shootout in the hall of mirrors in *The Lady from Shanghai*.

struggle to make what he wanted to film. The ensuing years in Europe were fruitful. He starred in his most famous other-directed film, Carol Reed's *The Third Man*. He parlayed his character of Harry Lime from that film into a BBC radio series. He did a BBC television series as well, *The Orson Welles Sketchbook*. And by piecing together funds from performing jobs, he finished *Othello* in 1952. For a friend and political mentor, Louis Dolivet, he filmed *Mr. Arkadin*. The friendship broke over the production, which Dolivet thought went over time and budget. The film was taken from Welles and reedited. And reedited again. There exist at least three versions of *Mr. Arkadin* in English (all available in a package from the Criterion Collection), a film that, in whatever version, is an ugly duckling marked with extraordinary plumage.

No matter, it is one of my favorite Welles films. There is a driving energy to it, a capturing of postwar Europe not as slick as *The Third Man*, more primitive and handmade (Welles wrote, directed, did costume and production design, and the original editing). Akim Tamiroff,

FIGURE 23 Akim Tamiroff as Jakob Zouk in *Mr. Arkadin*.

the Russian-born actor who appears in four of Welles's films, including the never-to-be-completed *Don Quixote*, is an extraordinary Beckett-like character in this film. His Jakob Zouk, forlorn in the wreckage of a room with an upside-down portrait of Hitler on the wall, is a tragicomic figure of the postwar Jewish remnant. To deliver—or save himself from—the information he holds about Arkadin, he requests a goose liver for Christmas dinner. He does not survive. There are amazing images early in the film, taken at night dockside, with the shadow of a man moving out of synchronization with the motion of his actual body. A train goes by in the distance. Shadows try to swallow everything. This is imagery that foreshadows Antonioni's landscapes, which would mark the modernist phase of European filmmaking in the 1960s. (Welles despised Antonioni, found

him boring, and was perhaps unaware that his own work prefigured the Italian filmmaker's style.)

While *Mr. Arkadin* is a temporal jigsaw puzzle like *Citizen Kane*—Arkadin sends the American blackmailer Van Stratten to search out his past so he can kill those who remember his thuggish early years as a Polish sex trafficker—but even more than *Kane*, the quest is more interesting than its goal. In fact, no matter how often you watch *Mr. Arkadin*, it's unlikely you will figure out its plot (I had to look at James Naremore's summary in his book *The Magic World of Orson Welles* to be sure of the "facts") for the reason that, like *The Lady from Shanghai*, it is not about plot or facts. *Arkadin* concerns masks: the mask of time, the mask of character, literal masks worn by characters at an Arkadin party, the mask of Arkadin himself, whose mask of a face is introduced by his wearing a mask. Here is perhaps the best or the worst makeup job that Welles ever wore. Gregory Arkadin is all mask, all obvious mask. You can clearly see the outline of Welles's wig on his built-up forehead (see figure 10). There is a double impenetrability at work here. It is hard to penetrate the reason why Welles wears such ridiculous makeup in this film, but if we accept the fact that he does, then we move to the next step, which is that the character himself is impenetrable, as much as his past itself. He is his own bulwark against time, against character, against the worldwide hunt on which he sends Van Stratten. The characters Van Stratten digs up are mostly grotesques: the flea circus ringmaster; the bulbous antiques dealer Burgomil Trebitsch (played by the august British actor Michael Redgrave), with a dusty stuffed alligator hanging from the ceiling of his messy shop; one beautiful ex-lover and another one, Sophie, gone to seed. All of this is done with enormous élan, propelled by Paul Misraki's score, and a sense of play that underlies so much of Welles's work.

Mr. Arkadin is a globe-trotting comedy and a fantasy of corrupted, murderous power, as well as another reason for Welles to play with space and time. Its deep-field compositions, loony characters, and

lurching editing style—there is a vertiginous scene aboard a yacht in which set, camera, editing, and characters stumble about in a relentless heaving—mark a change that Welles will more fully exploit in his next and last American film, *Touch of Evil*. His time in Europe had made him familiar with postwar corruption; he had more than an inkling of the corruption of American politics before he left as the HUAC investigations were gaining speed. In the 1940s he was active in the Hispanic rights movement and made the Sleepy Lagoon trial—in which a group of young Mexican Americans were accused of murder—a personal cause. He would have, while in Europe, been familiar with the scourge of Joseph McCarthy and seen it firsthand on his return in 1953. And even though McCarthy was finished by the time he came back again in 1956, the brutal Cold War, anticommunist discourse remained.

Touch of Evil is an imagining of mid-1950s America as a wrecked border town, with a McCarthy-like sheriff falsifying evidence and an upright Mexican government official tracking down a gang of drug smugglers. The premise of the film is pulp fiction—very liberally adapted from a work of pulp fiction, Whit Masterson's *Badge of Evil*. The pulp at the film's base, however, is exploded into dark, menacing spaces probed by a restless, serpentine camera following characters who scuttle around a border town that has no recognizable borders. Welles turns the contemporary political-cultural moment into a nightmare of corruption and self-righteousness, exploring, as if in an allegory, the domestic spaces of the Cold War. Returning home after so many years, Welles came full circle to the end of *The Lady from Shanghai*, finding his country a crazy house.

Touch of Evil is remarkable on a number of levels, not the least of which is Welles's use of the moving camera, sometimes dramatic, as in the opening three-plus-minute shot of the film, sometimes insidious, as in the acid-throwing scene: Vargas leaves the hotel where he has left his wife for safety (on the American side of the border, though it never is quite clear because this is a border town of the imagination and,

besides, it turns out that Susie is not so safe).Vargas is catching up with Quinlan and his entourage, who are heading for a local strip club (on the Mexican side of the border). One of the Grandi boys, Risto, waits for Vargas. The camera tracks back as Vargas moves into shadow, his pursuer following in deep focus behind him, moving behind pillars. There is a cut that reframes Risto, who heads straight for the camera. The arches of the buildings behind him recede at a crazy angle to the rear. Another cut picks up Vargas and moves around slightly to the left. There is then a brief cutaway to Quinlan and his entourage entering the back door of the club, Quinlan talking about how the bomb—the one that blew up Rudy Linnekar and his companion, Zita (at least I think it's Zita), one of the strippers in the opening sequence of the film. On Quinlan's growl "he wanted them destroyed . . . annihilated," Welles cuts back to Vargas, walking along a wall, his shadow prominent next to him and the shadow of his pursuer following. Actually, the words spoken are in Vargas's ear range, though the spatial confusion of this sequence, like the rest of the film, is disorienting. The camera continues to track Vargas as he approaches the others until Risto, who is following him, calls out to him. As Vargas turns to him there is a sudden close-up of Risto holding a vile of acid. Another cut as Vargas turns toward Risto. Newspapers blow around the nighttime shadows. Cut to Risto, looking determined; cut to Vargas calling out. He is positioned by a poster for the stripper, "Zita—This Week Only." Cut back to Risto, who hurls the acid and, in doing so, moves into shadow. The next quick cut is Vargas's hand gripping Risto's—a fraction of a second until the next cut as the acid annihilates the poster of Zita, and Vargas whips Risto around and against it. There follows an intricate tracking movement as Vargas chases Risto around the pillars.

I'm parsing this sequence with the hope that all the edits were made by Welles rather than the studio. They work so well with the sinuous moving camera to emphasize the all but unparsable space that constitutes the dark world of *Touch of Evil*. Nothing is what it seems

FIGURE 24 Vargas wrestles with the acid thrower in *Touch of Evil*.

because whatever seems to be is suppressed on the level of plot and visually swallowed into the darkness Welles's camera tries to explore. One of the few sequences filmed in daylight, and about which there is no question of editing because there isn't any, is the interrogation of Sanchez in Marcia Linnekar's apartment. Marcia is the daughter of the man blown up with Zita; her boyfriend, Sanchez, proves to be the guilty party, though the announcement of this, late in the film, goes by all but unnoticed. Six to eight people (they come and go) in a crowded space are covered in a shot that lasts about seven minutes, interrupted by a scene of Susie in her motel room and Vargas phoning her in a bizarre shot framed with a blind woman who stares out with one opened eye. The return to the apartment constitutes another long shot of almost five minutes, during which Quinlan and his longtime partner, Menzies, plant dynamite in the shoebox that Vargas had pre-viously found empty.

These are the spaces of guilt and frustration, the cramped quarters of a woman and her shoe-salesman lover, who committed a grotesque crime and is being nonetheless setup for that crime. It is the space of racial tension and the contention of old evil—Quinlan—and the

upstart from a foreign country—Vargas. It is the space of betrayal and corruption and the beginning of Quinlan's downfall, which will occur when Menzies turns against him and helps Vargas. The two slosh after Quinlan in the garbage-filled canal, gathering evidence by means of a tape recorder.

Touch of Evil is amazing in ways that Citizen Kane, made some fifteen years earlier, is not. Where Kane is polite in its innovations, Touch of Evil pulls out all the stops. Where Kane, for all its experimentation and innovation, is a film of the early 1940s, Touch of Evil is very much of the 1950s. That benighted decade, strangled by Cold War rhetoric, with Hollywood wracked and all but wrecked by the blacklist, still saw some remarkable films. Hitchcock's most mature work was made during these ten years. John Ford made The Searchers, probably the most influential film after Citizen Kane. Samuel Fuller made raw and lovingly awkward war movies and one key Cold War film noir, Pickup on South Street. Nicholas Ray, an uneven, tormented filmmaker, made one of the strangest westerns early in the decade, Johnny Guitar, and In a Lonely Place, arguably the most powerful film about the anguish of masculinity next to Vertigo. Stanley Kubrick began his career in the early 1950s. Welles stepped into a political cauldron and a ferment of the imagination when he returned to Los Angeles. Welles was free to look back at the political swamp that was the United States in that decade and to look forward to a renewed career. He succeeded in the former and failed at the latter. Universal's refusal to execute his editing instructions so infuriated and disheartened Welles that he left once again and made two of his finest films in Europe.

Touch of Evil and Psycho

Before looking at those films, I want to dwell a moment on Psycho, a film replete with extraordinary images. One of the remarkable things

about this remarkable film is its unlikely debt to *Touch of Evil*, made just a year earlier. There are superficial resemblances: Janet Leigh stars in both films. Mort Mills, who plays the assistant D.A. in *Touch of Evil*, is the policeman with dark glasses in *Psycho*. Robert Clatworthy was art director on both films. Both feature a creepy motel and a loony hotel keeper (Dennis Weaver in Welles's film, Anthony Perkins in Hitchcock's). In both, the Leigh character is trapped in the motel, killed in it in *Psycho*, doped by a Latino gang in Welles's film. In *Touch of Evil* Sheriff Hank Quinlan falls dead into an open sewer. In *Psycho* Norman Bates sinks the car with Marion Crane's body into a swamp. On a deeper level both films deal with a looming darkness swallowing the characters into a vertiginous night. But there the similarities end.

Welles engulfs his characters: the off-centered, canted compositions and his moving camera push them through unwelcoming, often threatening, spaces. Hitchcock is much more reserved, despite the film's startling eruptions of violence. The world of *Psycho* is airless and slightly putrid, like the swamp that swallows Marion's car, like Norman's room, redolent with masturbation, with its stuffed rabbit and Beethoven's *Eroica* symphony on his record player. Hitchcock's characters are constrained by something just more than squalid lives. In *Touch of Evil* Janet Leigh's Susie Vargas, trapped in a hotel, removes the dangling lightbulb and hurls it at the men across the way who are spying on her. She refuses to be passive until held down by the Grandi boys and girls in the out-of-town motel. Janet Leigh's Marion Crane is found in a cheap hotel room at the beginning of *Psycho* during a lunchtime assignation with her boyfriend, Sam Loomis. Hitchcock's camera has to roam across the Phoenix skyline to find them, finally creeping under a partly opened window, where, in a postcoital state, they argue about their future, the camera often assuming that high angle Hitchcock uses when characters are in trouble. An electric fan in the room, prominent in the frame, only emphasizes their airless lives.

This opening sequence has always struck me as the grimmest in

the film. Its violence is contained within the emotional poverty of the characters. The grayness of their surroundings expresses the dreariness of their lives; it imposes on them and it sets the mood for more dreariness to come. Curiously enough, there is a sense of life in *Touch of Evil*, supplied by Welles's own energy at creating his shadowy world. As always, the pleasure of the eye outstrips the convolutions of the plot. Perhaps more accurately, the visual convolutions, while communicating forcefully the thrust of the narrative, become more interesting than the details of the story. It took me years, and finally somebody telling me, to realize that Hank Quinlan was right, that the shoe clerk planted the bomb that blows up the car at the end of the long take that begins the movie.

Hitchcock's visual energy is very different. The movement of his camera in *Psycho* is restrained for the most part. There is the virtuoso crane and twist up the stairs of Norman's old dark house, which ends with the camera looking ninety degrees down as Norman carries his mother down to the fruit cellar ("You think I'm fruity?" we hear her ask). Earlier, the camera had assumed the same position as Mother rushed out, knife in hand, to kill detective Arbogast. Near the end of the film, when Marion's sister, Lila, climbs the steps to the house, Hitchcock indulges in his favorite camera movement, tracking with the moving character intercut with point-of-view shots of the object— the house in this case—moving closer to that character. But all of this is different from what is perhaps the most famous moving camera shot in film history: the opening track in *Touch of Evil* that pursues the car with the bomb, craning up, moving over buildings, coming back down to the street on the other side of the border with people and push-carts passing by, catching up to Susie and her husband Vargas "hot on the trail of an ice cream soda." They kiss and BOOM, Welles cuts and zooms into the car bomb going off.

Hitchcock's best are fearful films made by a fearsome intelligence. Welles's films are fearless. Hitchcock was fond of saying how frightened

he was of being stopped by a cop. Welles also said that the most frightening thing was being pursued by a policeman. But Hitchcock's comment was personal, emerging from a fear of being disrupted from a comfortable routine and placed in a disturbing situation. Welles's was a political statement, an intuition of sorts that he had when he returned to the United States. *Psycho* is dank with fear and entrapment. Almost everything, every horror, occurs indoors or in constricted spaces: Marion's drive through the night, imagining the voices of her boss and the man whose money she stole; the motel parlor; the shower; the basement of the old dark house; a prison cell. Much of *Touch of Evil* occurs outdoors but hardly in *plein air*. The outside of *Touch of Evil* is a dark space with garbage blowing in the air, oil wells pumping, oily sewage pits through which Vargas wades to gather evidence on Quinlan, where Quinlan, like Macbeth, tries to wash the blood off his hands, and into which he falls when he's shot.

Neither film allows us our own space. *Psycho* is, like all Hitchcock, highly manipulative; it takes us exactly where it wants us to go but on subsequent viewings allows us in on the joke at *Psycho's* heart. In the parlor scene, where Norman and Marion meet and she first hears Mother's voice yelling at her son, the confrontation exposes who Norman is and pretty much what is going to happen to Marion. The sequence is worth looking at in detail.

"Mother . . . my mother . . . what is the phrase? She isn't quite herself today," Norman tells Marion after the outburst in the old dark house. And so he invites her to have the supper of milk and sandwiches he's prepared to serve in the parlor behind the office. The first thing Marion notices in the parlor, and that we see, because Hitchcock allows us to assume her point of view, is a stuffed owl, wings outspread, ready to pounce. Once inside and seated, Hitchcock presents the two in one shots—that is, they are seen separate from each other, Marion comfortably seated on a sofa, a lamp next to her, Norman seated forward in his chair next to a stuffed bird, its bill pointed toward him. They

FIGURE 25 The influence of *Touch of Evil* on *Psycho*.

talk about stuffing things, Norman's hobby. He pets the bird next to him as he tells Marion that he sometimes runs errands for his mother, "the one's she allows I might be capable of doing." Marion asks if he goes out with friends. "A boy's best friend is his mother," says Norman, which, if nothing else was said in this scene, should give us pause. It does for Marion, who, already having heard "Mother" yelling at Norman, gives Norman a knowing look. They continue talking at cross purposes, Norman wanting to know what Marion is running away from, Marion worried he'll find out about the money she stole from her boss to finance her marriage to Sam. They talk about being trapped on their own private islands. "We scratch and claw but only at the air, only at each other." In a moment Norman will be scratching and clawing at Marion. Talk turns back to Mother. When Marion expresses her outrage at the way she heard Mother talk to Norman, something interesting happens. Hitchcock reframes Norman, close, from below, against shadow, the stuffed owl, its wings raised, as if swooping for the kill. There is a picture of a naked lady behind him. The reverse shot to Marion is also much closer. When we return to Norman, the framing remains at that same low angle, but he momentarily relaxes into his chair as he gives his version of Mother, her lover, and their death. Another picture, perhaps of a rape, is seen behind him.

The conversation continues, Norman expressing his self-thwarted desire to leave his mother—but "the fire would go out." When Marion suggests he might put her "some place," another reframing occurs. A tighter close-up of Norman, the bird on his left ready to peck at his head. "You mean an institution . . . a madhouse?" He leans forward, his head threatening the bounds of the frame, just as, years earlier,

Uncle Charlie in *Shadow of a Doubt* turned to the camera with a full-faced threatening gaze (see figure 7). In the reverse shot of Marion she shows a little fear. Music comes up quietly. Norman's description of a madhouse, "the laughing and the tears and the cruel eyes studying you," suggests some intimate knowledge. "But she's harmless. She's as harmless as one of those stuffed birds. . . . It's not as if she were a maniac. A raving thing. She just goes a little mad sometimes. We all go a little mad sometimes. Haven't you?" All of this is true, because there is no Mother, or rather Mother is Norman and Norman Mother. But still at cross purposes, Marion takes his lesson to heart and decides to change her ways and return the money. Norman takes things to heart, becomes Mother, and stabs Marion to death in the shower. When Marion gets up to leave the parlor to go to her room and the shower, a stuffed crow is pointed at her neck.

"Of course" is the response when you see this sequence the second time. It's all there, the film's big reveal occurs during this conversation. You might even recall the conversation between Marion and Sam in the opening sequence in the hotel, when, talking about having to live and make love at Sam's sister's home, they'll "turn Mama's picture to the wall." But there is another "of course," another revelation that goes beyond the one that Norman and Mother are one and the same. The end of *Psycho* is in two parts: the climax is Norman's attempted attack on Lila in the fruit cellar followed by the long disquisition by the psychiatrist about Norman's state of being out-of-his-mind. But there is a coda, another scene that makes *Psycho* the chilling film it is. Norman is in his cell, sitting perfectly still against a blank wall, wrapped in a blanket, his right hand resting on his left knee. The camera dollies in slowly as Mother's voice assures us she couldn't commit murder, that her son should be put away ("some place"?). Norman shakes his head as Mother's voice speaks. "As if I could do anything except just sit and stare, like one of his stuffed birds." Norman looks down at a fly on his hand. "They'll see and they'll know. And they'll say, 'why, she

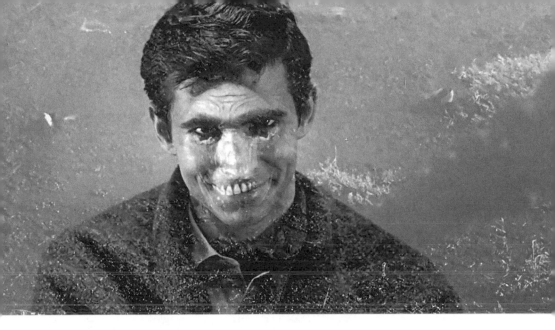

FIGURE 26 "Wouldn't hurt a fly." The end of *Psycho*.

wouldn't even harm a fly.'" Norman's eyes look up and a hideous grin spreads across his face. There is a quick double dissolve as Mother's skull appears behind Norman's face and a chain, a heavy chain pulling Marion's car out of the swamp, emerges as if from Norman's neck. The famous Bernard Herrmann three-chord dying fall ends the film on the image of muck. Of course Norman is mad, but this is a madness without rational explanation. The closing scene of the film negates the psychiatrist's analysis because, in the end, we cannot analyze madness and the chaos that ensues.

There is a parlor scene in *Touch of Evil*. Hank Quinlan goes to visit his old friend, the local madam, Tana, played by Welles's old friend, Marlene Dietrich. In a movie without much sentimentality it is a touching scene, with Henry Mancini's lovely tune played on Tana's pianola. Touching, though introduced by a piece of garbage blowing by Quinlan as he enters the building. Tana's parlor is as cluttered as Trebitsch's antique shop in *Mr. Arkadin*. There is an animal figure sitting on a table reminiscent of the doll in Susan Alexander's room in *Citizen Kane*. (The references to *Kane* are marked: Quinlan walks with a cane, and after he murders Uncle Joe Grandi, he forgets it in the hotel

FIGURE 27 Hank and Tana in *Touch of Evil*.

room. The camera zooms and freezes on a sign on the door: "Stop! Forget Anything?") The talk between Hank and Tana reveals only loss and regret. He wishes he could get fat on her chili. "Better be careful, it may be too hot for you." Tana is Hank's tender voice of doom.

He visits her later in the film when she is reading her Tarot cards. "Your future is all used up," she tells him. Here Welles composes Hank beneath the head of a stuffed bull, not only a visual reference to Hank's own fall but a foreshadowing of Hitchcock's images of Norman sitting in his parlor under those predatory stuffed birds. Unlike Norman, Hank does not hide his predatory nature. But his luck as a bull of a law enforcer, a forger of evidence, is over, undone by a Mexican, whose very ethnicity he despises. The Mexican gathers evidence on Quinlan by recording his conversation, adopting some of Hank's own methods. Everyone is trapped. In both films the characters finally have no air— Hank in the swamp; Marion in the shower and then her body in her car in the swamp. Tana goes off into the darkness: "He was some kind of a man. What does it matter what you say about people?" Norman, now Mother, sits in his cell, the camera slowly tracking into him until his mad grin is displaced by his mother's grinning skull and punctured

by that chain pulling the car out of the swamp. But this final movement is not a liberation but a further rupture, an ugly, violent image that, with Norman's psychotic grin, ends the film with a question mark and a sinking feeling.

Labyrinths, Lost Time, Dying Falls

Anthony Perkins exits *Psycho* and enters *The Trial*, a film that is all question mark and sinking feelings but also elation at its extraordinary visual imagination. In the labyrinthine illogic of its nightmare, time does not exist, only the looming, threatening spaces that engulf Josef K. and disorient the viewer. Late in the film, Josef K. enters a building of the court, climbs up a winding set of stairs past a huge, boiler-like object and enters a wooden cage. He is pursued by a pack of screaming young girls—wards of the court, he's told—who pull at him as he climbs. The cage belongs to the court portrait artist, Titorelli, who, dressed in prison stripes, speaking with a fey voice that was dubbed by Welles himself, attempts to seduce K. with the various kinds of acquittal he might be able to wrangle from the judges he paints. Welles creates a visual frenzy (typical of the film as a whole) as he intercuts close-ups of the two men in this cage, which is slashed with shadows, the eyes of the girls peering through its slats. Titorelli threatens the girls, asking them if they remember his ice pick. K., faint with the numbing, circular oppressiveness of Titorelli's argument (ostensible or definite acquittal, indefinite acquittal or deferment—definite acquittal is never possible, ostensible or deferment lead to continual arrest and trial), begs to leave.

Given a door different from the one he entered, so as to avoid the girls, he finds himself in a huge room, the law court office, lined with file cabinets and bound papers, a grid of fluorescent lighting above, in a forced perspective, photographed at a tilt. He turns; Welles cuts, and

FIGURE 28 Titorelli's room in *The Trial*.

at the other end of the room are a crowd of tattered men, more of the accused. K. is at this point his most hysterical, practically sobbing in despair. "It's my mouth, my mouth," he cries, having been told how guilt is recognized in the accused. The men shrink back at his outburst. Welles performs a 180-degree cut—that is a cut that takes us to the direct opposite side of where we were in the preceding shot—and then cuts again, but this time returning us to the slatted room and the little girls. But it's no longer a room; rather, it's a long slatted tunnel. K. runs, and the camera flees before him (see figure 5). The girls pursue. The wooden slats give way to an underground passage, and the flight continues until K. finds himself in huge open space, addressed by a priest and then by Advocate Hastler, Welles himself, standing before that white movie screen we have seen in his other films, ready to deliver Kafka's parable, "Before the Law," that actually served as the film's prelude. K. wants none of it and is led off to his assassination. In Kafka's novel K. dies "like a dog . . . as if the shame of it must outlive him." Welles's K. is handed a knife to kill himself, which he refuses to do, so he is blown up, defiant to the end. Welles's sense of

humanity will not allow this victim to be totally passive in the face of overwhelming malice.

It's not easy to find a copy of *The Trial* (though there is a very good Blu-ray available from Japan), so such verbal details help to communicate the fine controlled madness of this film. Not as explosive as *Touch of Evil*—though both contain bombs, the one in *Touch of Evil* going off at the beginning, the other at the end, blowing up Josef K. in a mushroom cloud—it is the climax of the Wellesian high modernist style. The high-contrast, deep-focus image making that started in *Citizen Kane* is, in *The Trial*, combined with the arrhythmic cutting begun in *Othello* to create a hallucinatory film that becomes the contemporary resetting of Kafka's early twentieth-century modernist novel. It is Welles's cry from the heart about the diminishment of individual agency, the ability to act positively in a dark and fearsome world. It is a reflection back on the Holocaust, Stalin's show trials, Joe McCarthy, the HUAC hearings. It is a triumph of form, of cinematic vision expressing a distressing content.

This is not far from Hitchcock's and Kubrick's vision, but it is one that Welles would not hold on to. I noted how *The Magnificent Ambersons*, though shot in the dark Wellesian style, and a tale about loss and decline, is really the opposite of *Citizen Kane* in its sentimentality over that loss. Charles Foster Kane may be sentimental about his mother and *Rosebud*, but George Orson Welles is sentimental about the loss of an earlier age, not innocent, not simpler, just lost. The same duality occurs between *The Trial* and *Chimes at Midnight*. The latter, the last full-length fiction film Welles was able to complete and release, is a joyful, lyrical, elegiac celebration of Shakespeare and the doomed, always foretold tale of Falstaff and Prince Hal. Like the films that precede it, it is about endings but not the violent endings of Welles's other Shakespeare adaptations, *Macbeth* and *Othello*. Rather it is about the spirit of raucousness and rebellion in the face of the inevitable reassertion of patriarchal order. There is violence, a grueling and extraordi-

nary battle sequence, but the emphasis of the film is on the bittersweetness of an impossible friendship between youth and old age, in which the vitality of age falls to the growing authority and repressiveness of youth, a foreshadowing of Sigmund Freud's *Totem and Taboo*. The visual representations of this are the tavern, where Falstaff and Prince Hal cavort, and the castle, where a fretful Henry IV awaits his son's coming of age. Welles constructs his sets so that the two buildings are seen across the mists from one another.

Actually, Welles (and Shakespeare) complicates that straightforward contrast. Old age is split between the warm raucousness of Falstaff in the tavern and the cold stewardship of Henry IV, seen in the barrenness of his castle, intoning his discontent as only actor John Gielgud can. His son, Hal, Falstaff's companion, must inevitably grow up to become king, and this tension pervades the film until Hal becomes Henry V and renounces and banishes Falstaff, resulting, inevitably, in Falstaff's death. The clues to the transition come in various exchanges early in the film, in particular a sequence outside the tavern where Hal delivers his speech "I know you all, and will awhile uphold / The unyoked humor of your idleness." Hal is in the foreground, all but eclipsing Falstaff, who stands in the doorway of the tavern. The final reverse shot of the sequence, from far behind Falstaff, shows Hal walking toward the castle, which looms in the distance. As so often in Welles, the space is skewed, so that the castle walls sit straight on the horizon while the tavern doors, Falstaff, and Hal appear tilted rightward. Space and the figures and objects that populate it are as eloquent as the words the characters speak, and what they speak is the fall of all the tavern stands for.

A number of events intervene before the renunciation scene, none more important than the battle at Shrewsbury, a chaos of blood and

FIGURE 29 A triptych of the battle sequence in *Chimes at Midnight*.

mud that Welles constructs with almost surgical skill, moving from large troops converging on each other ("large" as a function of careful editing and camera placement, since Welles had a limited number of actors for this film) to individual combatants thrashing at each other in the blood and mud with maces, shields, axes, and swords. All of this is intercut with shots of Falstaff in armor, hiding from the fray. The accompanying music punctuates the grueling horror of the sequence, which has been as influential as anything in Welles's work. Mel Gibson remakes it in his *Braveheart*, and Steven Spielberg has it in mind in *Saving Private Ryan*, as does Oliver Stone in *Alexander*. The sequence is a triumph of idea and execution over limited means.

Earlier in the film is a little scene that hasn't had much influence but remains, in its few seconds of screen time, as beautiful a piece of film-making as one can find. The scene takes place in the Gadshill robbery sequence, which derives from *Henry IV Part 1*. Hal, Bardolph, Poins, and Peto, along with Falstaff, set off on a lark to rob a group of pilgrims. Welles sets the sequence amid a stand of trees. Leaves cover the ground, looking white as snow in the slanting sun. The participants put on white robes and hoods, and after they chase away the pilgrims, Hal and Poins put on black robes in order to fool Falstaff. The chase is on. The music moves to a sprightly register. The camera, looking straight on through the trees with Falstaff and company in the near distance, begins a leftward track. Welles cuts in close shots of the fleeing Falstaff and the club-brandishing prince, but the scene keeps returning to that wonderful lateral track. As I said, the scene lasts but a few seconds, but

to my eyes they are some of the most rapturous few seconds in cinema. Welles owns the cinematic space, and what he does with it is thrilling in its lyricism and vitality. This is an extraordinary image.

Hitchcock and the Abyss

There are two films that, like *Touch of Evil* and *Psycho*, join Welles with Hitchcock in interesting ways. Just before *Vertigo*, in 1956, Hitchcock made *The Wrong Man*, a film often referred to as documentary in style. But despite the fact that it is based on actual characters and events and doggedly follows the process of arrest and trial of an innocent man for robbery, there is little of "documentary" in this film. Rather, it is a grueling study in passivity and descent into madness, a swallowing into the dark of bass player Manny Balestrero and his wife. Manny is accused of a crime he did not commit, and his wife goes mad as his anxiety is passed on to her, causing her to live, as her psychiatrist says, on the dark side of the moon.

Welles's adaptation of Franz Kafka's *The Trial* was made in 1962 and is a film about a man accused of a crime he didn't or did commit. *The Trial* could not be accused of a documentary style. Welles's voice-over introduction states that his tale has the quality of a dream . . . a nightmare. Where the spaces of *The Wrong Man* are explored through realist images, perhaps more accurately neorealist images—New York streets, a police department, the Stork Club, a courtroom—the spaces of *The Trial* are overwhelming, frightening, breathtaking. This is Welles at his most imaginative, creating an alternative universe alive with grotesque figures scurrying through a ruined, cavernous landscape. Both films explore the nature of guilt—Hitchcock on a local level, Welles on a universal one.

The Wrong Man is an allegory of the HUAC show trials in Hollywood during the late 1940s and early 1950s, humiliation rituals in

which people were forced to name names or face blacklisting or jail. In *The Wrong Man* Henry Fonda's Manny Balestrero is paraded before the various shopkeepers who accuse him of robbing them. Josef K., forgoing Manny's passive acceptance of his assumed guilt, plows through the courts of the law, seduced by women who find the accused attractive, fighting against his court-appointed lawyer, who proves to be a useless sycophant of the court, refusing the comfort of a priest, defying his executioners, blown to smithereens with a bomb that explodes into a mushroom cloud.

Manny Balestrero is saved by divine intervention. He prays. Hitchcock zooms in on a picture of Jesus, and then, over Manny's supplicating face, there is a dissolve to an image of the actual thief. "Do you realize what you've done to my wife?" Manny says when he meets his double in the police station. Rose is gone, unresponsive, unreachable. She is a foreshadowing of *Vertigo*'s Scottie after the presumed death of Madeleine/Judy. When Midge visits Scottie in the sanitarium, he is unresponsive, and Midge leaves, disappearing as she walks down a gray corridor and out of Scottie's life and the film (see figure 31). Just so, Manny leaves his affectless wife and walks down the corridor of the sanitarium. But this is two years before *Vertigo*, and Hitchcock is not yet ready to leave his viewers in complete despair. The film ends with a far shot showing Manny and Rose in Florida with a title card that tells us all is now well.

Michael Wood says of Hitchcock's endings that he is fond of "insinuating a little disarray into what was supposed to be a resolution." "A little disarray" may be true of the pre-*Vertigo* films. With the exception of *North by Northwest* there is *only* disarray and a lack of resolution in those films of his maturity. Scottie stares into the abyss of his own ruined life; we stare into the abyss of madness at the end of *Psycho*; the birds are poised for their next attack at the end of their film. "Mother, mother, I am ill," chant the children at the end of *Marnie*, indicating that despite her reconciliation with her husband and his helping her to

confront her mother and their past, all is not, and never will be, well. The tagged-on ending of *The Wrong Man*, perhaps true to "facts," is false to the truth of the film and its dark, sullen imagery.

The feeling that all is not well in Hitchcock's films is so often communicated by his signature high-angle shot. We saw it in *The Wrong Man*, where the camera leaps back and up when Manny momentarily voices his anger at being held for questioning. Look what happens in *Shadow of Doubt*: the infiltration of chaos and corruption into a small town and the small mind of young Charlie through the agency of her Uncle Charlie is conducted through a series of moves that signal the dawning recognition on the part of young Charlie that her uncle is a killer.

Charlie may be in denial, but we understand more quickly than she what is going on, given the expressionist shadows and skewed angles of the staircase in young Charlie's house whenever Uncle Charlie is present. The moment when our knowledge and hers coalesce occurs in the town library, where young Charlie rushes to find the newspaper item her uncle clipped out and threw away. It is late in the evening, just before nine, when the library closes. As she approaches (after being delayed by the town traffic cop, who seems to be on duty twenty-four hours a day), the lights in the library windows go off, one by one, with each chime of the town clock. Charlie begs the librarian to let her in. The latter, like the keeper of the Thatcher Library in *Citizen Kane*, is a stern older woman, in keeping with the stereotypes of the time. Charlie searches the racks of papers and finds what she is looking for. Hitchcock holds her in profile as she looks and notes her expression of recognition at what she reads. He then makes a hard cut to the headline: "Where Is the Merry Widow Murderer?" The main theme of the film, the elusive "Merry Widow Waltz," grows in crescendo as the camera scans down on the details of the newspaper article, ending with the name of one of the victims, "the beautiful Thelma Schenley." Cut back to Charlie and a shot of her looking at the ring her uncle gave her

FIGURE 30 A high-angle shot in *Shadow of a Doubt.*

earlier in a moment that looked, for all the world, like an incestuous mock wedding ceremony. The ring is inscribed to "T. S." Charlie puts the ring down, stands up, and the camera begins to ascend. Up and up, isolating Charlie in the grief of her knowledge. The Merry Widow dancers appear again, dissolved over Charlie, alone and diminished, and then another dissolve to Uncle Charlie out of doors, seen from behind, reading a newspaper.

The high-angle shot becomes a signature move for Hitchcock, just as its opposite, a low-angle shot, is for Welles or the tracking shot and perfectly symmetrical composition is for Kubrick. As genres supply structure for filmmakers, so certain camera, lighting, and compositional gestures anchor them in stylistic traits that are recognizable in film after film. In style lies conviction, and in conviction lies all but a guarantee of meaning that recurs across a director's work. When Hitchcock's camera goes high, we know that threat lurks and the char-

acter is vulnerable. This is not to say that Hitchcock won't go in the opposite direction. There is the extraordinary vertical crane down to the key in Alicia's hand—the key to the wine cellar where the Nazis have stored Uranium 235—in *Notorious*. There is, as I noted earlier, the equally extraordinary creep of the camera up the stairs of Norman's house in *Psycho*. But at the top of the stairs it rises further, twists and contorts itself into a ninety-degree position above the landing, as Norman carries "Mother" down to the fruit cellar.

Vertigo's high shots are somewhat different from the Hitchcockian norm: they are mostly from Scottie's point of view down to the abyss from heights that he cannot master. At the beginning of the film and the first time he chases after Judy/Madeleine up the mission bell tower, Hitchcock engineers his remarkable zoom/track in opposing directions to indicate a simultaneous expansion and collapse of the space that controls and disorients Scottie. But when Scottie exits the tower after he thinks Judy/Madeleine has fallen to her death (it's Gavin Elster's wife who has actually been thrown off the bell tower), Hitchcock leaves his point of view and regards him from the top of the mission tower as he makes his way down. When he leaves the mission, Hitchcock's camera gazes at him from a tremendous height so that Scottie is a minuscule figure almost invisible in the lower right of the frame. The gesture is repeated in *North by Northwest*, when Roger O. Thornhill escapes from the UN building after it appears that he has stabbed a delegate (he hasn't). The high angle looking down the side of the building looks like a Mondrian painting.

There are other high angles in *Vertigo*, and I don't want to get too microscopic in my analysis, though we need to notice that the end of the film, when Judy-now-Madeleine does actually fall to her death, when Scottie is devastated beyond redemption, Hitchcock looks almost directly at him, just slightly tilted up, as Scottie stares into the abyss, his arms held out from his side. Scottie's state of loss transcends mere vulnerability. A high-angle shot at this point would

not communicate the full sense of Scottie's bereavement. Only an all-but-straight-on gaze at him looking down allows us to measure and respond to his desolation.

The conventional resolution of a film is meant to close up its story space. If everything and everyone is all right, evil subdued and good redeemed, we can resume our own lives and forget what has gone on during the past two hours. Lack of resolution is a cause for discomfort. Hitchcock filmed a largely silent sequence in which Scottie returns to Midge at the end of *Vertigo*. It was meant to satisfy the censors and was apparently shown in England. It drains the abyss that opens beneath Scottie in the actual ending of the film, which is essentially a disturbing *beginning* for this character who has lost everything. Where could Scottie really go after having remade a woman and then made love to a ghost, only to have her die once again? The open-armed gaze from the bell tower leaves us in a state of awe and pity—in catharsis, to invoke a still useful literary term.

It was not always this way. Earlier Hitchcock films do resolve, though with some "disarray." At that funeral for Uncle Charlie, the serial killer of elderly widows in *Shadow of a Doubt*, we hear the voice of the preacher praising him while the FBI agent who was tracking Uncle Charlie and becomes romantically involved with his niece—his once innocent double—tells her the world "seems to go crazy every now and then." *Shadow of a Doubt* is ostensibly about a serial killer and his niece, but it is also a film about America and World War II. Uncle Charlie is the serpent that insinuates itself into pristine Santa Rosa, California—like Franz Kindler insinuates himself into a Connecticut town in *The Stranger*. Uncle Charlie is a mark of the insinuation of fascism and war into the unsuspecting innocence of an isolated country. There is a hint of this when young Charlie goes to the library to look up press clippings of Uncle Charlie's exploits as a killer of widows and we are offered a glance at a headline about the Japanese army general Tojo. A poster for war bonds is on the

wall behind her, reminders that would not be lost on a contemporary audience.

So, too, the end of *Notorious*, made just after the war and, like Welles's *The Stranger*, concerned with the remnants of Nazism. The world has already gone a little crazy, and a few of the remaining crazies are hoarding uranium powder in the wine cellar. More important, Devlin, the American intelligence agent, is using Alicia, daughter of a Nazi, to procure information for him. Like Scottie after him, Devlin has molded a woman to fit his needs. She marries a Nazi who, along with his mother, proceeds to poison her. The depths of degradation and torment seem insuperable until, at the last moment of this captivity narrative, Hitchcock plays with space. Devlin, suddenly become the prince saving the princess from the dark tower, swoops the bedridden Alicia into his arms and carries her down the staircase and out of the house. Hitchcock orchestrates the rescue as a play of gazes back and forth from Devlin to Sebastian (the Nazi), Sebastian's mother, and their assorted Nazi guests. The resolution lies in this play of eyes and faces as Devlin gains control of the space into which he had abandoned Alicia and now, just in time, reclaims his love (see figure 41).

There is in all this the mystery of engagement. Why do we fall so willingly into the spaces of love, death, and incalculable loss created by these directors? Perhaps "willingly" is not the problem. Perhaps the peculiar strength of the cinematic image is such that it forces more than it invites engagement. I used to think it was the light of the screen in the dark of a movie theater that concentrated us on the shadows playing out on the screen. But the effect is undiminished when I look at a film at home on large-screen, high-definition television. Desire plays as much of a role as the power wielded by these filmmakers. I *want* to be engaged over and over again with *Vertigo* or *Touch of Evil* or just about anything by Kubrick. Familiarity breeds a desire to become even more familiar with these films, to resample their pleasures, and to see if their mysteries will yield up more on subsequent viewings.

FIGURE 31 Two corridors: Midge disappears, and the ghost of Madeleine appears in the hallways of *Vertigo*.

The spaces and stories the filmmakers create and tell us create a cycle of desire-fulfillment-desire. There is a distancing effect at work: the strangeness and yearning created by the films keep us both engaged and separated, wanting more, being refused, being offered, wanting more still. The images demand our attention; we need to look.

Any filmmaker wants our complete absorption into the spaces of his or her work. Just think about how inescapable are the emotions generated by a Steven Spielberg film. Few, however, create the cycle of desire and incomplete fulfillment, creating more desire in an ongoing cycle. The films of Hitchcock, Welles, and Kubrick continually whet the visual and intellectual appetites; they see more; we want to see more with them. Hitchcock plays on this desire in subtle ways within a film. In *Vertigo*, for example, there are a pair of scenes in which darkness and color, light and dark play with both the perceptions of the characters in the film and the audience watching it. Scottie drives around in the San Francisco sun as he begins his obsession with a ghost. He pursues, indeed stalks, Madeleine/Judy as she leads him on. In his daytime rambles there is a striking sequence in the dark as Scottie follows Madeleine into an alley. He leaves his car and walks to the door Madeleine went through. A point-of-view shot starts in the dark, but as the door slowly opens, we see the colorful brightness of a florist shop where Madeleine purchases the bouquet she will hold in imitation of the painting of Carlotta Valdes, the woman Scottie has been told is haunting her. The other dark turn in *Vertigo* is subtler and more fascinating. Scottie and Midge visit an old bookseller to find out more about Carlotta. As they talk, as the old man tells them about the mad Carlotta who was "thrown away" by the men who kept

her because back then they "had the power" to do so, daylight turns to dusk. Outside, the light grows dim as a kind of correlative to what is happening to Scottie's mind. And there is that other correlative later in the film that I've already mentioned: after Midge visits Scottie, institutionalized with paralyzing depression. She walks silently down a gray corridor, exiting Scottie's darkness and disappearing from the film. She had offered some ballast for Scottie, but his equilibrium is now permanently destroyed. The scene will be mirrored later in the film when the resurrected Madeleine—a creation of Scottie's crippled imagination—emerges down a hotel corridor, bathed in sickly green light.

With such effects Hitchcock draws us into the film's mysteries, which, it turns out, are more fearsome than mysterious because the actual mysteries exist in Scottie's mind. Hitchcock wants to make us see the way Scottie sees with his eyes wide shut, to present the world in semidarkness, in an intriguing play of the seen and unseen. These are the kinds of effects—subtle, suggestive—that make us alert and engaged. Like Scottie's first view of Madeleine/Judy, when the walls behind her glow red with Scottie's passion, they are the means to let us know how very much things are and are not what they seem. They are also ways to attach us to the complexity of the film's images, engage us in its space and the inexorable decay of Scottie under the vertiginous burden of his obsession.

Vertigo is not the only Hitchcock film of vertiginous spaces. There is much falling and dangling throughout his work. As far back as *The Lodger* in 1927, the central character, believed to be the murderer of young girls, is left dangling off a wall, held only by his handcuffed hands hung on a railing. In the 1929 *Blackmail* the accused man falls through the dome of the British Museum. We are spared the sight here, but later falls are made quite visible. Young Charlie slips on a step sawed loose by her Uncle Charlie, who violently falls from a moving train into an oncoming train at the end of *Shadow of a Doubt*. Stitch by stitch, the saboteur's sleeve comes undone as he dangles from atop the Statue of Liberty until he

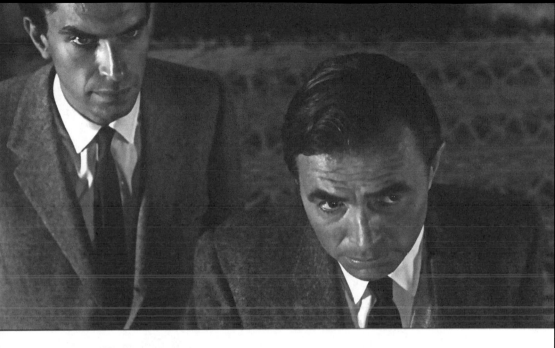

FIGURE 32 "This matter is best disposed of from a great height . . . over water."
North by Northwest.

falls dramatically at the end of *Saboteur*. The most famous rescue from a fall is at the end of *North by Northwest*. But before Van Damm's colleague, Leonard, tumbles and Roger Thornhill pulls Eve Kendall from the face of Mount Rushmore to the upper berth of a train speeding into a tunnel, Hitchcock does an interesting thing. Van Damm and Leonard discuss how to dispose of Eve, revealed as a government agent. Hitchcock starts with a close-up of the two as Van Damm says, "This matter is best disposed of from a great height . . . over water." As he says this, Hitchcock's camera rises and rolls above them in one of his most eloquent and sly movements. Like the Merry Widow dancers in *Shadow of a Doubt*, visible only to the viewer, the villain's murderous thoughts are turned into a kind of visual metaphor or a visual redundancy telling us viscerally what the dialogue is only suggesting.

Falling or being saved from falls, Hitchcock so often places his characters and the viewers who watch them in precarious spaces, from a mountain to a mission steeple to a shower, people are threatened with going down. Hitchcock's films threaten violence and expose vulnerabilities; they are precarious statements of precarious situations, always

predicting, often showing the dying fall. This is a vertigo of despair and a kinetics of death, a visual exposure of that most discomfiting of experiences, losing one's balance. How often in the hypnogogic state between wake and sleep do we imagine slipping and almost falling.

This representation of internal states of fear is born of Hitchcock's own roots in German expressionist film. This movement of shadow and insanity, of stressed characters in madly distorted landscapes, was Hitchcock's training ground in his early years, when he visited the Ufa studios, observing the work of Fritz Lang and F. W. Murnau. Like Welles, whose expressionist instincts came from his theatrical work in the 1930s, the exaggerated mindscapes of the movement never left Hitchcock for long. Even in as "realist" a work as *The Wrong Man*, the expressionist impulse arises when, looking at Manny Balestrero in his deeply shadowed jail cell, Hitchcock's camera inscribes ever increasing circles around his head. But recall the glowing glass of milk in *Suspicion* and the distorted faces experienced by Alicia as she is being poisoned in *Notorious*. Even in the color films there are expressionist touches: the collapse of space representing Scottie's sickness of heights; Madeleine/Judy against the glowing red walls of Ernie's restaurant; the ghost of Madeleine in a green ghastly haze when she appears to Scottie after he has made her over, into his dream, his nightmare.

THE DREAMWORLD

The dreamworld emerges in many of the films of our three directors. Hitchcock's films sometimes contain dreams—*Spellbound*, with its dreamscapes designed by Salvador Dalí, and *Vertigo*, its dream images animated by a Disney animator, for example but more important, they play on the psychology of the unconscious, the oneiric. They emerge from the same places that dreams, or nightmares, do. "Last night I dreamt I went to Manderley again," says the new Mrs. de Winter in voice-over at the beginning of *Rebecca*. "I have brought you nightmares," Uncle Charlie tells his niece in *Shadow of a Doubt*. But the audience itself is permitted to dream, or at least to peek into the spaces of the film's unconscious. Throughout the film, under the credits, when Uncle Charlie gives young Charlie a ring in what amounts to a marriage of doubles, when young Charlie discovers the truth about her uncle in the library, and when Uncle Charlie falls to his death from a moving train, Hitchcock dissolves in the image of figures dancing to the "Merry Widow Waltz." The characters in the film don't see this, though at one point the music carries over from the image to the narrative space. At the dinner table after the ring ceremony, young Charlie hums it: "I can't get that tune out of my head." Uncle Charlie seems to know what it is and becomes upset when he

thinks young Charlie knows the name of it. Hitchcock allows us to share in the psychic disturbance of his characters and uses a dream-like motif to stitch their anxieties to ours.

Many of Hitchcock's characters, and his viewers, get caught in bad dreams that seem to take place in a palpably awake world. This is Hitchcock's plan, to present a rupture of the unconscious, a return of the repressed to overwhelm character and viewer. His women fear the predations of threatening men, like young Charlie in *Shadow of a Doubt*. Marion Crane is assaulted and murdered by a woman who is really a man in *Psycho*. In *Rear Window*, however, wheelchair-bound Jeffries uses a woman to flush out the presumed murderer, Lars Thorwald, in the building across the way, only to be assaulted by him in the end. The turn occurs when, wrestling with Lisa, Thorwald discovers Jeffries by looking out and making direct eye contact with the camera/Jeffries/us (see figure 14). It's like awakening with a start. *Vertigo* presents us with a man psychically assaulted by a woman he assaults in return. Scottie becomes the victim of another man's plot and is in turn enthralled by a woman who, he is led to believe, thinks herself possessed. It is he who is possessed until his nightmare shows him falling into a grave that he has essentially dug for himself. Recovering from a psychic break, he pursues the woman who played the woman he fell in love with, and whom he now makes over to be that woman. The nightmare becomes permanent when the woman falls to her death. Logically, it is Scottie who tortures poor Judy into becoming Madeleine once again. "It can't matter to you," he insists when she protests being remade into Scottie's image. But he is helpless in the face of his illusion of her. He is the one made over by Elster's original plot and remains at the mercy of his own bad dream.

It bears repeating that *The Trial* is Welles's nightmare film. He states as much in his introductory voice-over, and the film's hallucinatory illogic, borrowed from Kafka and realized in spaces too bizarre to square with any known reality, create a dreamlike state. *The Trial* is

a logical extension of where Welles had been going ever since *Kane*. If we look back at *Citizen Kane* from the perspective and context of Welles's later films, it remains, as I've said, a fascinating but tame work. Of course there are the experiments with deep-field composition and the energetic use of a variety of cinematic devices. But *Kane* remains a young man's film and his dreams remain optimistic. Welles matured, and his style changed, sometimes as the result of the circumstances of production, and he moves further away from realism-based filmmaking. The dreams that darken *Othello* are an interesting example. Due in part to its production history, the result is a fragmented fever dream of exploitation, murder, jealousy, and revenge. It is Shakespeare, of course, but as in all of his Shakespeare adaptations, Welles makes the text his own, moving lines around, giving them to different characters, even inventing a character as he does in his *Macbeth*. *Othello* looks the way it does because circumstances dictated aesthetics. And the aesthetics become the expressive means of this tale of the darkening of the spirit and the malleability of desire that turns murderous.

The shooting, if not the editing, of *Touch of Evil* was entirely under Welles's control. The film was made in Los Angeles with the full backing of the studio, until the studio took editing out of Welles's hands. The resulting film is about a world out of control, a nightmare vision of porous borders seen through a distorting lens. Already, the world of *Touch of Evil* exists only in cinema, only in its own dreamscape. The brutality, sweetness, and nostalgia of *Chimes at Midnight* are a dream of a lost world. Combining Shakespeare's Henriad and Falstaff plays, Welles alludes to a mythical time, the dream of "Merrie Olde England" and its inevitable end in Henry V's renunciation of Falstaff.

But I need to be somewhat circumspect here. There is a common notion that all films are like dreams, that they may even trigger the dream-making functions of the brain. Stanley Kubrick has stated as much. The French essayist Roland Barthes called the cinematic experience "para-oneiric," though it might be more appropriately said

that films mimic the hypnogogic state, that twilight moment between wakefulness and sleep where the most extravagant images and even mininarratives seem entirely real only to evaporate in a fraction of a second. The experience of film viewing could be thought of as a protracted state of hypnagogia, especially those moments when we lose sight of the fact that we are watching a film and become absorbed in the process of storytelling. There are films by other directors that consciously evoke the unconscious. Fritz Lang's 1944 film *The Woman in the Window* is a story that turns out to be the dream of its central character, a psychology professor who dreams that he commits a murder. The surrealist Luis Buñuel often includes dream sequences in his films (the dream in *Los olvidados* may be the most startling in cinema). But we need to be careful. Films are finally not dreams, though they may be about dreams. I have argued that our three directors work to separate us from the illusion of ongoing story and make us pay attention to the formal properties of storytelling rather than enter a dream state. The savage editing of *Othello* disallows us from riding along a wave of continuity, which is necessary to fall under a film's dreamlike spell. Those high-angle shots that are Hitchcock's signature statement of a character in physical or moral jeopardy startle us, jolt us out of a trancelike immersion into the film's story. Almost every shot, edit, and camera movement in a Kubrick film is meant to draw our attention to the way we respond. I am moved by Alex's walk through the record boutique in *A Clockwork Orange* not out of admiration for Alex but for the bravura work of Kubrick's moving camera, just as I admire Martin Scorsese's chutzpah in the long tracking shot through the Copacabana nightclub in *Goodfellas*.

What I see on the screen is, in the end, not *my* dream and, although it may depict a dreamlike state, I am still awake and conscious of what is happening on the screen. I am taken, moved by the images, shaken by the editing, curious about what the next shot will reveal or hide. The unconscious is a curious entity: it keeps looking for something

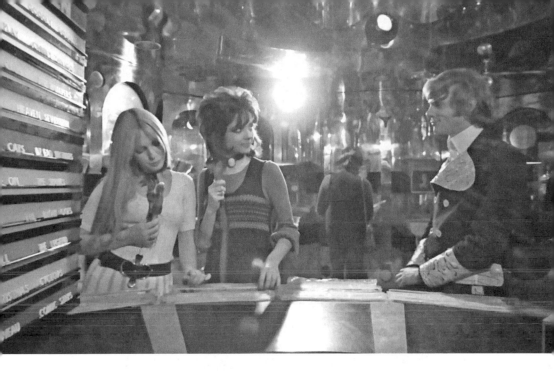

FIGURE 33 Alex in the record boutique in *A Clockwork Orange*.

rich and strange; it makes up crazy stories, just like our filmmakers. Perhaps it would be more accurate to say that films are extensions of our unconscious, and at the very least they create additions to our dreams or want us to dream into another consciousness.

"In dreams begin responsibilities," wrote the poet Delmore Schwartz. The imagination carries the debt owed to the unconscious and pays it, in film, by creating worlds that are sometimes dreamlike or that exist as if in the interstices of dream and wakefulness—all of which proves how difficult it is to define the story space of movies and how we interact with it. In Kubrick's dream film, *Eyes Wide Shut,* there are no markers to indicate the change from wake to sleep, unlike the version made for Austrian television in 1969, where a sound or look indicates the possible movement into a dream. Even Arthur Schnitzler's novella, *Traumnovelle*, with a subtle shift in tone and description suggests a shift to a dream state. Kubrick gives no cues, except perhaps for the mask that mysteriously appears next to a sleeping Alice when Bill returns from the second round of his odyssey (he perhaps "uncon-

sciously on purpose" left if behind). When, after his first round, he returns from the orgy, Alice tells Bill about a dream she had—a dream about an orgy—and throughout the film Bill has dreamlike imaginings of the naval officer making love to Alice. The orgy itself, presented as *there*, happening to Bill and in front of our eyes, yet so fantastic, is in the end so silly that it is hard to accept as "real." "And no dream is ever just a dream," says Bill during the final sequence of the film. He seems to accept his limits, though with the knowledge gained from his peregrinations through the imagined New York streets and the erotic haunts of the superrich. Alice wants less lofty reflections. She offers her love but insists there is something they must do right away—"Fuck."

What is extraordinary about this last sequence is its banality both in form and content. *Eyes Wide Shut* takes place at Christmastime. The characters, unlike their originals in Schnitzler, are not Jewish— Kubrick made clear to his screenwriter, Frederic Raphael, that he did not want Bill and Alice to be Jewish. There is, save for the Christmas lights that appear in every scene, along with a brief sequence in which Alice wraps presents, no overt reference to the season by any of the characters. But the last sequence of the film takes place in a toy store, where Bill and Alice are Christmas shopping for their young daughter. Their final dialogue is shot in a format that Kubrick hardly ever uses, at least in a straightforward manner: he films it in the conventional over-the-shoulder shot/reverse shot style that is the lowest common denominator in American filmmaking. Space is contracted here to the well-worn conventions of the Hollywood style. The two dreamers, Bill and Alice, have seemingly come awake to their need for each other and the necessity of taking things day by day. Alice says that "the important thing is that we're awake now and hopefully for a long time to come." "Forever," Bill says. Alice responds: "Let's not use that word. It frightens me."

The banality is marked, and it was this final sequence that left me feeling empty and bereft, not because I was unhappy to see the movie

ending just there but because the last word from Kubrick felt both startling and disappointing. The dream was boring. But I began to consider that actual last word, and it suddenly sparks the final sequence, almost as if Kubrick was giving the finger to everyone. Is he disavowing his film? Or more likely, is Alice's wish for uncomplicated sex a move to a healthy relationship or a mistaken return to what got them both into trouble in the first place? Uttering that word finally makes sense of the constriction of space in the final sequence of *Eyes Wide Shut*. Or more accurately *senses*. Kubrick, the supreme ironist, rarely allows only one sense to be made at almost any point in any film. The end of *Eyes Wide Shut* is a return to the quotidian, to everyday domestic concerns, to everyday cinematic concerns. A final bow? A happy ending?

Kubrick has never done happy endings since the two lovers meet at the train station in his second film, *Killer's Kiss*, and even there it is an ending of happy desperation. If the spaces of *Eyes Wide Shut* constrict to the over-the-shoulder shots of the now reconciled couple in a toy store at Christmas, it may just be the last sigh of an elderly, fatigued director, who died before the film's release (this even assuming that the film was shot in sequence—films rarely are). Or it could more likely be his bow to the history of film, like Orson Welles so many years before demonstrating that he could with *The Stranger* make a film "just like all the other fellas." So, is Kubrick saying that he can now relax into the commonplace and celebrate the domesticity that he, in his life, enjoyed with his wife and family? But of course *Eyes Wide Shut* is not commonplace; it is a complex inquiry into sexuality and desire, with a dream, perhaps, of an ending. It is Kubrick's last film and, given his age and the amount of time it took to get to the film and get it made, he must certainly have known that it would be his last. The ending may be the resolution of all of his films, of all films.

In the end *Eyes Wide Shut* remains a hard nut to crack. It has the least immediately attractive characters of any of Kubrick's films. When I first saw it, in that broken-down theater with a dim projector bulb, I came

away disappointed and frustrated—actually more hurt and betrayed than disappointed. What had happened to Kubrick in his old age? Had he completely lost his touch? Many contemporary reviews of the film echoed these worries. Since then I've seen, taught, and written about the film many times and have begun to understand many of its secrets. Now, whenever I hear the music of Dmitri Shostakovich's *Jazz Suite No. 2*, emotion and anticipation well up. I can't completely explain the contradiction except that the passion of this film, more contained and tamped down than in any of Kubrick's previous work, has managed to become an obsessive interest. I still find the orgy sequence ridiculous, but perhaps it's meant to be in this oneiric world where a banal man searches for sexual release far from anything that might be logically possible in a fully awake world. Maybe the doublings and recapitulations of its story space—indeed even of its dialogue, where Bill tends to repeat in the form of a question everything said to him—are themselves so powerful that they overcome the somewhat stilted acting of Cruise and Kidman. Maybe that stilted acting and the blatantly artificial sets are themselves part of the hypnotic dream pattern of the film.

When it was released, the film was criticized, in part, for its artificiality, particularly its representation of New York. Kubrick had not been to New York, indeed to the United States, probably since the late 1960s. He knew what his native city looked like only through films and memory. More to the point is that the artificiality, as in Hitchcock's *Marnie*, is expressive of the troubled state of the characters, a reverie of the unconscious made into visible, artificial images. While the composition of the images is not as severely symmetrical as in the earlier films, the narrative, the odyssey of Bill Harford through the imagined streets of New York, is as perfectly symmetrical as in *A Clockwork Orange*. Shaken by his wife's admission of her own sexuality, Bill sets out on a quest, an inner space odyssey in which he tries to establish for himself his own sexual identity. But Bill has no defined identity, and the more he looks, the more he is told, in a variety of ways, that

he will fail. He is perhaps the only Kubrick character who is given so many warnings, which, of course, he ignores. On his first voyage he visits the home of a patient who has died. The dead man's wife declares her love for him (the corpse lies in the bed behind them), only to be interrupted by the arrival of her boyfriend. On the street he sees, in a tracking shot worthy of Hitchcock (Bill walks and looks; there is a cut to his point of view), a couple making out. The sight makes him imagine his wife making love to a navy man. It was this admission of her desire for a naval officer that sent Bill over the edge and into the streets.

From this point on his odyssey becomes stranger and stranger. A group of boys, reminiscent of Alex's droogs in *A Clockwork Orange*, gaybait Bill and knock him over. (In his second voyage out he will question a gay hotel clerk, who tries to come on to him.) A prostitute takes him to her cramped, dirty apartment, a book, *Introducing Sociology*, clearly visible in her bedroom. Her name is "Domino," an old word for a mask. Meanwhile, at home Alice watches on television Paul Mazursky's 1973 film *Blume in Love*. Mazursky was a childhood friend of Kubrick's and had a role as the crazy soldier in his first film, *Fear and Desire*. The movie she's watching is about marital infidelity. She calls Bill, interrupting his foreplay with the prostitute. Coitus interruptus becomes Bill's problem throughout his wanderings. As if he were moving through the ill-defined spaces of his own id, everything from the people he meets to the shops he passes and the graffiti on the walls to the orgy itself reflect his sexual confusion and insecurity.

The spaces he traverses are deeply marked, signed, as it were, with the names of shops, graffiti on the walls, newspaper headlines. "Lucky to Be Alive" screams a headline in the *New York Post* that Bill picks up on his second round following his return home after the orgy. The newsstand where he gets the paper is a visual allusion to the young Kubrick's most famous photograph of a newsstand showing the headline of the death of Franklin Delano Roosevelt, the newsstand's owner looking down sadly. Allusion marks the spaces

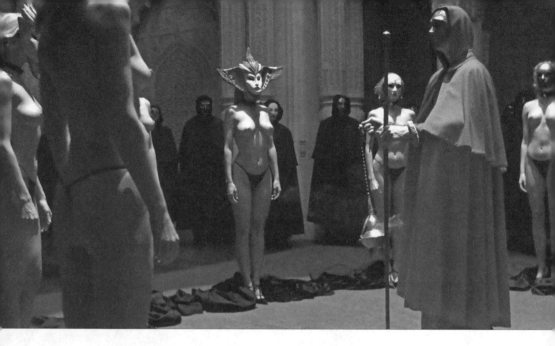

FIGURE 34 A nightmare of an orgy in *Eyes Wide Shut*.

of Bill's odyssey, from the movie Alice watches to the book on Domino's shelf, to the Sonata jazz club, where Bill learns the password to the Orgy: *Fidelio*. This is the name of Beethoven's opera about a faithful wife who disguises herself as a man to liberate her husband from prison. More significant still is the name of the jazz club itself, because, more than a simple bell-shaped curve, the narrative structure of *Eyes Wide Shut* is roughly analogous to the sonata form of music. The exposition occurs when Alice and Bill prepare for and attend the Zieglers' Christmas party. Here both Alice and Bill are sexually tempted, he by a pair of girls who promise to take him "over the rainbow" (the costume shop where Bill is outfitted for the orgy and is tempted by the costumer's daughter is called "Under the Rainbow"), she by a Hungarian lothario, more lounge lizard than seducer. The development occurs with Alice's revelation of her sexual longings, leading to Bill's walking the streets and going to the orgy. The recapitulation happens with his retracing his steps the next day. He moves in dreamlike circles. The toy store sequence acts as the coda.

It is amazing that as unattractive as I found *Eyes Wide Shut* when

FIGURE 35 Reconciliation in the toy store at the end of *Eyes Wide Shut*.

I first saw it, I still can't seem to stop talking about it. Again, like any Kubrick film, it takes time and constant re-viewing to get to all its complexities. As these are unraveled, the film takes on more meaning and provokes my desire to see even more. Kubrick's films have been accused of being cold. They are in fact deeply moving, but the emotions need to be accessed through the intellect: by seeing more, understanding more, being amazed again and again, the films' emotions bubble through and in the end every Kubrick film becomes an addiction: the more you see, the more you want. I wanted to dream a different film than Kubrick made in *Eyes Wide Shut*. Now I need to keep moving through the images and spaces of the dream he had.

The Spaces of Space Fiction

This was the case for me on first viewing *2001: A Space Odyssey*, a film about space. The space of my first viewing, in that London cinema with a huge Cinerama screen, was too overwhelming. I couldn't

quite see what was going on. Kubrick wanted the vastness of the Cinerama screen to encompass the vastness of his imagination of the future. But there is too much detail in the spaces of *2001* that got lost on the horizon of that wide screen. (Cinerama, incidentally, was invented in the early 1950s as a three-camera-and-projector process and was used mostly for travelogues. In its single lens, 70 mm format, it was used for some features—*How the West Was Won*, for example, and Kubrick's film. Imax has taken the place of Cinerama.) Despite its location in the future, in the vastness of the universe, *2001: A Space Odyssey* is, finally, not about outer space but rather about consciousness, not about the expanse of human activity into the outer reaches of the galaxy but about the collapse of human activity into something else, something less than and more than human.

2001 is a film of incredible visual detail. There is, to borrow a term from art history, a *horror vacui*, a dread of empty spaces, in this film about space. A number of things are going on here: Kubrick is consciously working against the visual and narrative poverty of 1950s science fiction films, and I want to take a little voyage through the history of 1950s sci-fi to understand what Kubrick was up to and to demonstrate how this original filmmaker was in fact fed by the films he had seen. The 1950s were the golden decade of the genre, though golden only in the sense of popularity because, with few exceptions, 1950s science fiction films were made with small budgets and were rarely considered prestige films by the studios. There were early space exploration films, like George Pal's *Destination Moon*. But so many others were gray, depressed films, often set in the California desert, about the terrors of alien invasion and infiltration. As such, they were allegories of the decade's fear of communism, a displacement of cultural and political terrors that could only be assuaged, in the films at least, by the military, which almost always conquered the aliens.

Despite the Cold War pall there were excellent films created during this period. Robert Wise's *The Day the Earth Stood Still* was perhaps the

only "liberal" science fiction film of the decade, positing a representative from space come to warn Earthlings to quit their "petty squabbles" or be destroyed by an implacable robot, part of a squad of intergalactic peacekeepers that may have given Kubrick the idea for the Doomsday Machine in *Dr. Strangelove*. Howard Hawks was perhaps embarrassed to sign *The Thing from Another World* and instead gave director credit to his editor, Christian Nyby. The Thing is an invader of an arctic air force base, a blood-sucking vegetable, played with howling rage by James Arness, who would become famous as Marshal Dillon on the long-running television show *Gunsmoke*. There is in this film an interesting reflection of the anticommunist struggles of the time as the airmen and a clever woman join forces to fry the vegetable, while a scientist, an intellectual wearing a Russian-style fur hat, wants to reason with it, putting everyone on the base in danger. Anti-intellectualism was rampant in the 1950s, and the scientist in *The Thing* stands for all that the decade thought dangerous (read "communistic") in intellectual endeavor.

Then there is *Forbidden Planet*, a high-budget MGM color and widescreen spectacle based on Freud and Shakespeare's *The Tempest*. (MGM would back and distribute *2001*). Dr. Morbius, the Prospero surrogate, lives with his daughter, Altaira, on the planet Altair 4. They live alone in an Edenic setting, tended by the film's Ariel, one of cinema's wonderful robots, Robby. They live alone because earlier settlers from Earth were wiped out by an emanation of the planet's former inhabitants, the Krell—creatures from their id, their Caliban. The Krell got too smart for their own good, for their own existence. Dr. Morbius, yet another 1950s caricature of an intellectual, wants the Krells' knowledge, and it costs him his life. The film, particularly its fine imagery, has had a long-ranging influence. A hologram of Morbius's daughter provides a template for the hologram of Princess Leia in the first *Star Wars*, a film whose visual design owes so much to *2001: A Space Odyssey*. A striking composition of the Krells' underground power station

is duplicated in Lucas's film. As Morbius and the crew from Earth who have come to rescue him travel down to the Krells' power station, there is a brief light show consisting of symmetrical geometric forms that surely influenced the journey to "Jupiter and Beyond the Infinite" that introduces the final sequence of 2001.

"Outer space" for the filmmakers of the 1950s was frightening, and from it emanated all manner of malevolence. The fears of postwar America are palpable in even the most ridiculous of these films. They are the forerunners of the postapocalyptic, zombie, and vampire movies that have plagued movie and TV screens in the new century. Fear is always part of the process that turns cultural currents into cinema, but fear is not the catalyst for Kubrick when he tackles a genre. Even *The Shining*, which concentrates on the fear experienced by its characters, is as much a gloss on the fear generated by horror films as it is horrifying itself. All of Kubrick's films are "meta" in one way or another. *2001: A Space Odyssey* is as much a film about science fiction as it is a science fiction film, just as his war films are a gloss on the genre of war films that reaches back to cinema's earliest years. *2001: A Space Odyssey* takes its cues from the genre of the 1950s, but it reexamines them, as if Kubrick is holding them in his hands and then opening them up to reveal all the concerns of the previous films reimagined with an attention to detail and an embrace of time and space that marks, finally, a break in the genre so clean that it took almost ten years before it was revived again in the films of George Lucas and Steven Spielberg.

"Space" for Kubrick is, like every subject he tackled, an intellectual problem to be solved visually and temporally. Of course, every filmmaker has to solve this problem because time and space are the material of film itself. But Kubrick, like Hitchcock and Welles, made the solution part of the process of viewing, as well as making, his films. The enigmas of 2001 are played out in a number of spaces, two of which are invisible—the mind of the aliens (if indeed there are "aliens" at work), who seem to be controlling human development, and the mind

of the HAL 9000 computer, the self-proclaimed "conscious entity" that controls the flight of *Discovery One* and is seen only as an electronic eye and the modules of its memory. Everything else is visibly detailed, from a meteorite spinning toward the camera in a bid to show off the wide Cinerama screen down to the smallest button on a spacecraft's control panel. And, like the eyes that predominate the film— the glowing eyes of a leopard, guarding its prey; the hominid's fearful eyes in the night; the startled eyes of Dave Bowman as he is hurtled through new dimensions; the frightened eye of the fetus circling Earth at film's end; and HAL's eye, red, unblinking, reading lips, taking in and processing everything that goes on in the ship—we are asked to look and look and look again.

Even white space is carefully articulated with suppressed meaning. The most irritating talk in this film that is marked by minimal dialogue occurs in a speech given by Dr. Heywood Floyd to his colleagues on moon base Clavius, where he has come to view the newly discovered monolith. They are in a room surrounded by four large white screens— the brightness in this lunar conference room is here the opposite of the dark war room and looming "threat board" Kubrick created in his previous film, *Dr. Strangelove.* Floyd, at a lectern, talks to the men and women seated around him about the cover story of a viral epidemic they have created to prevent the "cultural shock and social disorientation" that might occur were news of the discovery of a monolith made public. The establishing shot for the scene is done with a typical (for Kubrick) wide-angle lens, so that the space is slightly distorted on the sides. There follow a very few simple setups with an American flag prominent in most of them. (Kubrick has not given up on the Cold War here: earlier, on the space station, there is an interchange with Russian scientists about the Americans holding back information about the discovery on the moon.) Floyd gives his speech, asks for questions, is applauded, and walks off. The purpose of the speech is to be tedious. The humans inhabiting the spaces of *2001* are a boring lot.

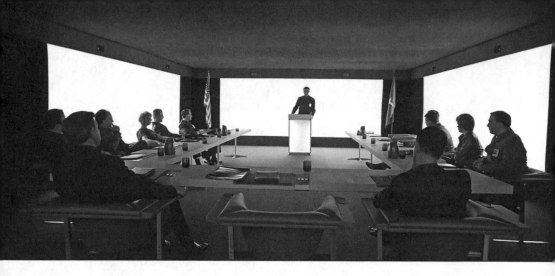

FIGURE 36 Heywood Floyd delivers a boring speech in a conference hall on the moon in *2001: A Space Odyssey*.

They are, with the brief exception of Astronaut Dave Bowman's colloquy with HAL, without affect. They are technocratic human robots, completely unmoved by the enormity of what surrounds them and by the discovery of an object buried on the moon. The white screens reflect their emptiness.

There is a direct cut from the conference room to a small craft carrying Dr. Floyd and his colleagues to the site of the monolith. The stark white room is exchanged for the craft flying through the dark canyons of the moon. György Ligeti's eerie *Lux Aeterna* plays on the soundtrack, cluing us that there is more going on than the nonchalance of the ship's occupants. The pilots' cabin is bathed in scarlet light, screens and buttons glowing. There is a breathtaking shot of Earth above the moon. But onboard, bathed in blue light, the banality continues, as the scientists chatter among themselves about the synthetic sandwiches they have to eat, as they view images of the monolith's crater with only muffled amazement and then have some coffee. "Watch this now," the person pouring the coffee says, unaware of the irony; "it's hot." The contrast between what we see and what the characters in the film are doing in their daily business is marked. They can no longer see what we are seeing for the first time, what Kubrick has imagined for us for the first time. Kubrick, along with Arthur C. Clarke, has created

a version of the *sublime,* a word I use both in Harold Bloom's sense of "extraordinary hyperbole" and in its eighteenth-century sense of having one's emotions being carried beyond reason by a view of wild nature or a painting representing that state. Watching *2001* is a double act of response: marveling at the detail of its extraordinary images and an emotional response that follows on the experience of those images. The film puts us in a superior position to the characters in it, maybe putting us in the position of HAL.

All this takes time and re-viewing, a processing of the images, moving with their sublimity into their meaning, abstracting the ironies embedded in them, coming to terms with the complex of ideas that swirl like the bills blown around the airport runway at the end of *The Killing.* That swirl is duplicated in startling and numbing fashion during the "Star Gate" sequence that represents Bowman's entry into a new realm of consciousness. With the aid of special-effects artist Douglas Trumbull, Kubrick creates a delirium of light and dark: sheets of light, galactic explosions, curious blobs of light that look like a lava lamp, Bowman's space pod streaming along like a spermatozoa, symmetrical geometric forms, monoliths floating together, briefly gathering into a cruciform shape, and finally an alien landscape, solarized and colored, a spectacular version of the landscapes traversed by the B52 on its bombing run to the end of the world in *Dr. Strangelove.* All of this is punctuated by close-ups of Bowman in his space suit, his face in distress, shuddering, and his eye blinking, red and blue, green and red, purple, yellow and purple, red and green, yellow and blue, finally normal as he peers out at his new accommodations.

Just about the time Kubrick was completing his film, astronomer John Wheeler coined the term *black hole,* an astrological phenomenon Albert Einstein had predicted—a collapse of the matter of a dead star, so dense no light can penetrate or escape from it. Within black holes, astronomers, science fiction writers, and filmmakers have imagined all manner of strange events. The extreme geometrics of light that

constitute the Star Gate sequence are a kind of preimagining of the black hole phenomenon, perhaps in reverse: an emanation of light, rather than its total absorption, or a tear in the space-time continuum. Kubrick draws some of his imagery from Arthur C. Clarke's novel *Childhood's End* that imagines a voyage to an alternative world, as well as from the film *Forbidden Planet*. (Clarke's story "The Sentinel" was also a major influence on the film.) The ending of an early screenplay for the film contains these prophetic words: "In a moment of time, too short to be measured, space turned and twisted upon itself." At the end of the film itself, space becomes transformed; astronaut Bowman becomes deformed, transformed, reformed; and we become witnesses to another enigma. The visual stimuli of the Star Gate light show lead to the collapse of time and the entry into a dark new place that, paradoxically, is fluorescently lit, without shadows. It is a space of the gaze, of looking and being looked at: Bowman looks; we look at what Bowman is looking at. The first shot of the last sequence is through the porthole of the space pod (Bowman's point of view) that has, unaccountably, landed in a strange room, painted a pale gray-blue and decorated in period furniture with seventeenth-century paintings on the wall, a floor made up of fluorescent grids, a gleaming blue-gray bathroom visible through a doorway.

Again those Kubrick bathrooms. It's interesting to compare the bathroom in the mysterious room in *2001* and Ziegler's bathroom in *Eyes Wide Shut*. The palatial grandness of the latter hides the sordid business of whoring and drug use on Ziegler's part. It is a projection of wealth and corruption, of ostentation and the security that comes from being too wealthy to worry about a drugged prostitute in your midst, especially when a personal physician can be called in to look after her. *2001*'s bathroom, like the entire room it is part of, is another kind of projection. What would an astronaut imagine as an elegant lodging? Clean and spare, sterile. The bathroom is gleaming and untouched. Like the room as a whole, it is a still, solitary space, with no indication of an

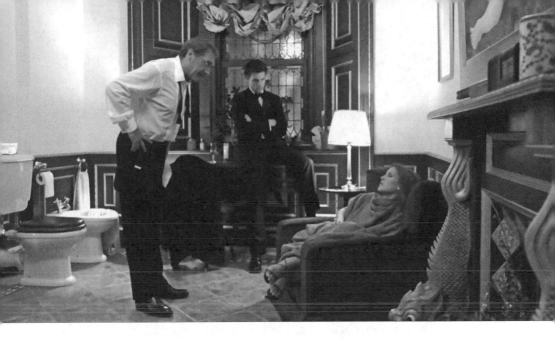

FIGURE 37 Ziegler's bathroom in *Eyes Wide Shut*.

exit. The room exists for Bowman's gaze and ours. But is this a room or a cage? Sounds of chattering voices (based on Ligeti's *Adventures*) are heard, as if Bowman were being observed by unseen eyes—certainly ours among them. Where does this space, this elegant room and bathroom, exist—somewhere beyond the infinite or inside Bowman's consciousness? Or another consciousness entirely? Time no longer exists in this space. Bowman has time only to look at his room and examine the bathroom, to see himself in the mirror, and finally, while having a meal, to look at himself growing old. Kubrick uses the old convention of over-the-shoulder shots as he does at the end of *Eyes Wide Shut*. But here the convention is turned on itself as, looking over his shoulder, we see Bowman seeing himself aging, dying. At the end a husk of himself, he sees the monolith at the foot of his bed, as the camera, with its wide lens, dollies in to this object whose shape is opposite—tall and narrow as opposed to wide and compressed. Bowman emerges on the other side—of another black hole?—as a fetus circling Earth.

Whose consciousness indeed? In interviews he gave during the film's premiere, Kubrick talked freely about "aliens" and higher powers

FIGURE 38 Dave sees himself old and dying at the end of *2001*.

and his decision not to actually show them. Certainly Arthur C. Clarke, in the works that inspired the film and in the verbose novelization of the film, spoke of superior intelligences, who in this case are "free at last from the tyranny of matter." It might be argued that the essential pessimism and ironic misanthropy to which Kubrick gives voice in his films could lead to the belief that some extraterrestrial power was necessary to control humans' wayward ways—or to make them more wayward. After all, left to their own devices—in fact the nuclear devices they constructed in *Dr. Strangelove*—they blew up the world. But the irony is that, whatever or whoever guided their evolution in *2001*, humans, their hominid ancestors, and even their machines commit murder, including HAL's murder of all the hibernating astronauts on the voyage to Jupiter, Dave's astronaut partner, Poole, and the attempted murder of Dave himself by locking him out of the spaceship. Alien intelligence has not done a good job, and to believe in the outlandish notion of extraterrestrial control would diminish the film. Despite the alien lineage reaching back to 1950s sci-fi and Clarke's own writings, including a very early screenplay for the film, I find it difficult to read *2001* as a movie about aliens. It is too easy a way out and not commensurate with the complexity of the film and Kubrick's work in general. In other words, if *2001: A Space Odyssey* could be explained

FIGURE 39 Dave dismantles HAL while a prerecorded message on a television monitor informs him that HAL is in control of the mission in *2001*.

as a film about intelligent design, with the intelligence being some mystical force of space Overminds (to borrow a notion from Clarke's *Childhood's End*), it would be a lesser work, diminished by a silly explanation. There are no aliens (that we are alone in the universe would be the ultimate Kubrickian irony), certainly not in the film, and, besides, there is something else going on in the film that distances it from generic commonplaces. There is a joker in the pack (there is almost always an often bitter joke embedded in a Kubrick film), a homegrown kind of alien, the HAL 9000 computer.

As Bowman is in the process of lobotomizing the murderous HAL in the blood-red room that contains the elements of his mind (Lucite rectangles that look like miniature monoliths), a video monitor goes off in the background. It is a prerecorded message from Heywood Floyd, that boring functionary, who announces that knowledge of the mission has been held exclusively by HAL. If there is an "Overmind" in the film, it exists in the spaces of HAL's consciousness. HAL, of course, is the most interesting entity in the film: smug, self-assured, frightened, all-knowing. He demonstrates emotion where the human characters are all but neurasthenic. He is the object of Kubrick's fears of technological overreach and his celebration of technological progress (an analogue, perhaps, to the

tension in Welles's work between the past and the modern). Kubrick was entranced by technology—particularly of the cinematic kind. He experimented with lenses and film stocks; his use of sole-source candlelight in *Barry Lyndon* was a major advance in film lighting. The technology of *2001*, this film about technology, is itself a marvel of carefully crafted models, synchronization of multiple images projected on multiple screens, exquisite detail of everything from rocket ships to the visions of traveling through time and space. All of this is pre-CGI, though Douglas Trumbull seems to have taken some inspiration from computer graphics pioneer John Whitney. So I need to ask myself: how much, indeed, is Kubrick afraid of computers taking over? Does HAL represent the ongoing concern in his films about man-made systems gone awry, or is the overriding joke of the film that it is HAL's dream, his nightmare? An elegant interpretation of the film is that machine consciousness envelops the human automatons who populate the film and that everything we see is contained within the spaces of HAL's blood-red brain. HAL's eye is always open, always all-seeing. Shut down, he has only his internal eye to see its own imaginings of a posthuman world.

■ ■ ■

Space is an articulate expression of mood and meaning for Kubrick and is more varied than the more flamboyant spaces created by Orson Welles or the constrictions of Hitchcockian space. Wellesian space tends to be similar from one film to another because the deep-field, dark, madly angular compositions he favors are carried over with important and fascinating variations from film to film (at least until *The Other Side of the Wind*, in which the little bits that have been publicly shown demonstrate a very different, very fragmented concept of space). Wellesian space overwhelms; Kubrickian space astonishes by its calculation. Wellesian space obscures by showing a great deal, inviting us into the dark; Kubrickian space implies a great

deal by keeping us at a distance. *Barry Lyndon*, for example, explores the varied possibilities of pictorial space. Its images are constructed with the formality of composition and color that recall seventeenth- and eighteenth-century paintings. This requires a particular kind of attention that itself demands a particular knowledge on our part. We need to know what seventeenth- and eighteenth-century paintings look like to appreciate what the film is doing, and if we do, we may be distracted by trying to guess exactly what painter or painting is being imitated. (There is some direct imitation, but the genius of the film's pictorial strategy is to capture an essence of painting rather than an imitation.)

The film's images do stand on their own, despite their painterly lineage. But even on their own they are such unusual images that we are asked to look *at* rather than *into* them. And if we try the latter, that is, try to pierce the compositions to get at the characters and their stories, we are further surprised. Many shots in the film start relatively close to the characters involved, and then Kubrick begins a slow zoom back from them until they become one object amid a larger landscape. Kubrick's films are almost always about diminishing lives: in *2001* men are diminished by the technological and astral spaces that surround them; in *Barry Lyndon* they are diminished by having the camera withdraw from them, leaving them open and vulnerable, leaving us without a close-up. There is yet another thing left behind and diminished: the genre of the costume drama itself, steeped as it most often is either in nostalgia or faux reverence. I find most costume dramas unwatchable. They suffer from an essential inauthenticity because they are based on the only thing they can be based on, contemporary notions of the past. Kubrick already made an inauthentic costumer, his sword-and-sandal epic *Spartacus*. His lack of control over the production was, I think, only one reason he found the project untenable. The tensions in the script and the various contradictory needs of writer Dalton Trumbo and producer-star Kirk Douglas, and the need to create a film that

cleaved however tenuously to the conventions of Hollywood costume drama realism, were others.

There are aspects of *Spartacus*, as with so many costume dramas, that are risible if not downright irritating. From sword-and-sandal epics through *Downton Abbey*, when filmmakers try to represent the past, they trip up on the very invisibility of the past, which they try to make visible on the screen. *Barry Lyndon* solves the dilemma by encapsulating the past in a simulacrum of the past's own images of itself. By composing his shots as if they were paintings, by zooming back from his characters to isolate them from too close proximity, and by slowing the rhythm of the film and the acting, which, along with the repetition of elegiac music (the Handel *Sarabande* and the Schubert Trio) and the characters made-up with thick white face powder, Kubrick creates an almost ceremonial effect. The film is contemplative, deliberate, beautiful to look at. I know this sounds almost like a warning, like a film we are meant to take rather than comfortably enjoy, and this may be the reason for its poor critical and audience reception. The fact is that *Barry Lyndon* is the jewel in Kubrick's crown of work, an elegy for lost ambition, a film that uses the past as a lens for the present, a quiet film whose ironies enfold its central character, who is caught between his violent tendencies, the losing battles he wages to climb the social ladder, and a voice-over narrator, who keeps assuring us of his ultimate and inevitable failure. The elegy of *Barry Lyndon* is a *lacrimae rarum*, a sadness of things that moves me more than anything else in Kubrick, with the exception, perhaps, of the long tracking shot of Poole jogging and shadowboxing around the circular interior of *Discovery One* on its way to Jupiter, accompanied by the Adagio of Aram Khachaturian's *Gayane* ballet suite. Past, present, and future are folded together in these films. Time is spatial, and spatiality makes room for time's inevitable return. In this way the emotional temperature of his films is measured. Even in small increments within a Kubrick film.

In her wonderful study of *Barry Lyndon*, Maria Pramaggiore says, "Kubrick marshals a sense of history's protracted and inexorable cyclicality in ways that minimize the significance of characters, motivations, and actions. Narrative elements involving backstory, plot events, and cause and effect—along with the potential for spectator identification—are attenuated, no longer obeying the injunctions of time. Ambition, greed, and lust shrivel into petty absurdities under Kubrick's withering gaze, which takes its rhythmic cues from the epochal, not the ephemeral."

There is an interesting paradox here. In Kubrick's films history is variously apocalyptic, protracted, and cyclical. "You've always been the caretaker," the ghostly Grady tells the hallucinating Jack Torrance in *The Shining*. In the spaces of Jack's failing mind, time and space are both protracted and cyclical; he falls, growling and vicious, through them until his wife and child break the cycle—a rare moment of escape from the Kubrickian trap. Jack is frozen in space and time, literally in the snowy hedge maze, fantastically in the photograph from 1921 that hangs on the Overlook's walls. Barry Lyndon is frozen by means of cinematic technology—the freeze-frame that stalls him in time as, missing the leg that was amputated after the duel with his stepson Bullingdon, he is about to enter a coach to take him to his banishment. The troops are given just a little time before being sent back again to the front to be killed in *Paths of Glory*. The cycle of Cold War madness ends with an apocalypse as the American president, his aides, and Dr. Strangelove fight over mineshaft space in the cavernous darkness of the War Room. Private Joker in *Full Metal Jacket*, having proven himself "hard core" by killing a female Vietcong sniper, marches endlessly to the Mickey Mouse Club song, trapped in a world of shit, like the soldiers at the end of *Paths of Glory* and *Fear and Desire*. Bill Harford travels in the dreamlike circles of his sexual inadequacy only to find in the end that he is fixed, for better or worse, in the straits of his marriage.

Cycles and Symmetry

There is an amazing edit that occurs in *A Clockwork Orange*, though in this case it is not a direct cut. Alex de Large, murderous rapist and our humble narrator, at the peak of his powers, strides through a record boutique to the synthesized "Turkish March" from the last movement of Beethoven's Ninth Symphony. It is one of the most stunning tracking shots you can find in film. For me, its only equals are the track around the center of the spaceship in *2001* and the lateral track through the woods that occurs in the robbery sequence of Welles's *Chimes at Midnight*. The latter sequence makes up just a few moments of lyricism and is communicated only through movement and music. If a moving camera can be physically experienced by the viewer, these are. The track of Alex, in which the camera precedes him, lights shining and flaring into the lens, is not lyrical but commanding. It ends with Alex approaching the sales counter, an album of music from *2001* clearly present on the record rack, rapping his walking stick for attention. He has it and proceeds to pick up two girls and take them home for "a little of the old in-out, in-out" (see figure 33).

Poor Alex is subsequently captured, tried for murder, sent to prison, and chosen to be the subject of the "Ludovico Technique," a process by which he is medicated, tied down, has his eyes pinned open, and is forced to watch violent movies. One of the clips forced on him, possibly taken from Leni Riefenstahl's celebration of a 1934 Nazi rally, *Triumph of the Will*, shows Adolf Hitler marching through a huge mass of troops, followed by marching soldiers holding Nazi flags. The music? The same synthesized "Turkish March" from Beethoven that accompanied Alex's march through the record boutique. The cut from bone to spaceship (actually an orbiting nuclear device) in *2001* signaled the passage of violence from the primitive to the modern, collapsing the intervening history of violence within the invisibility of the edit. The match on music of Alex triumphant to Alex suffering

as he watches Hitler ties together the visibility of violence. Alex commits violence and then becomes its victim (for a while) in the fearful symmetry of *A Clockwork Orange*'s narrative. His life and acts are of a piece with the history of violence in the twentieth century. *A Clockwork Orange* takes place in the near future, but it is a future marked by the near past because, for Kubrick, time infiltrates historical space, and space is the rigid container of time. Everything moves in inexorable circles and cycles.

Maria Pramaggiore talks about "the way [Kubrick's] films conceive of and manifest the passage of time, within particular spatial configurations." I noted earlier that Kubrick's characters are more like ideas than the illusion of fully formed, psychologically motivated figures we are used to seeing in film. Like Welles and Hitchcock, Kubrick is fascinated not by character per se. For Welles, character is fate and fate is character—one follows his character to the end. For Hitchcock, characters are constrained by the violence committed to or by them. Kubrick's characters are buffeted by the spaces around them and the inexorable movement of time, a movement that most often does them in because they have tried to control it.

It's a commonplace that real time and reel time—more appropriately narrative time—are incommensurable. As in dreams, condensation is necessary. Less obvious, perhaps, are the ways in which filmmakers do the condensing. For Kubrick's characters, despair and fall are functions of time, which often works against them, no more obviously than in *The Killing*, where time becomes the structure of defeat for a band of would-be thieves. But even in the picaresque and picturesque landscapes of *Barry Lyndon*, where time seems to all but stand still in obeisance to the painterly compositions that entrap the human figures, Barry is caught in the cycles of defeat he suffers from various hands. The film is bookended by duels. Barry's father is shot down in the very first image of the film, and near film's end, Barry is wounded by his stepson in a duel that is a ceremony of cowardice and attempted redemption.

Barry refuses to shoot his stepson and asks the duel to be stopped. Lord Bullingdon refuses and shoots Barry. Barry winds up cast out of his family and without a leg; Kubrick stops time by freezing the frame in which Barry is helped into a coach to leave for his exile. But this is not the end of the film. Kubrick returns to Lady Lyndon, her son, and her bookkeeper, passing bills and checks between them in an endless ceremony of accounting. I will return to these final scenes of the film.

Kubrick must have decided that the poor reception of *Barry Lyndon* required something more visceral as a follow-up, and so came *The Shining*, another tale of the cycle of violence. Entrapment is a key to Kubrick's spatiotemporal constructs, and this is not the same as the self-made constraints suffered by Hitchcock's characters. All of Kubrick's characters get trapped, often because the circumstances they set up become out of their control. The lost patrol is caught in the madness of war in *Fear and Desire* and *Full Metal Jacket*. Davey and Gloria, though they seem to escape New York at the end of *Killer's Kiss*, reach their escape after a desperate struggle against a rapacious thug, climaxed by a bizarre battle in a mannequin factory, plaster heads and limbs chopped and scattered. *The Killing* is scaffolded by an elaborate time scheme, erected by Johnny Clay in order to pull off an impossible racetrack robbery. The film's voice-over narrator (as I noted earlier, many of Kubrick's films use voice-over as a means to elaborate, disembody, sometimes contradict the actions of the characters within the film) gives us seemingly precise timings of the events— some of which are inaccurate or confused. They are also impossible, because the plan doesn't take contingency into account, and, as I have noted, contingency—chance, the unexpected—plays a major role in Kubrick's films, as it does in Hitchcock's. Kubrick's is a world of the unexpected. The robbery fails not only because its time scheme shatters but also because George Peatty's wife rats out the plan to her lover, who kills everyone but Johnny, who gets as far as the airport with a suitcase filled with the take. A yapping dog escapes onto the runway,

causes the baggage cart to swerve, the suitcase to fall and open, and the money to swirl in an extraordinary whirlpool of a lost dream of impossible gain. Johnny and his wife leave the airport, surrounded in perfect symmetry by two cops.

The accused soldiers in *Paths of Glory* and their attorney, Colonel Dax, are trapped in an inflexible military system, so corrupt and amoral that Dax's pleas for moral decency appear an impotent joke. Spartacus's revolt is destroyed by Roman politics and might, and Humbert Humbert's desire for Lolita is thwarted by his double, Clare Quilty (when Humbert comes to take his revenge, he asks, "Are you Quilty?" and the latter answers, "No, I'm Spartacus. You come to free the slaves or somethin'?"), and by Lolita herself, who nips his desire and repentance by becoming an ordinary, crushingly banal hausfrau. *Dr. Strangelove* posits the terrifying eternal return of fascism, as Strangelove rises from his wheelchair, heils his Führer, and the world blows up. Dave Bowman, the surviving astronaut in *2001: A Space Odyssey*, is all but outfoxed by HAL, held captive in an alien hostel, and reverts to an encapsulated fetus circling Earth. Alex is trapped in a cycle of violence and political control; Barry Lyndon does a long dance to castration and getting frozen in time, like Jack Torrance in *The Shining*, who has always been the caretaker of the Overlook Hotel and is doomed to repeat the cycle of entrapment, murder, and his own demise. The marines of *Full Metal Jacket* are as lost as their distant relatives in *Fear and Desire*, unmanned by their training and undone by a woman sniper, the least likely of enemies to destroy them (this is a mirror of the early *Fear and Desire*, where a woman is bound to a tree and shot by a crazed soldier after he unties her). Bill and Alice Harford in *Eyes Wide Shut* are trapped in the cycle of their dreams and nightmares, sexually fraught with desire and jealousy, love and hatred, the eternal return of repression and anxiety.

This litany of constraint, failure, and fall is not a simple theme in Kubrick's work; it is its very form. Starting early on, based on his experience as a photographer, Kubrick traps his characters in the film

frame itself, creating symmetrical compositions, forcing the gaze at the image. Kubrick's symmetrical compositions create an uncanny effect, the startle of the twice seen. Conventionally, filmmakers compose their images off of an imaginary ninety-degree line in front of the characters and their surroundings. In other words they rarely place the camera straight on to the action because there is an unfounded concern that if the camera were placed directly in front of the scene, the artifice of the image would become more apparent. Such a setup might emphasize the flatness, the two-dimensionality of the screen. It is one of the unwritten rules of the so-called "Hollywood continuity style" that we look *through* the image at the story and not be distracted by an unusual camera setup. The driving force of Kubrick's vision, like that of Welles and Hitchcock, is that they want us to look *at* the image and be conscious of it; they want us not to forget that we're watching a film. Looking more closely at Kubrick's particular fearful symmetry illuminates the ways in which he locks his characters, his narrative, his viewers into inescapable realizations of no exit.

Photograph of a Photograph

These repetitive cycles include the viewer as well as the character— trapped in the hard symmetry of the extraordinary image, bound to look again and again. According to that foremost Kubrick scholar, Jack Nicholson, Kubrick told him during the filming of *The Shining*: "In movies you don't try and photograph the reality. . . . You try and photograph the photograph of the reality." Kubrick started his professional career at an early age as a photographer, and his filmmaking is infused with the photographer's notion of the perfect still image. As a photographer he knows well that the image is not the reality but, in fact, its image, that slice of the world framed by the photographer's eye and reinterpreted by the chemical or digital process that retains

and reproduces the image. The image is many times removed from the reality it photographed. It is its own reality. In his films Kubrick affirms and accentuates this by hard-framing his images and emphasizing their artifice by shooting directly straight-on, with the elements of the frame often arranged in geometric symmetry.

There is both an aesthetic and obsessive element to this. I spoke about the way he fashions a closed universe (even, when in *2001: A Space Odyssey*, he explores the universe), worlds that, however much they reflect contemporary culture and politics, remain sealed in Kubrickian cycles. Let me stick with *A Clockwork Orange* for a few more moments. The film is born not simply out of Anthony Burgess's novel but out of the early 1970s Nixonian vexations of "law and order" and the very British teenage rumbles of "mods" and "rockers." It is ruffled through with concerns about free will and government control and, more abstractly, with larger issues of brutality and civilization. Alex's exploits as violent rapist and lover of Beethoven caused much controversy. There were, as I noted earlier, reports, probably false, of copycat crimes in England that led Kubrick and Warner Bros. to remove the film from British screens, where it was not shown until after the director's death. But on the formal level there is something more interesting going on, namely the dynamic internal rhythms of the film—its concentrated gaze on Alex and his exploits.

The opening shot of the film is a blank orange-red screen with the booming music of a synthesized version of Henry Purcell's *Queen Mab*, infiltrated by the music of the *Dies Irae*, the "Day of Wrath" of the Catholic mass, which Kubrick will use again at the opening of *The Shining*. The studio credit appears, and then the screen turns blue, announcing "A Stanley Kubrick Production." The film's title appears as the red-orange screen returns. The effect is something like a Mark Rothko painting, drawing us into featureless blocks of color until we see a tight close-up of Alex, staring into the camera,

breathing slowly, one eye made up with false lashes, the camera slowly tracking back to reveal his gang, his "droogs," on either side of him, sitting in the Korova Milk Bar, a black space with perfectly symmetrically placed patrons, bouncers, and plaster white statues of reclining naked women. Alex's voice-over introduces us to him, his droogs, and his activities.

The film immediately enfolds us into its fictional space, and I'm reminded of Steven Spielberg, whose films are also able to capture our attention completely from beginning to end. Six years after *A Clockwork Orange*, Spielberg's *Close Encounters of the Third Kind* begins with a black screen, music slowly reaching a crescendo and a blast of light that introduces us to the chaotic action of the first scene. Absorption via illusion, an agreement to get caught up in the action on the screen. Or, in the case of *A Clockwork Orange*, to be taken in. The joke is on us as we ride on Alex's irresistible voice: boasting, wheedling, pitiful, victorious. Yet, at the same time, we are aware of the "photograph of the photograph." Spielberg's films play on all the conventions of Hollywood sentimental realism, even in a science fiction film about aliens; Kubrick's film's play against them. The opening of *A Clockwork Orange* may make us attuned to Alex's voice and gaze, even side with him because his is the most energetic presence in a deadened world. But that world is photographed in ways that do not allow easy assimilation.

Alex's rape of Mr. Alexander's wife as both are tied and gagged, Mr. Alexander forced to watch, is not only unnerving but disorienting. Mr. Alexander is photographed with a distorting wide angle lens, making his anguish palpable and a bit ludicrous. While Alex commits this atrocity, he sings "Singin' in the Rain," a tune not ordinarily associated with violence but with romantic high spirits. The whole sequence is slightly ridiculous, as well as horrifying, and we are thrown into a state of disgust and astonishment—in short, a kind of discomfort not usually evoked in mainstream film, which, if it depicts violence, will simply allow us to be revolted or, if done as an act of revenge, experi-

ence pleasure. But contrary responses constitute the state of watching a Kubrick film in which artifice is foregrounded, in which the spaces of the story being told beg our attention—indeed demand it—and where story time itself becomes a source of a carefully crafted aspect of the story being told.

Structurally, both *A Clockwork Orange* and *Eyes Wide Shut* follow a bell-shaped curve (the sonata form of *Eyes Wide Shut* is a variation of this curve), a different kind of cycle. In *A Clockwork Orange* Alex is in ascendancy during the first part of the film: he is caught, imprisoned, and subjected to the Ludovico Treatment, performing his abasement onstage near the downward part of the curve, after which he goes into rapid decline, beaten by the hobo and his mates, whom he had attacked earlier; beaten by his droogs, who have now become policemen; and finally returning, with the same lateral track of the camera that introduced him the first time, into the home of Mr. Alexander. Here he is rediscovered by the now gibbering mad writer who, with his cronies, drugs Alex, plays his once favorite Ludwig Van (as Alex calls him), which causes him to leap out of the window, tracing the full downward fall of the curve. The film ends with the curve on an upward swing as Alex becomes deprogrammed and reprogrammed as a tool of the state. "I was cured all right!" Alex's final words as he fantasizes sex in the snow and the finale of Beethoven's Ninth segues into Gene Kelly singing "Singin' in the Rain."

Symmetry within the image and in the narrative structure of a film is Kubrick's way of maintaining control over content, character, and viewer. It allows him to emphasize the artificiality of the image—the photograph of the photograph—and to communicate the essential uncanniness, the familiar made to appear unfamiliar, that is at the core of his work. The bell-shaped curve or the cyclical narrative contains his characters and our response to them. But this is not the kind of containment I spoke about in Hitchcock's work, and the contrast is telling. Hitchcock's films tend to work like interlocked blocks, each

segment, often ending with a fade to black, advancing or retarding the story being told or the emotional or physical violence being done to the character. A stricter pattern begins to emerge when Hitchcock teams up with the industrial designer Saul Bass, beginning with the title sequence of *Vertigo*. The Lissajous figures, based on artist John Whitney's early computer graphics, that emerge from a woman's eye set the tone for the downward spiral that constitutes Scottie Ferguson's descent into madness. Bass's design for *Psycho* places an invisible grid over the images so that they are contained in tightly linked patterns of airless terror. Welles prefers a more complex, labyrinthine structure, where we are drawn into leads and false leads through worlds with no apparent bounds.

None of these patterns square with the "realism" we expect from movies. Instead, they force us to look at something startling and unnerving, even dreamlike. Kubrick *arrests* us with his imagery, capturing our attention, stimulating a sense of awe, forcing us to look. Welles tends to pummel our perception while Hitchcock draws us into worlds of agony and panic.

POWER AND SEXUALITY

Throughout *Vertigo*, recurring like a rhyme, is the word *power*. Gavin Elster, ready to snare Scottie in his trap, weaving him in the web of lies about his wife—who, he says, is haunted by the spirit of Carlotta Valdes—sits at his desk with shipbuilding cranes moving behind him, reminiscing about old San Francisco:

> I should have liked to have lived here then.
> Color, excitement, power.
> Freedom.

Midge, Scottie's friend, takes him to visit Pop Leibel, the bookstore owner, who tells his tale of Carlotta Valdes, the ghost Scottie believes is inhabiting Madeleine. Scottie and Midge listen as dusk falls outside. He tells of one of her lovers:

> A rich man. A powerful man.

She had a child, and her lover, Pop Leibel tells them, tossed her aside:

> So, he kept the child and threw her away.
> You know, a man could do that
> in those days.

They had the power and the freedom.

During the inquest, after "Madeleine" (actually Elster's wife) is pushed to her death from the mission tower, the coroner berates Scottie:

> [Elster] could not have anticipated that Mr. Ferguson's weakness, his fear of heights, would make him powerless when he was most needed.

Finally, Scottie to Judy, whom he has remade into Madeleine and then discovered Elster's ruse, recalls Elster's words:

> With all of his wife's money and all that freedom and that power, and he ditched you.

All three directors deal with power—in their lives and in their films. Kubrick's early filmmaking life was a quest for complete control over his work, which he succeeded in getting. Welles's quest for control only occasionally met with success, an often lonely and fruitless attempt to get financing without strings. Hitchcock had the rare gift of ongoing power over the subject of his films and how he made them. The films themselves speak to the ways their characters attempt to assert themselves. Scottie, in *Vertigo*, is perhaps the most powerful and powerless of the lot. He has the power (as did Gavin Elster) to transform a woman into the image he wants her to be. Elster succeeds; Scottie fails at the cost of his sanity. Scottie's power is an ongoing attempt to, first, express his passion to a woman who is not who he thinks she is, and, second, to change the woman who masqueraded as Elster's wife into the woman she pretends she was so that he can revive his passion. Power that attempts to impress itself on a phantom is either quickly dissipated or deflected back onto the person who is attempting to exercise it. This is exactly what happens to Scottie, whose attempts to regain Madeleine do enflame his love until he discovers the truth about her. He overcomes his vertigo by dragging Judy back up the

FIGURE 40 Elster's power over Scottie is seen in his dominance in the frame in *Vertigo*.

mission tower, where, frightened by a nun (recalling the ironic use of religious imagery in *The Wrong Man*), she falls to her death, leaving Scottie powerless, in an emotional void.

Power is a contentious affair in all three of our directors' films. Hitchcock's characters rarely want it but often have it thrust on them by external or internal forces beyond their immediate control. Roger O. Thornhill in *North by Northwest* and his distant relative Hannay in *The 39 Steps* are thrown into an adventure with spies. Thornhill and Hannay are shackled—Hannay literally to Pamela—by seemingly inescapable forces, false identities forced on them. In Thornhill's case he is put on display, an actor at the hands of the spies. When he confronts them at a Chicago art auction, he complains that they want to see him dead. "Your very next role," says the spy Van Damm. "And you will be quite convincing, I assure you." *North by Northwest* is a kind of comedy, a kind of thriller, though finally it is in a genre of its own, which should be called "Hitchcockian" because of the uncomfortable depths it plumbs on its way to being resolved. Its more serious counterpart is the earlier *Notorious*, in which Cary Grant's Devlin pushes a woman into marrying a Nazi in order to get his secrets. Eve Kendall in

North by Northwest is pushed by government agents into becoming the lover of the spy, Van Damm. She and Thornhill meet cute on the 20th Century Limited to Chicago.

Thornhill escapes a series of coincidences that not only put him in danger but force on him the very identity of the nonexistent character the spies believe him to be. This is a peculiar twist on the events of *Vertigo*, the film that preceded *North by Northwest*. There, two men enforce an identity on a willing woman; in *North by Northwest* the power of persuasion is forced on a mama's boy who just happens to be in the wrong place, making the wrong gestures, at the right time. The masters of the Cold War, who loom gently over the film, allow such manipulations in the name of the greater power of the state. "The Professor," Eve Kendall's handler, takes the place of Prescott in *Notorious*. That character is completely callous, lying in bed eating cheese and crackers, pushing Devlin to whore out his lover. The Professor is a more superficially benign puppet master, who allows Eve to be the lover of the smarmy Van Damm before she falls for the not-so-innocent Roger.

Power becomes diffuse, manipulation severe. Eve is a government spy who beds down with the enemy; she falls in love with Roger, who has been forced, against his will, to be someone else. When he discovers one of Eve's identities, he turns against her—"she puts her heart into her work, in fact her whole body," he tells Van Damm during the auction sequence. Van Damm removes his hand from Eve's shoulder in an act of revulsion. He tells Thornhill that he overplays his various roles—Madison Avenue executive, the fugitive from justice, the peevish lover. "It seems to me you fellows could stand a little less training from the FBI and a little more from the Actors Studio." Hitchcock was voluble in his distaste for the Actors Studio Method acting, adding to the irony of Van Damm's mockery of the victim he has created.

Acting in the theater of the Cold War is performed by small and large betrayals and power manipulations, which Hitchcock translates into sexual terms. How is a woman used? Who has power over her?

Roger Thornhill, Eve Kendall, and Van Damm play out a remarkable dance, indeed, in the reigning metaphor of the film, a theatrical performance of control and deception. Roger falls in love with Eve as he is escaping Van Damm's unwavering belief that the meek advertising man is the government spy George Kaplan. The foreplay in Eve's train compartment is heavy and unconsummated, and Roger understands that Eve is not who she claims she is (an industrial designer, similar to Midge in *Vertigo*) when they meet in a hotel room after the famous crop duster episode. She runs to embrace him, and Roger holds his hands up and away from her, his suspicions overcoming him, his passion in question. "I bet you could tease a man to death without half trying," he tells her as they play out their dance in her hotel room.

Like Alicia in *Notorious*, Eve is sexually manipulated into her various roles, by the government, represented by "The Professor"—"CIA, FBI . . . , we're all from the same alphabet soup"—and by the spies. She is a sexual tool, a prop in Cold War theatrics, and she survives only when Roger pulls her up from the rockface of Mount Rushmore and, by means of that wonderfully sly and pleasing cut, into the upper birth of a train speeding into a tunnel. Because *North by Northwest* has elements of comedy, the stakes are somewhat less dire than they are in the earlier *Notorious*, where, at the last minute, Cary Grant also saves his lover from the death he led her to, not by lifting her out of danger but by carrying her down the stairs of her husband's house, daring the gaze of Sebastian's mother and their Nazi friends.

The Nazis in *Notorious* are civilized, their brutish power on the wane and subject to oversight by the U.S. government, who, as in *North by Northwest*, will use women and their sexuality to advance their control. The U.S. agent Devlin manipulates the woman he loves because he has political power behind him. He uses Alicia's sexuality to discover the Nazi's secrets. Our first sight of Devlin is at Alicia's drunken party after her father has been found guilty of spying for the Nazis. He is seen from behind as a dark, unmoving, almost phallic threatening

FIGURE 41 Saving Alicia in *Notorious*.

presence. And it turns out that his power is all but absolute; he is the opposite of Scottie in *Vertigo* because he tries to *un*make the object of his desire. Despite his love for her, he manipulates Alicia and humiliates her until she is all but dead. He allows the Nazis Sebastian and his evil mother (the first of Hitchcock's scary matriarchs) to slowly poison Alicia until the very last minute. He looks on from a distance, and his last-minute conversion and rescue of his near-dead lover is barely convincing. There has been, to return to Michael Wood's phrase, too much disarray introduced, and it bears heavily on Devlin's sudden change of heart.

Eve Kendall's power is in her persistent passivity, a contradiction not to be taken lightly. Hitchcock's women are complex creations, the subject neither of a virulent misogyny or an excessive adoration. And

while there has been some biographical and psychological analysis of "the Hitchcock blonde," it seems to me more interesting to look at the complexities of these women's roles in the films. In her well-known study of women in Hitchcock's films, Tania Modleski writes that "Hitchcock's fear and loathing of women is accompanied by a lucid understanding of—even a sympathy for—women's problems in patriarchy." I'm not sure about the "fear and loathing," but the recognition on Hitchcock's part about "women's problems in patriarchy" is clear enough. As we have seen, women become the subjects of male fantasies and their manipulations; their stock rises and falls according to where they are in the hierarchy of male abuse.

At the same time, as I noted earlier, there is no homogeneity inherent in these female characters. The blonde women in gray suits that populate the 1950s and early 1960s films represent a kind of Hitchcockian everywoman, though each is inflected with her own characteristics. Grace Kelley's Lisa in *Rear Window* and Doris Day's Jo McKenna in the 1955 version of *The Man Who Knew Too Much* become quite active figures. But Marnie is emotionally and sexually flattened, damaged as a child from a violent attack by her mother's lover, whom Marnie killed in the process. Her diminished state is echoed by the reduced state of the film's spaces. These were criticized (as were Kubrick's in *Eyes Wide Shut*) for being artificial, studio-bound, using rear screen projections and matte paintings—nowhere more noticeable than when Marnie is riding her horse, Florio, or when she visits her mother in a Baltimore row house, a painted ship looming large in the background. While it may be true that Hitchcock was cutting corners and avoiding locations, the artificiality lends a kind of subdued expressionist air, emphasizing the restricted flatness of Marnie's affect, the nightmarish interior world she inhabits.

Like *Eyes Wide Shut*, *Marnie* is not an easy or enjoyable film. It has a dry airlessness, and its characters—Tippi Hedren's Marnie and Sean Connery's Mark Rutland included—exhibit a grinding

unpleasantness and an unrelieved pain. There is much work we need to do to get at them, and when we do, we find only the hurt. I could say the same thing about some of the earlier films—*Psycho, Vertigo, Notorious*. But those films are still sparked by Hitchcock's wit and an inventiveness of form that makes them endlessly fascinating. I noted earlier that *Marnie*, like *The Birds*, is a kind of essay, a metafilm— Hitchcock thinking about more than dramatizing his concerns and obsessions. The power here is the voice of the director, explaining why his characters must suffer, and in the character of Marnie herself, who remains stoically burdened, powerless in the vacuum of her fears and her uncertain sexuality.

Rear Window is a study in yet another kind of power, the power of the gaze—who owns it, who is its object, and who is manipulated by it. L. B. Jeffries sits crippled in his wheelchair with nothing to do but peer through the telephoto lens of his camera (he is a professional photographer and received his wound, his broken leg, while photographing a car race), spying on his neighbors in the apartment building across the way. The lens gives him potency, and each window through which he peers becomes, for his eyes, a movie screen out of which he can create a fantasy for each of the characters who inhabit them. His is the passive power of the movie viewer—Hitchcock knows this, and it is reflected in his cameo: he is seen in the apartment of the songwriter, winding a clock as if setting the whole mechanism of the film in motion, for us, for Jeffries. The mechanics almost chew Jeffries up. His obsession with looking allows him to all but ignore the advances of his beautiful girlfriend, Lisa Fremont, who is free of Jeffries's physical constraints but also all but free of his complete affection. Unlike the character James Stewart will play in *Vertigo*, Jeffries seems sexually neutered, excluding Lisa from his game of gazing until she becomes useful in a plot he has conceived, at which point he becomes excited.

The paradox of Jeffries is that he does not want to be contained. He would like to continue wandering the world with his camera without

being tied down to the beautiful Lisa. He wants to create an active life, even if he now can't be physically active, and he wants to evade Lisa by closing her out of that life, until he becomes convinced that one of his actors across the way is a murderer who hacked his wife to bits. Lars Thorwald is indeed a suspicious character, leaving his apartment with a metallic suitcase—does it contain his wife's body parts? There is a frightened scream at one point—from his apartment? What Jeffries does not see, because he is asleep and the camera assumes its own point of view separate from him, is Thorwald leaving with a woman whose face is obscured. Who she is we never find out. Perhaps it is his wife and they are leaving for a late drink. But such banalities are not good either for Jeffries, the movie he imagines, or the movie we watch. He sends Lisa to Thorwald's apartment to investigate what is going on. Here, as I noted, there occurs one of the most inventive moments in Hitchcock's films: a shift in the gaze, a shift in power. Thorwald catches Lisa in his apartment, where she is pointing out a wedding ring to Jeffries across the way. He turns and looks at the direction of her gaze; Jeffries's invisibility is ended. He ends up tossed out the window by the pathetic, thuggish Thorwald—whose power comes only from brute strength—and now has two broken legs (see figure 14).

There is in Hitchcock's films a spectrum across the exercise of sexual power. His women rarely have it, but they can resist and overcome it. Even the depictions of rape in his films demonstrate a variety of responses. Alice stabs her rapist in the 1929 *Blackmail*; Marnie is raped by her husband, and the terror of the act is duly represented. She attempts suicide afterward. A psychopathic rapist-murderer rages through London in *Frenzy*, and the horror is registered on the face of one of his victims. For the second rape, however, Hitchcock demonstrates a reticence, withdrawing from the room in which the outrage will occur and tracking his camera down the stairs and into the noisy street. This is an act of evasion, smugness, and cleverness, allowing a camera maneuver to substitute for the gruesomeness of the act. It

reminds me of the British films where Hitchcock kept trying out various formal devices as he developed a coherent narrative style. *Frenzy* is in many ways a return to the British films, in fact promoted, after the flops of *Torn Curtain* and *Topaz*, as "the original Hitchcock" and his return to filming in England after many years in the United States. That camera movement is a clever rhetorical turn but also an excess of form. The power of directorial rhetoric replaces the depiction of power by the character who is committing rape and murder.

In Hitchcock's best work the power held by the owner of the gaze is a constant concern: who sees owns power; who loses the gaze loses power. "The cruel eyes studying you," complains Norman to Marion in *Psycho* when she suggests that he put mother "somewhere." The power of the gaze—what I see, what the characters see, what the camera sees and when it sees—is at the core of Hitchcock's cinema. It is his overriding theme, and he will go to great lengths to astonish us by what he and his characters are looking at. Lisa talks to Jeffries about "rear window ethics," but Hitchcock is talking about rear window opportunities, looking aggressively, powerfully, transgressively. Like Welles in *Citizen Kane*, he ignores the caution about no trespassing and exerts his power even when the characters he portrays are powerless or use their power to destroy. Hitchcock liked to brag about playing his audience like a pipe organ, especially in regard to *Psycho*, whose carefully wrought structure leads the viewer shot by shot to its preordained conclusion. But inside *Psycho* lies a perversion of power so very complicated that it has to be unraveled in layers. In *Vertigo* the ghost is a ruse; in *Psycho* the ghost is real, a psychological entity that inhabits Norman and makes him a killer, one who owns the gaze. Just recall that image of Norman peering through the hole in the wall at Marion undressing in the bathroom and his malicious, psychotic stare that ends the film.

George Toles called it "the infection of the eye," the ability to spread the cankered point of view of his characters to the audience itself. Power in Hitchcock is so often used for destruction, and our

gaze is so often aimed at a victim, sometimes belonging to the victim-izer him- or herself. Hitchcock's films are about deeply flawed, often profoundly dangerous, characters whose pain is derived from the pain caused to others. That the viewer derives pleasure and pain in various measures from this infection is a great paradox of Hitchcock's work, a sign of a certain masochism responding to the sadism of his characters, an ability of the filmmaker to allow us to be moved by the suffering of others in a dark cinematic universe.

Power and sexuality infuse Kubrick's films like an obsession. It is present even as a negative. *Paths of Glory* is a compact, dark, and angry film, the first in which Kubrick demonstrates his sense of making cin-ematic space articulate the story he is telling. From the stunning track through the trenches as Colonel Dax prepares his men for the impos-sible attack the German fortification called the Ant Hill, to the deep spaces of the chateau where the generals plot the tactics that will send their men to their deaths, Kubrick's camera defines the hypocrisies and inequities of the "Great War." Three men are chosen to face a firing squad because of "cowardice" in the face of the enemy. In truth neither they nor any of the other men could advance very far from the trenches. The court martial and execution of the three is ugly vengeance on the part of the generals, one of whom ordered firing on his own men to try and get them to move. Colonel Paris is the most articulate of three condemned men. In a dank cellar where they are kept before they face the firing squad, Colonel Paris, on the brink of a breakdown, says to the sergeant come to collect them: "It just occurred to me . . . funny thing . . . I haven't had one sexual thought since the court martial . . . pretty extraordinary." He collapses in hysterics and is told to pull him-self together, to "act like a man . . . or we'll have to drag you out of here." He and his two comrades, one of them half dead already, having been beaten by Paris for trying to attack the priest, come to give them their Last Rites, are dragged out and executed.

Paris's lack of sexual thoughts marks him as dehumanized in the

FIGURE 42 Trash talk in the latrine in *Full Metal Jacket*.

face of the mortal panic caused by his immanent death. We've seen the opposite occur in *Eyes Wide Shut*, where sexual panic causes hypersexuality in Bill Harford, who sets out on a quest to prove his potency. In *Full Metal Jacket*, his fifth war film (if we count *Spartacus* and *Dr. Strangelove*), Kubrick's characters are fully sexualized but at an adolescent level. Marine training has unmanned them, transformed their sexuality into a vulgar companion to the violence they are trained to commit as soldiers. There is an odd little scene, almost dropped into the film out of the blue. In a perfectly symmetrical shot, the rows of toilets on either side of them, Privates Joker and Cowboy are mopping the latrine, talking about Private Pyle, who is going slowly mad, eventually shooting the drill instructor and himself in that very latrine. Before that, Pyle has begun talking to his rifle—he calls it Charlene—an event commented on by Joker and Cowboy in the scene in the latrine. The camera tracks toward them slowly. The conversation about Pyle ends abruptly and inconclusively, and just as abruptly, Joker says (the fly on his shorts coming open), "I want to slip my tube steak into your sister. What'll you take in trade?" "Whad'ya got?" Cowboy responds. The scene ends.

This spasm of vulgarity emerges from a film in which sexuality and gender teasing form a large part of its dialogue. Hartman calls his trainees (among other choice words) "ladies," and the insistent comparison of them to feminine weakness is undone by the end when a female Vietcong sniper decimates the platoon and, when Joker kills her, marking him as a hero manqué. But to the men it's all "Mickey Mouse." "What is this Mickey Mouse shit?" Hartman yells as he enters the latrine where Pyle has gone homicidal, suicidal. A Mickey Mouse doll is seen in the *Stars and Stripes* office in Vietnam where Joker works. The troops sing the Mickey Mouse Club song as they march off in a "world of shit" at film's end. The powerful marines are reduced to powerless children, playing games of life and death, their sexuality reduced to the banality of the infantilized impotent.

A tormented sexuality is apparent as early as *Fear and Desire*, Kubrick's first fiction film and first war film. The lost patrol at its center captures a woman (perhaps from the unnamed enemy) and ties her to a tree. They leave her to Sidney, a soldier slowly going mad under the pressures of combat. He babbles to her, caresses her, unties her; she runs; he shoots her dead. This is told in the fragmented style that is the mark of this early work: sharp close-ups, rapid cutting in the style of the Russian revolutionary filmmakers Sergei Eisenstein and Lev Kuleshov that mark Kubrick's search for a usable form. But even this early, confused, distressed sexuality marks the vague psychological landscape, a country of the mind, as the narrator defines the location of the film. When that form and place are established, as they are by the time of *Dr. Strangelove*, Kubrick's fourth war film, sex and power are inextricably linked.

I mentioned earlier the sexual imagery that underpins *Strangelove*, but it's important to emphasize how thoroughly Kubrick sees warfare, power, violence, and sexuality inextricably entwined in this film. The very names of the characters are hilariously sexualized: General Buck Turgidson, whose swollen sense of military potency helps destroy the

world; President Merkin Muffley (the first part referring to artificial pubic hair, the second to the vagina). Jack D. Ripper, the general who sets the whole doomsday scenario into action, is named after the London lady killer, about whom Hitchcock made *The Lodger* back in 1927. The Russian ambassador is named de Sadesky, his boss Premier Kissoff. The sanest member of this crew is Lieutenant Mandrake, named after the root of a plant that was once a metaphor for the human form. ("Get with child a Mandrake root," the seventeenth-century poet John Donne wrote.) Lieutenant Mandrake attempts to engender some rational behavior in the chaos, but in the end he is all but undone by Colonel Bat Guano and a Coca-Cola machine. Dr. Strangelove himself finds strength in destruction, power and arousal at the thought of nuclear annihilation. "War has genital potency," Henry Kissinger (one of the models for Strangelove, in addition to the Nazi scientist Werner von Braun) was once supposed to have said.

The deadly serious nonsense of Cold War rhetoric and its ultimate apocalyptic outcome becomes entangled with sexual dysfunction or, perhaps, sexual overfunction. Ripper is afraid for the depletion of his precious bodily fluids, so he avoids ejaculation and doesn't drink fluoridated water: "Do you realize that fluoridation is the most monstrously conceived and dangerous communist plot we have ever had to face?" he remonstrates with Mandrake. Ripper thinks sex and communism are the equivalents of death, not the "little death," as orgasm was once called, and certainly not what the French call "jouissance," but the death of vitality—of life. Major Kong, riding his H-bomb, grandly fucks the Earth (see figure 49). *Wargasm* is the term invented by James Naremore. Total sexual confusion would be even more apt in a film that posits the apocalypse as the confusion of what happens during sexual intercourse. Meanwhile as the inhabitants of the war room rail against the Russians and plan to choose women for their sexual characteristics to join them in mineshafts as the doomsday device goes off, they fail to see the reborn Nazi in their midst. And it never fails,

FIGURE 43 "Mein Führer, I can walk!" The Nazi reborn in *Dr. Strangelove or: How I Learned to Stop Worrying and Love the Bomb.*

as many times that I see Strangelove get up from his wheelchair and salute his *Führer*, the hairs on the back of my neck stand up. The revelation of real danger in the midst of manufactured terror is irresistible precisely because it is a revelation that only the viewer can recognize amid the bluster, madness, and impotence of the characters in the film.

All of Kubrick's male characters act in a mode of sexual confusion or dysfunction or excess. And in all instances their sexual power, whatever it might be, leads to a diminished state, and more often than not to their destruction. Humbert Humbert likes very young girls. He manipulates Lolita's mother, Charlotte—"The Haze woman . . . the cow . . . the obnoxious mama . . . the brainless baba"—into marriage so that he can get to her daughter. Charlotte makes him feel "limp as a noodle." Lolita is an obsession that may bring him erect but ultimately causes him grief and loss. Clare Quilty (Peter Sellers's first role for Kubrick), Humbert's double, undoes him in rancid perversity at every turn. Kubrick's Humbert, as I noted earlier, is not the smarmy narcissistic pervert of Nabokov's novel. James Mason's embodiment of

the character softens him, makes him more of a victim than obnoxious perpetrator. But that is just the point. Kubrick's Humbert, no less than Jack Torrance or Bill Harford, is at the mercy of a sexuality and gender confusion that controls them. Kubrick's Humbert is a pathetic creature, attempting to maintain dignity without the power to control his obsession or the consequences it incurs. He is an abject character and a comic straight man as well. Kubrick invents another character for the chameleon Clare Quilty/Peter Sellers to play: Lolita's school psychologist, Dr. Zempf. He appears as if he were a monster in a haunted house. (There are actually two haunted houses in the film: Humbert's home and Quilty's mansion, where, at the beginning of the film's circular narrative, Humbert comes to kill his double. Early in their relationship, Humbert, Charlotte, and Lolita go to see a horror movie.) Dr. Zempf sits in a pool of light surrounded by the dark. With slicked back hair and Coke-bottle glasses he is a spirit of evil. With a comic German accent—a prelude to Dr. Strangelove in Kubrick's next film—he chides Humbert for keeping Lolita from the school play, *The Hunted Enchanters*, which Quilty wrote and where he begins his plans to steal Lolita away and put her in pornographic movies. "You, Dr. Humbartz [as Zempf pronounces his name], should definitely un-veto that girl's nonparticipation in the school play." He is a hilarious predator, more malicious than his victim—poor, powerless Humbert.

A hapless sexual abuser becomes undone by an abuser more cunning than he. But in the end both Quilty and Humbert are undone by Lolita's move to humble maturity. Humbert's teenage lover becomes the pregnant wife of a working-class guy with a hearing aid. Humbert is reduced to tears and rage. He searches out Quilty and shoots him. His ultimate act of revenge is shown at the beginning of the film, and Humbert's approach and entrance into Quilty's lair is repeated at the end, so that the film is a perfect circle of despair and impotent, deadly rage.

Quilty's mist-enshrouded home, its floor covered in garbage and

empty bottles, is likened to a haunted castle. The Overlook Hotel in *The Shining* becomes a more conventional haunted house, a brightly lit habitation of monsters from the id. At first glance the power in *The Shining* would seem, in good horror film fashion, to be coming from some ghostly past visited on Jack Torrance—there is that business about the hotel being built on an Indian burial ground. But there is, in fact, no ghostly past in Kubrick's films, and Jack's undoing is the result of his own mad vengefulness against his child and his wife, "the old sperm bank upstairs," as he says to Lloyd, his hallucinated barman. While the image of Jack looking down at his wife and son in the hedge maze pretends a godlike gaze, it is in fact an inverted one. His wife and son will outwit him; he is powerless and finally mad, a condition many of Kubrick's characters fall into in the course of their cinematic lives. In their madness, their frenzy, their delusion, they can attain a modicum of potency. They can pretend that they will prevail, that they will maintain power over the unexpected, against contingency. They never do.

Power in Kubrick's films is a devious, treacherous affair. Those who have it use it disastrously; those who don't and want it are crushed. I noted that there is an interesting intersection between Kubrick and Hitchcock. Bill Harford in *Eyes Wide Shut* and Scottie Ferguson in *Vertigo* are unlikely doubles. Both are caught in nightmares of their sexual fantasies and confusions. Both want women to be made in their image. Both travel in circles through the spaces of their sexual anxieties. Both fall: Bill back into the situation that started his hopeless dreamquest, Scottie into the abyss that opens when he realizes fantasy and death become inextricable. Bill doesn't even have the limited power of Scottie to make over a woman into his image and tries instead to make over his own image as, perhaps, a more sexually attractive man. He fails because he is inept, because contingency works against him, and because, as Ziegler tells him, there are incredibly powerful people above him who maintain access to the kind of sexual freedom Bill thinks he wants and can never get. Scottie and Bill are ultimately

sucked into a powerless void where both desire and fulfillment evade them, where they can only dream or have nightmares about what they can never have.

But there the similarity with Hitchcock ends. Kubrick thinks more narrowly about sexuality and power than does Hitchcock, but he speaks about it more eloquently, even more sternly in his images. There is a different experience of airlessness between both men's films: Hitchcock's dark and claustrophobic, Kubrick's bright and detailed. I experience a very different response to each because their characters inhabit such different worlds and attempt to pursue their place in it in such different ways. Hitchcock wants me to identify, in conventional ways, with his character's pain—that masochism I mentioned earlier—and move stepwise through the building blocks of his films. Kubrick wants me to look at things whole and find, as Henry James once wrote, the figure in the carpet.

It's a commonplace that power is always misused, that it corrupts minimally or absolutely. In talking about the work of our filmmakers I have to add that it *destroys* minimally or absolutely. For Orson Welles power is a source of humiliation and degradation. It is hard to resist the biographical in talking about this. The cliché about Welles's career is precisely that it was a downward slope of humiliation and loss of the enormous power he had when he came to Hollywood in 1939. Do his films reflect this any more than Hitchcock's reflect his fears of impending chaos or Kubrick's obsessive need for control? There is no denying that Welles's films concern loss and diminishment, that Hitchcock's address the eruption of fearsome chaos, that Kubrick's reflect the collapse that attends a blind rigidity. Does the life of an artist enter his work? If so, it's not a simple entry. As we've seen, Welles's post-*Kane* life, beginning in the late 1940s, was partially consumed with making enough money to make his films. Hitchcock's control was always exerted in sync with the studio system. It could be argued that Kubrick had the greatest control of the three. He worked at home. He made only

the films he wanted to make. He had the power to do what he wanted, though that meant that uncertainty about how to use his means made him waver and discard many of the films he wanted to make.

But so did Welles; only for him this discarding of projects was because it became harder to fund them. He had no studio backing and protecting him (when he did, with RKO and, later, Universal, they turned on him), and unlike Kubrick, his imagination sometimes outstripped his means. So did his difficulties in controlling his finances. But how is this reflected in his films, or is it? I must restate my reluctance to equate biography and the finished product of a film. And as much as I have been moved by the ability of Welles to push on despite all obstacles and make great movies into the early 1970s, as much as I am angered by what was done to his films by uncaring hands, I am moved more by the films themselves. That they all speak to loss of power is as much the artist's existential vision as it is a product of the troubles of his quotidian existence. This is so well figured in Welles's lovely, golden bathed miniature, *The Immortal Story*, the only released fiction film of his made in color. Here, an old merchant in Macao, Mr. Clay, "erect, silent, and alone," has his clerk read to him "the bills, estimates, and contracts of his business" to entertain him on sleepless nights. For a change in this dry routine, his lowly, solitary Jewish clerk—a late version of Kane's Mr. Bernstein—reads to him from the prophet Isaiah. This confuses Clay, not merely the prophesies but the notion of stories, of lies. He wants to make a story come true, and one story in particular intrigues him: an old seaman's tale about a virginal sailor who comes ashore and for five guineas makes love to an old man's wife. The story, like all stories, frustrates Clay because, in his diminished old merchant's life, he wants facts and not fiction.

He decides to make the story come true, to reverse the power of art and life by making art life itself. The results are, of course, a disaster. Levinsky, Clay's clerk, pays Virginie, the daughter of a man Clay once ruined and caused to commit suicide, to act, in effect, as a prostitute.

FIGURE 44 "I have heard it before. . . ." Levinsky and the seashell in *The Immortal Story*.

Clay pushes the story further. He hires a sailor, Paul (Paul and Virginie are the legendary lovers of an eighteenth-century French novel), to take part in his story and, in fact, to cause Virginie to bear him an heir. For her part Virginie hopes by taking on the task laid upon her to take revenge for her father. In the course of their acting out Clay's fantasy the couple take on a life of their own; they make love and not fiction— though they are in a fiction—in the most erotic sequence Welles had yet filmed. Their love is Clay's undoing. Fiction is strong enough; turning fiction to "fact" upsets the very order of things. The sailor leaves with an offering of a seashell—a late version of *Rosebud*—and promises never to tell the story of that night. "Reality" refuses to turn itself back into story, and story remains in the realm of art. Mr. Clay dies of the excess of trying to play God. Levinsky puts the seashell to his ear. "I have heard it before. Long ago. But where?" The screen fades to white.

The Immortal Story is part of Welles's late-life inquiry into art and illusion that will be carried over into *F for Fake*, and it resonates with the elegy to loss and death that he had already enacted in *Chimes at*

Midnight. Its delicate color and deep, closed spaces, lacking Welles's usual flamboyant camerawork, mark a world of loneliness and decline, a somber meditation on art and the impotent failure of the materialist imagination.

To return to the question of biography for a moment: *The Immortal Story* could indeed be read as something of an allegory of Welles's career, though not in the usual sense. In such a reading Orson Welles would be both the merchant selling his wares—something Welles had to do continually throughout much of his life—and the artist, who then turns money into works of art. He was only spottily successful at the former, colossally successful in the latter. This is very much at the heart of my admiration for Welles and is also at the heart of *The Immortal Story.* The work of the imagination is so different from the work of finance. Ledger books are not poetry, and poetry or, in our case, great films, while made for money and to make money, are not the money they are made with. Producers, the Mr. Clays of the film world, want to turn money into more money. Filmmakers like Welles, who did have to play the role of producer, wanted to turn money into something else that is not money and might not make money. This is an exercise of power, based as always on chance, but when successful creates works of great energy and a power that exceed their origins.

This might explain the fascinating paradox in Welles's work that I touched on earlier, the struggle between sentimentality over a lost past and the modernism of diminished men caught in contingency and expressed through complex formal structures made visible to the viewer. *Citizen Kane* is a film in the modernist tradition if only because of its foregrounding of form. *Kane* wants us to look at it, to revel in the vital energy of its creation. While its immediate takeaway might be trivial—rich people are lonely and unhappy—the telling of its story is not, nor are its politics or commentary on contemporary media. Franz Kafka's *The Trial* was a great modernist novel, written in 1914, published in 1925, and it inspired Welles's great modernist film of 1962.

Both speak to a loss of agency, loss of power, of existential angst in an unfathomable world, and they present that anxiety through formal means that are, in *The Trial* especially, anxiety-provoking because they are not transparent. Welles's *The Trial* is the summation of his visual bravura, his deep-focus, high-contrast black-and-white restless cinematography. But *The Trial* is quickly followed by *Chimes at Midnight*, also about the loss of power, also stunningly shot, but not the angry denunciation of contingency and anonymity that its predecessor had been. Rather, it is a sentimental retelling of Shakespeare's own lament on the loss of the green world, of the innocence of ease and drink and sex in which, despite its grueling battle sequence, a gentle chaos ruled. Along with *The Immortal Story*, it is Welles's autumnal work, a film about grace in the face of the loss of power.

The Magnificent Ambersons, that glorious remnant of a Welles film, is also about loss, here the dwindling of a great family in the face of the bad behavior of its scion and of ineluctable progress. Eugene Morgan, inventor of automobiles, all but sings a song of modernity:

Old times?
Not a bit!
There aren't any old times.
When times are gone, they're not old, they're dead!
There aren't any times but new times.

Welles reluctantly agrees but laments the fact, hence the darkness of his original cut of the film that preview audiences didn't like and the studio destroyed. Welles's addiction to filmmaking was an addiction to the modern: film is the art of modernity. For him to have used his art to lament modernity is not a contradiction but a tension, perhaps as strong as that between money and imagination. We can use our tools to present our grievance and grieving, and our grievance and grieving become in their turn the tools of the imagination.

The power of Welles's characters and their effectiveness within the

stories he tells is pushed and pulled by longings for the impossible past and improbable future. They are pushed and pulled by their own deficiencies, their terrors and petulance. In a 1985 essay titled "Power and Dis-integration in the Films of Orson Welles," Beverle Houston coined the wonderful phrase "Power Baby." Her description is worth quoting at length:

> I have come to call this central figure of desire and contradiction the Power Baby, the eating, sucking, foetus-like creature who, as the lawyer at the center of *The Trial*, can be found baby-faced, lying swaddled in his bed and tended by his nurse; who in *Touch of Evil* sucks candy and cigars in a face smoothed into featurelessness by fat as he redefines murder and justice according to desire; who in his bland and arrogant innocence brings everybody down in *Lady from Shanghai*; who, in the framed face of Picasso, slyly signals his power as visual magician and seducer and who is himself tricked in *F for Fake*; but who must die for the sake of the social order in *Chimes at Midnight* and who dies again for his last effort of power and control in *Immortal Story*; and who, to my great delight, is figured forth explicitly in *Macbeth* where, in a Wellesian addition to Shakespeare, the weird sisters at the beginning of the film reach into the cauldron, scoop out a handful of their primordial woman's muck, shape it into a baby, and crown it with the pointy golden crown of fairy tales.

Welles's characters make demands, and the demands made on them usually result in a petulant, violent reaction. Baby-faced Mike O'Hara in *The Lady from Shanghai* is a left-wing brawler who shot a Franco spy, or so we are told. Elsa Bannister reduces him to adolescent adoration and impotence in the face of the corruption around him. When that world literally shatters around him, he can only watch, shot in the hand, slowly coming around to understand how he has been used. Charles Foster Kane is held in thrall by a childhood lost; like his

whining double, George Amberson Minafer in *The Magnificent Ambersons*, he needs constant feeding and care, finally lashing out and pushing away Jed Leland, the one person who loves him most. Hank Quinlan and Sir John Falstaff are, in their different ways, two of Welles's most prominent "Power Babies." Quinlan, also moved by a disturbing past (his wife was strangled by the only perpetrator Quinlan could not catch), spends his present feeding himself with candy bars while he plants evidence on others. His power, while not exactly infantile, is certainly vindictive; his sense of self, like so many of Welles's characters, is entitled, and this entitlement is based on a malformed ego only. Not so with Falstaff, who is all id, father and son to Hal. Falstaff is a man-baby without a past and certainly with no future. Falstaff is childlike and childish, his power as a merry companion eclipsed by the fact that his companion must grow up and disown him like Kane's parents did to Charlie.

The Power Baby metaphor takes us just so far into the Wellesian universe, which is a place of power-hungry and power-losing moves, and where sexuality and gender are part of the hunger and loss. From *Citizen Kane* onward, women are a continuing source of difficulty for Welles to portray and his characters to deal with. With one major exception. Agnes Moorehead's performance of Aunt Fanny in *The Magnificent Ambersons* creates an empathy that is equaled only by Patricia Collinge's Emma in *Shadow of a Doubt*.

A penniless, lonely figure, frustrated by her unrequited love for Eugene Morgan, Aunt Fanny becomes the hysterical representative of the fall of the Amberson family and home. In a late sequence where she and George meet in the bare ruins of the Amberson mansion, Fanny leans on and then falls against the house's cold boiler. George begs her to get up. "I can't," she says; "I'm too weak," and when he worries about her burning herself, she says, "It's not hot, it's cold." She says this in despair, growing more frantic as the scene proceeds. Welles's ending for the film was a meeting of Fanny and Eugene in the board-

FIGURE 45 "It's not hot. It's cold." Aunt Fanny breaks down in *The Magnificent Ambersons*.

inghouse where Fanny now lives. It's a bitter ending, Fanny completely alone. But this was too bleak for audiences and for RKO, who shot a final scene of a sentimental reconciliation between Fanny and Eugene, walking a hospital corridor, having visited George. They smile, and redemption is in the air. It's so different in tone from everything that preceded it in the film that it causes something like revulsion. Welles's original concept might possibly have had the same effect as *Chimes at Midnight*, a bittersweet sense of the inevitability of change and the unrecoverability of loss.

While similar in the empathy the characters elicit, the hysterical energy of Aunt Fanny is actually the opposite of Emma's restrained, almost stream-of-consciousness, voice in *Shadow of a Doubt*. But both express the anchorless position of women in families that over-

whelm and threaten to destroy them. They are powerless in worlds where power is held and misused by men who more often than not destroy themselves as well. They are also figures who disprove the charges of misogyny often leveled not only at Welles and Hitchcock but at Kubrick as well. Welles's characters do not abuse women with the ferocity of Hitchcock's. Kane slaps Susan during the "picnic" in Florida; Michael O'Hara leaves Elsa Bannister to die alone in the funhouse in *The Lady from Shanghai,* crying out "I don't want to die." But Elsa is in line with the seductive, killer women that sidled through the noir films of the 1940s and 1950s, who ruined their men and died for their sins. Gregory Arkadin has women killed, accessories to his past and present, inconvenient reminders of who he is. But Hank Quinlan's memory is held by Tana, and the women of the court are attracted to Josef K. because they are aroused by guilty men. The world of *The Trial* is strange indeed.

Welles once said that two things were impossible to film: a person praying and a couple making love. But some biographers are now saying that Oja Kodar, his late-life companion, released Welles's inhibitions about depicting sexuality onscreen, and *The Other Side of the Wind* contains at least one scene of copulation (in the front seat of a truck). The lovemaking between Paul and Virginie in *The Immortal Story* is told with great delicacy and beauty. But in the majority of Welles's films sexuality is less an issue than an inflection—a means of hurt or regret. Kane gets caught in "love nest" with "singer" (as the headline in the opposition newspaper says), and it ruins his political career. For Tana, Hank Quinlan was "some kind of man." Falstaff and Prince Hal frolic with the prostitute Doll Tearsheet. About prayer nothing is said in the films, save for the priest who briefly appears at the end of *The Trial,* warning K. that his case is going badly. He calls him "my son." "I am not your son," snarls K., in one of his last moments of defiance. The religion of the law is not open to pastoral care.

Sexuality and its discontents are a commonplace in film, so much

so that, given that our three filmmakers work so much against commonplace, it is no surprise that they treat sexuality in unusual ways. For Hitchcock, grievous problems of sexuality and gender are laced through almost all of his films and ruin the lives of his characters. For Welles, sexuality is at least a digression for his characters, sometimes, as in *Touch of Evil* or *Chimes at Midnight,* a cause for sentimental regard. In *F for Fake* it is an illusion. For Kubrick, sexuality is another cause for his characters' failure, for their misconceptions, mistakes, often colossal blundering. "Women," says the ghostly Lloyd the barman in *The Shining,* happily mouthing the clichés Jack wants to hear. "Can't live with them, can't live without them." "Words of wisdom," says Jack, the would-be wife and child killer, "words of wisdom."

THE ART OF FEELING

The critical act is rational by definition. My task and pleasure has been to enter the films, find out what makes them work, and relate those findings in ways that open out their meanings, their stylistic traits, their obsessions, and perhaps their effect on me. But the critical act is almost hopeless when it comes to dealing with emotions. I can say that a film moves me, and indeed the films I have been discussing move me deeply, but it is difficult to find the discourse of emotional response. So what follows is an experiment. Through a process of description and quotation, often by indirection, I would like to try to create such a discourse, something of a memoir of response and a discussion of what Welles, Hitchcock, and Kubrick do to elicit emotion.

I begin, almost by default, with *Vertigo* and with the question of why this film outstripped *Citizen Kane* in the *Sight and Sound* poll of greatest films. *Kane* is an emotionally cool movie, and I've suggested that its excitement comes from its formal experimentation. We are intrigued by the methods by which Welles plays with the conventions of late 1930s cinema and, in so doing, prepares the way for the look of American films to come. There is the power of invention, an audaciousness about what to do with the camera and at the editing machine, and about how to build a narrative by exploring and inhabiting various

points of view. But emotionally the film is as reticent as its protagonist is distant. I've spent some time talking about the inapproachability of Charles Foster Kane—No Trespassing!—and the fact that Welles obeys his own warning. Kane remains not so much an enigma as he is the result of a pastiche of undependable impressions. The media baron is therefore as empty as the headlines of his newspaper. His egocentrism, jealousies, brutalities are told rather than felt, shown in light and shadow, depth of field revealing little of depth. When Welles indulges in a melodramatic moment—the close-up of Mrs. Kane and her son as they are about to be separated—it looks a little awkward in a film notably without close-ups. *Citizen Kane* is a monument to American film, with all the solidity and coldness that implies.

Hitchcock's career, as opposed to Welles's, has often been veiled by the patina of commerciality. He had, until his work of the mid-1950s at least, been seen as a talented, canny observer of audience need. The clichéd label, "master of suspense," served to tamp down serious critical response, at least until the 1960s when Robin Wood, picking up the interest the French were showing for American filmmakers, compared Hitchcock (now considered an "American" director) to Shakespeare. But there was still something *wrong* with Hitchcock. His work was too glib, perhaps, too tricky, lacking gravitas. But as film studies grew and the inherent complexity of Hitchcock's work became more open to critical scrutiny, that commercial patina became seen as just that, one layer over others that garnered greater critical interest. Perhaps it helped that *Vertigo* was not a commercial success in its time; perhaps it helped as well that the film was withheld from circulation for ten years. When it reappeared, it revealed itself as something more and something less than what we had known about Hitchcock up till then. *Vertigo* is not a crowd pleaser. It is slow, contemplative, its first part taken up with long sequences of Scottie driving around San Francisco, trailing the elusive Madeleine/Judy. It seems to have two different sections and to give itself away at the wrong time. Worst of all, it is not

FIGURES 46–47 Scottie and Midge discuss their relationship in *Vertigo*. The high-angle extreme close-up of Midge (right) speaks volumes.

clear about how we are to view its central character: is Scottie a victim of his own disorder and of the friend who takes advantage of it, or is he an obsessive abuser, forcing a woman into an image that finally causes her death?

In the end it is the contemplative tone, the elusiveness of easy interpretation, the ambiguity of Scottie's character, and, as simple as this sounds, the lack of a conventionally happy ending that began to draw closer attention to the film and allowed it to climb in critical reputation. Something else: the more one looks at *Vertigo*, the more it is seen, the more is seen, the more is felt. *Vertigo* is a well-wrought organism for generating emotional response.

The film's very opening seems to set up a contradiction. The credits, with their spiraling patterns emerging from a woman's eye, are backed by Bernard Herrmann's poignant, spinning score, "an extremely resonant configuration of high strings, winds, harp, celesta, and vibraphone." This resonant configuration marks not only the score but the film as a whole, whose structure is orchestrated visually and in its narrative structure in chromatic and dissonant layers. The mood set up by the credit sequence is broken by the first shot, a disorienting image of

hands clasping the rungs of a ladder on the roof of a building. What follows is something snatched from a police thriller, a pursuit over the roofs after an unidentified suspect. The lack of identification, the confusion on the part of the viewer about what exactly is happening, is important for what follows. In this film Hitchcock's obsession with the wrong man or, more accurately in this case, the wrong woman, indeed with the fact of identity itself, becomes a driving force in which two people, Scottie and Judy/Madeleine, lose themselves while trying to find an erotic anchor that does not, finally, hold.

Until the moment that Scottie sees Madeleine/Judy in Ernie's restaurant, there is no clear emotional path for us to follow. There are startle effects, like Scottie's clinging to a roof gutter in the opening chase sequence and the first visual effect—the simultaneous track and zoom in opposite directions—representing his vertigo. There is the superficially cute visit to Midge's apartment. Scottie is wearing a corset for his back and using a cane (cosseted like his predecessor Jeffries in *Rear Window*). We learn that Scottie was "a bright young lawyer," whose plan was to be chief of police. Because of his acrophobia, which caused the death of the cop trying to save him, he has quit the force. Amid the casual conversation, however, comes a silent clue that

Scottie has some profound sexual problems. "How's your love life, Midge?" Scottie asks. "Following a train of thought . . . Normal," she answers. Midge is at her drafting desk; Scottie reclines on the couch, waving his cane. "Aren't you ever going to get married?" he asks. "You know there's only one man in the world for me, Johnny O." "You mean me." We look at Scottie on the couch, smiling. "We were engaged once, though, weren't we?" Something extraordinary happens. The simple setup of the scene, loosely framed shots of Midge and Scottie, is broken by a tight close-up of Midge, at a high angle, looking down at her. That high angle always means trouble. Midge's eyes are looking off to her right; there is a slight smile on her face. A car horn can be heard faintly in the background. "Three whole weeks," she answers. Cut back to Scottie on the couch: "Good old college days. But you were the one who called it off, remember?" On the word *remember* Hitchcock cuts back to that same shot of Midge, her eyes lowered, a slight frown on her face, as Scottie claims that he's still available.

Something is amiss. The insertions of these oddly framed shots of Midge reacting to Scottie suggests that their "love lives" may not be exactly normal. Midge still wants Scottie; Scottie is still available; but something happened years ago. A brief engagement that Midge called off. That's all we learn. But we are warned by our gaze at Midge and her gaze away from Scottie that all is not right.

Hitchcock is very slowly building a case and a trap. The construction continues in Gavin Elster's office, where, in a carefully organized choreography in which Elster is given a visually superior position to Scottie, he constructs for the gullible, weakened detective his story of a wife possessed by the dead Carlotta Valdes (see figure 40). Scottie is made a reluctant tool to a murder plot. We are drawn into the lie. And it is just here that the pathos of the film is set. As accomplices to a fiction within a fiction (that is, the film itself), we first submit to Scottie's infatuation with the woman he thinks is Madeleine possessed by Carlotta, as opposed to Judy, who is playing Madeleine, while at

the same time being subject to questions posed by the visuals in the film: Midge's odd gaze, the dark alley that opens into a colorful flower shop, the mysterious McKittrick Hotel, Pop Leibel's story of the mad Carlotta, Madeleine/Judy's dive into the San Francisco Bay, and the suggestion that Scottie makes love to her comatose body. All of this is capped by the rapturous sequence in the sequoia forest and the embrace of the lovers by the pounding ocean accompanied by Herrmann's surging, Wagnerian score. The scene is so over-the-top that its melodramatic energy all but collapses under its own weight. And collapse it does when Scottie's vertigo makes him powerless—as Elster predicted it would—to save the fall from the mission tower of Madeleine (we think), of Elster's wife, in (fictional) fact.

Trauma momentarily takes the place of obsession (though obsession is a form or expression of trauma). Scottie is humiliated during the coroner's inquest, a gray congregation of men in a low-ceilinged room opposite the mission. His very potency is questioned; he is left powerless and bereft. We have no idea where the film will go from here. Scottie visits Madeleine's grave—this would be the grave of Elster's actual wife—and then has a nightmare. For the dream sequences in *Spellbound* Hitchcock hired Salvador Dalí to design the sets; for *Vertigo* a Walt Disney animator supplied the images of opening and fragmenting flower petals. Bernard Herrmann supplies what Royal S. Brown calls a "grotesque reworking of the habanera for Carlotta Valdes." This gives the dream an element of kitsch, as if within the horror of Scottie's experience there is some small revelation of the nonsense of Elster's plot. The dream imagery shows us an imaginary Carlotta, displaying the broach that will give away Judy's identity later in the film. Scottie's gullibility is on display in his own nightmare as he falls into oblivion and a paralytic depression.

While hardly paralytic, we are left in a kind of narrative limbo, emotionally thrown about by a love story that we still don't know is based on a lie, shown a horrible death by falling, shown an all but

incomprehensible nightmare, and now left with our main character all but unable to move or speak. Even his helpmate and surrogate mother Midge is helpless, as she disappears down that long gray corridor of the asylum holding the unresponsive Scottie. The film is now almost two-thirds over and suddenly Hitchcock presents us with a conventional establishing shot, a pan of San Francisco. It is as if he were starting the film over again, and indeed Scottie, in some remission from his paralysis, is back on the streets of the city, believing he sees Madeleine in all their old haunts, retracing his steps, like Bill Harford in *Eyes Wide Shut*, who is haunted by the image of his wife making love to a naval officer. Haunted by a ghost. As Madeleine was presumably haunted by Carlotta, Scottie is now palpably haunted by Madeleine. Herrmann's yearning, sorrowful music accompanies his new obsessive rounds.

Discovering Judy as if by accident on the streets, Scottie becomes Pygmalion, turning the woman who had been turned into Madeleine back into the woman she had been turned into by Elster. The pathos is marked. Scottie, a figure of some sympathy, becomes an abusive, narcissistic character who successfully tries to remake a woman into his image of someone who never existed. He effaces, even defaces, her: "It can't matter to you," he tells her over her protestations of disappearing into the image he has of Madeleine. This negation of a personality is as violent an act, short of murder or rape, that Hitchcock has ever allowed a character to commit. It is also enormously sad for both Scottie and Judy. Its completion returns Scottie's potency; he can now make love to a ghost. But the void is already open. The gaping grave Scottie saw in his dream was a precise foreshadowing, as was his experience of falling through space. While he will not physically fall (indeed, he overcomes his vertigo), the fall of Judy is foretold, and Scottie will be left gazing into the void of his own self-destruction.

Vertigo is no less calculated than any other Hitchcock film. Each piece, each shot, each move is carefully thought out. But where a film like *Psycho*, for example, also calculates response, where the sufferings

of Alicia in *Notorious* or even the abused crofter's wife in *The 39 Steps* calls forth pity and sorrow, the emotional aura of *Vertigo* is incalculable and open-ended. We may know that Norman turns out to be Mother, and on subsequent viewings we can see how often Hitchcock gives away the joke. But while we know the outcome of *Vertigo*, the intricacies of Scottie's decline and fall strike us anew with each viewing; the film's melancholy tone, abetted by Herrmann's score, envelops us again and again. Scottie's ruin, no matter how many times we witness it, continually elicits a response of some distaste and a large amount of sadness. It's the kind of sadness that is called forth by a number of characters made by our three directors. Humbert Humbert in *Lolita* is a distant relative of Scottie, he turning a child into an object of desire, only to be destroyed by his attempt. Even Hank Quinlan in *Touch of Evil* receives a modicum of pity as someone destroyed by an attempt to create a world that fits his corrupt and corrupting vision. An ambivalent response not to judge is unwittingly a request for overwhelming emotion.

Welles's films are certainly less calculated than Hitchcock's, and their emotional charge is generated as much by their formal energy as by their content. I've pointed out the struggle in his work between sentimentality and a modernist impulse of a distant, formal contemplation of despair and death. It is possible, and I've certainly found it so, to return again and again to Welles's films to enjoy the emotions charged by the audacity of form. But the late films—*The Trial, Chimes at Midnight, The Immortal Story*, and *F for Fake*—betray not only a continued interest in formal experiment but also a greater lyricism, an elegiac tone that makes them the most emotionally felt of his output. Each of the three fiction films of the group speaks of challenges to individuality, the agency of the self, the ability to attain and maintain a workable presence in the world. The contemporary world of *The Trial* is a labyrinthine monolith of absurdity and constraint, where every move on the part of Josef K., every entrance and exit, is countered by another tribulation in another gigantic space. Spatial

continuity is sacrificed for the compression of illogic within the enormous confines of the law. In one instance K. moves from an open space filled with half-naked elderly people with numbers hung around their necks and a gigantic shrouded statue looming over them to a room filled with hundreds of onlookers—recalling Charles Foster Kane giving his election speech—where he attempts to defend himself. He is erroneously called a "house painter," and the images and words conspicuously recall the concentration camps of Adolf Hitler. The "hearing" is interrupted by a woman carried off by a huge man at the back of the room. When K. follows them out and closes the door behind him, he turns and sees the door overwhelming him in its enormity. Such juxtapositions of surreal sublimity jar us staggeringly into an amazed expectation.

K.'s anxiety is shared to an extent with the viewer. But the viewer of this or any film sees (if not knows) more than its central figure. The result of this in *The Trial* is anticipation of K.'s end, which is retarded by the individual sequences of the film and their utter strangeness. A kind of alienation effect occurs in which we are pushed forward by the narrative and halted by all but incomprehensible locations adding to K.'s pain. The pain of *Chimes of Midnight* is sweeter because its characters are less malignant. With the exception of the battle sequence, the body of the film plays gently around the dance of Falstaff and Prince Hal, and the latter's seemingly cruel denunciation of the spirit of his youth. That act, while full of pathos, has the logic of time's passage and the inevitable changes of things, the tears of things. Similarly, *The Immortal Story* presents us again with the inevitability of fall and failure. Mr. Clay is a sad wreck of a man, impoverished of imagination, and his attempt to turn imagination into fact simply kills him. This little film talks of a vast sadness, of the incomprehensible imagination and the devastation that occurs if we try to fool it.

Fooling the imagination is the theme of *F for Fake*, but the terms are more lightly negotiated. Here is Welles the magician, who owns

the imagination and its productions. As a joyful celebration of illusion making, of the artist imposing his will on an eagerly receptive audience, the film is unlike anything that Welles had done previously, and not only because it is a kind of documentary. Rather it is a radical attempt at foregrounding the face of self-effacement, Welles's face and voice, the reassurance of his power as a maker of illusion—of all artists making illusions either ephemeral or, in the moving passage about Chartres, authentic. Welles in his maturity, while still eager to create large cinematic moments, seems even more eager to grow closer to his audience, to lay bare an emotional vulnerability that had been absent from the earlier work.

But throughout his films the emotional charge of the Wellesian sublime is powerful in a way that carries us into and across his characters. His images, as I've often suggested, overpower characters and story—overdetermine them. The shootout in the mirror maze of the funhouse that climaxes *The Lady from Shanghai* tells us nothing other than the characters hate each other. We care not a whit for them but

are held in awe by the emotions discharged by the shards of glass that reflect and shatter their images (see figure 22). When Elsa Bannister lies dying after the shootout, the camera looking at her from below floor level, Michael in soft focus behind her, she calls out pathetically, like HAL in *2001: A Space Odyssey*, "I'm afraid. . . . I don't want to die," Mike ignores her and walks out. She had already delivered a bleak assessment of their lives—"We can't win," she says. Mike retorts, "We can't lose either . . . only if we quit." He attempts to maintain a semblance of control even after the sharks have eaten one another. He attempts, as well, to regain our sympathy, to proclaim that he is a fool and will die trying to forget Elsa. He, too, will die; but not quite yet. He walks into the sunrise on the San Francisco waterfront. But pathos has already turned to bathos. As in so many of Welles's films we have seen too much. Images have drawn our breath away.

Of course, the same could be said about Hitchcock, except for the fact that there is greater constraint on their environment than Welles allows. For Welles background becomes foreground. The complex choreography of figures in the scene in which young Kane's parents sign him away to Mr. Thatcher distracts us from the bad business that is being conducted. But this is not a flaw. The aesthetics of form are eloquent to the point of gaining enough of our recognition and emotional response even as we are distracted from the event itself. The dark, off-center, garbage-strewn world of *Touch of Evil* elicits more melancholy than the characters scurrying through it. The power of the image carries emotional potency, and this remains longer in the consciousness than any plot or character device. We remember the long crane up to the stagehands holding their noses as they listen to Susan Alexander try to sing opera in *Citizen Kane*, the mirror maze of *The Lady from Shanghai*, the frantic editing of *Othello*, the dark streets of Los Robles in *Touch of Evil*, the cavernous ruins of *The Trial*. They are written on our memory and in our feelings more than the stories the images are attempting to relate. Plot is short. The lodging of images in the emotional memory is long.

Of the three directors' films, Kubrick's have most borne the charge of being cold, perhaps passionless, somehow a reflection of the insular life of their creator. "An ice-pack of a movie," Pauline Kael wrote about *Barry Lyndon*. I think about such comments often because my feelings of closeness to Kubrick and his work seem to belie them. Does my own predilection for cool, intellectual cinema account for my love of Kubrick's work? If there is love, then certainly there should be passion. Is the passion one-sided? Am I taking more from the films, responding to more than is there? But the fact is that my desire for a Kubrick film is always fulfilled, again and again, though perhaps in different ways than the fulfillment that comes from other films. My emotions are set in turmoil by *Vertigo*, charged up and saddened by *Chimes at Midnight*, but brought fully alive by *2001. A Space Odyssey* or *Barry Lyndon*. Even *Eyes Wide Shut*, the film that has haunted these pages, elicits an all but overwhelming sense of anticipation and a haunting sense of lack of closure when I do see it. I sometimes wonder if my response to the films is based on a desire to get further into Kubrick's head, to know how much more he was thinking—in short, I want biography; I want some kind of personal contact.

I wonder if that makes me an intellectual stalker? Perhaps mine is only a complicated response that is commensurate with the complexity of the films and the demands they make. The surfaces of Kubrick's films are visually cold indeed. With the exception of the black interior of the war room of *Dr. Strangelove*, the candlelit sequences of *Barry Lyndon*, and some nighttime sequences throughout the films, Kubrick was fond of high-key, almost fluorescent lighting. This is the exact opposite of the lighting favored by Welles and Hitchcock, the latter, who, even in his color films, modulated the color scale, played with color effects, and always moved to darkness when things got threatening. Kubrick, himself a brilliant manipulator of color (just note the palette of *Eyes Wide Shut*), seems to want us to see everything, every detail, every element of set design. Discussing *2001: A Space Odyssey*,

I used the art history term, *horror vacui*, the desire to fill every space on the canvas with a figure or object. The film is an argument about the imperative to see and respond to the unknown and the uncanny. The astronauts don't respond; the HAL 9000 computer does; the viewer does. But at the same time the response is overwhelmed. There is too much visual information, and all of it—with the exception of the brand names that adorn the spacecraft, the food, and the space station—unfamiliar. Those names themselves—Pan American, Hilton, Seabrook Frozen Foods—seem out of place branding the objects and places of a speculative future. The familiar and unfamiliar clash— this is almost a definition of the uncanny—resulting in an assault on our eyes and our response.

It could be argued that much of Kubrick is an assault. He forces our attention through the creation of the extraordinary image. Certainly Dave Bowman experiences his trip through the black hole and into his own mind-made hotel room prison as an assault, represented by his shuddering, wide-eyed stare. He has achieved the exquisite perception of HAL, whom he attempted to destroy before his trip beyond the infinite and whose all-seeing eye he seems now to have inherited. *A Clockwork Orange* is all but a continuous assault. Beatings, rape, brainwashing, torture, expounded upon with a beaming joy or mock melancholy by Alex, our humble narrator. Both films, made one after the other during Kubrick's most productive period, look at a future world with a combination of futility, exasperation, irony, and awe. Because any fantasy of what may come is a speculation based on what already is, *2001* and *A Clockwork Orange* offer us a view of the present in which men (and they are concerned mostly with men) have relegated their responsibilities to machines or to the state. Kubrick had already destroyed the world in *Dr. Strangelove*. Coming back in a full circle to a future world, he is already stating that, if the world should exist at all, it will be a strange, posthuman place where the conventions of Western behavior and response have mutated almost beyond recognition.

Abundance of vision, speculation on the loss of humanity, an assault on the senses—the ironies of technological intelligence all combine into a potent mix. In *Strangelove, 2001,* and *A Clockwork Orange* Kubrick is presenting a kind of dare to his audience: if you do not respond to this, then you are complicit in the very things that I am critiquing. It is almost a Hitchcockian proposition, though stated without Hitchcock's tidy puzzle-like construction of images and scenes. "Viddy well," dear viewer, these three films beg of us; seeing is feeling, and feeling, even when filtered through startling, even brutal images, has to be acknowledged.

But, once again, how does one acknowledge the emotions generated by an artwork? When we laugh at Buck Turgidson gleefully telling the inhabitants of the war room how his planes can fool Russian radar—"If the pilot's good, see. I mean, if he's really sharp, he can barrel that baby in so low . . . you oughtta see it sometime, it's a sight. A big plane, like a '52, vroom! There's jet exhaust, fryin' chickens in the barnyard!"—a cascade of responses occurs. Some of them emanate from Turgidson himself: his manic delight in the capabilities of his pilots and then his realization that these capabilities will lead to the end of the world. The rest are the responsibility of the viewer, who must decode the satirical exaggerations of the character and his antics and the film as a whole. *Dr. Strangelove* is about the lunacy of Cold War discourse, the obsessive anticommunism and military chest-thumping that led to blacklisting, neglect of important priorities, and, in the imagination of Kubrick's film, the resurrection of fascism and the apocalypse. Presenting all of this as a comedy is risky, particularly at the time of the film's release, a few months after the Cuban Missile Crisis. Indeed, *Strangelove* was originally conceived as a serious film, based on a serious novel by Peter George; but the more they thought it through, the more Kubrick and coscreenwriter Terry Southern realized the comic absurdity in the situation they were developing. The risk is well taken as long as the viewer understands how the satire mocks but doesn't diminish

the potency and the pomposity of Cold War discourse. We can simultaneously be amused and horrified by the antics of the characters in the darkness of the war room, General Ripper's office, and amid the buttons and switches of the B52 cockpit. The whole apparatus of the film leads to a violent impotence and the final explosion of pent-up wrongheadedness, resulting in Major Kong's releasing his bombs by hand and riding one like a giant phallus to destroy the world. Like all great satire *Dr. Strangelove* requires a multilayered response of laughter at absurdity and a recognition of the deadly seriousness of its target.

The conflation of sex and aggression is, as we have seen, a lingering theme in Kubrick's work. Played for horrified laughs in *Dr. Strangelove*, it becomes a source of uncomfortable pleasure. In *A Clockwork Orange* pleasure causes a sense of guilt and stimulation. The vitality of Alex, the unalloyed joy he takes in beatings and rape and Beethoven confuses and misdirects us. Are we feeling what we should be feeling? Is this in fact another instance of a transfer of guilt? Kubrick tinkers with our response and disallows it to come without complications. Emotions come with a cost: if I am delighted not only with Alex, but with the electric propulsion of the film as a whole, I become complicit in the ostensible moral of the film, that free will is better than will constrained. Alex de Large, Alex *at* large, in all his brutal vitality is somehow better than Alex reduced by the Ludovico Treatment that leaves him a retching wreck in the face of sex and violence. In truth we are duped, we are given false choices, and we pay a price for being seduced by Alex.

Well, "price" is an exaggeration. There is no cost to the emotional response to a film. True, as I noted earlier, there may have been a few copycat crimes committed in England that spurred Kubrick and Warner Bros. to withdraw *A Clockwork Orange* from British screens for fear of lawsuits. But the emotions we feel when we are in our proper minds may linger, may cause us discomfort, but have no real-world consequences, but they do have imaginative consequences. Kubrick's

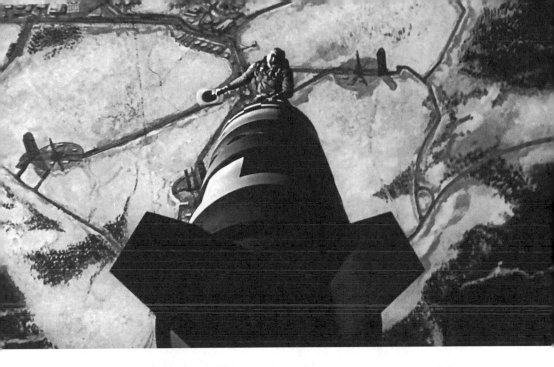

FIGURE 49 Apocalyptic fornication: Major Kong rides the bomb to Doomsday in *Dr. Strangelove*.

images tend to stay with us, as does the narrative movement of his films. We remember Alex and the curve of his ascent, fall, and rise; we remain puzzled by the last image of Alex screwing a young *devotchka* in the snow; we recall the charge we get when the climax of Beethoven's Ninth Symphony sounds as Alex calls out, "I was cured all right!" But only the application of thought to these emotions and memories can straighten out the deviousness of the film and its central character because of the irony underlying its set of false choices. And this is the trick played in most of Kubrick's films, not so much "emotion recollected in tranquillity," as the poet William Wordsworth would have it, but emotion recollected in rationality, in the afterimage of thought, in the pleasure of rational recall.

It's not that Kubrick is devoid of the emotion of the moment. *Barry Lyndon* is his most overtly sentimental film in which character and action express a longing and sadness, triumph and loss that one might find in any well-made film. But for one thing: *Barry Lyndon* is a costume drama about a lost time, and as such it is an extreme imaginative re-creation,

which Kubrick attains by creating painterly compositions that recall the work of seventeenth- and eighteenth-century artists. And he slows the action to an almost dreamlike pace in which emotion is felt through the slow process of painterly space and notional time. Complicating things further, the film supplies a narrator, who elegantly tells us things that we do not see, offers us opinions of Barry that we might not share based on what we are seeing, and tells us what will happen before it does. Every formal element of the film seems to militate against an immediate emotional response but in fact heightens it.

Earlier I spoke about the powerful emotional energy of *Barry Lyndon*. I want to demonstrate how that energy is generated by a clever thing that Kubrick does with his source, the effect of which is to turn the conclusion of the film into a painfully emotional series of tableaux. At the very beginning of William Makepeace Thackeray's novel *The Luck of Barry Lyndon* his unpleasant narrator—Barry himself—dismisses his memories of his lineage:

> However, why should we allude to these charges, or rake up private scandal of a hundred years old? It was in the reign of George II that above-named personages lived and quarreled; good or bad, handsome or ugly, rich or poor, they are all equal now; and do not the Sunday papers and the courts of law supply us every week with more novel and interesting slander?

Kubrick finds the pathos in the middle of this throwaway comment and places it at the very end of the film. Barry has been ruined and banished, his leg amputated; he is effectually castrated. After the freeze-frame of Barry entering a coach that is to take him away, there is a coda. To the dying fall of the Schubert Piano Trio, we see the remnants of the Lyndon family and retainers signing checks, their lives reduced to a ceremony of accounting. There are close-ups of Lady Lyndon and Lord Bullingdon, her son who wounded Barry in a duel. As she signs the bill for the payment that was part of the deal for Barry's banish-

ment, a look of minor regret, loss, and anger, crosses her face. The camera zooms into the bill; the year is 1798, a time of great change and revolution. Kubrick then cuts to a distant shot of the group, surrounded by the lavish accoutrements of their class. The shot is held for a time until the final title card appears:

EPILOGUE

It was in the reign of George III
that the aforesaid personages lived and quarreled;
good or bad, handsome or ugly, rich or poor
they are all equal now.

Barry Lyndon is an elegy to ambition lost, to male privilege ruined by sentiment (Barry is himself the most sentimental character in the Kubrick pantheon), to the overwhelming sadness of human endeavor and the inevitability of loss. The repositioning of Thackeray's words puts a period to the elegy and repositions the characters and the viewer into a state of sad contemplation.

Sentimentality is rarely the source of emotion in Kubrick's films. When Barry tearfully tells his dying son the story of his army bravery, it feels false, as if Barry were trying too hard to gain our sympathy, to recreate himself as a man of feeling. Barry is not as bad as the Barry who is created by the film's voice-over narration, and his outpouring of grief may be heartfelt. But it ruptures the tone of the film, whose slow solemnity would seem to preclude such an outburst. This may have been Kubrick's intention, to reduce Barry to the banality of sentimentality in order to allow him some humanity and prepare him (and us) for his selfless performance at the duel with his stepson, a selflessness that will leave him legless, homeless, all but penniless, and without heirs.

Barry's response to his son's death is unusual for a Kubrick character. Emotion in his films usually grows from their characters' desperation, overreach, lack of reach, passivity, or stupidity. The irony

FIGURE 50 The last sequence of *Barry Lyndon*: a ceremony of accounting and loss.

emerges from the way the films use these otherwise unappealing traits to excite us with a larger insight into a reduced situation, and an emotional response to the recognition of loss and death. Taken with complete seriousness, this could be a tragic view of the human state; but because Kubrick's is essentially an ironic/comic view, his view of human agency may be dim, but his pessimism is bright with the hope of recognition—in fact *our* recognition of ourselves in the characters, of the characters as less than ourselves, in their uncomfortable situation within Kubrick's extraordinary images.

In his *Anatomy of Criticism* Northrop Frye writes, "If inferior in power or intelligence to ourselves, so that we have the sense of looking down on a scene of bondage, frustration, or absurdity, the hero belongs to the *ironic* mode." This could be a precise description of Jack Torrance's situation in *The Shining*. He is an absurd hero, bound by his belief in the curse of the Overlook, frustrated in his desire to be a writer, and placed literally in bondage when locked in the refrigerator by the wife he wants to kill. Jack is as doomed a figure as any in the Kubrick canon, moving from clown to monster to a raving thing, undone by his son, finally frozen in perpetuity. There is no extended

feeling, no secure response, certainly no sense of identification that we can offer this protean, this diminished, laughable figure. Perhaps this is why a ludicrous amount of conspiracy theories has grown up around this film. From being an allegory of the Nazi extermination of the Jews to a covert admission that Kubrick helped NASA by creating the moon landing of Apollo 11, there has been a manic search for something in this film to grab onto. The ironic mode is hard to accept by the Mr. Clays of the world.

In fact, the ironic mode, carefully understood, should lead to a sense of elation, a reaction to the release the films offer us from the foolishness and the sufferings of the characters as well as a release, in Kubrick's case, from film conventions—the science fiction film, the war film, the horror film, the costume drama, the domestic melodrama. Form triumphs; no heroes emerge. Dave Bowman battles a computer and wins or loses. We are left at liberty to decide. Jack Torrance is frozen in the labyrinth of his own patriarchal muddle. Private Joker is trapped in the stupefaction of gender reversal, undone by and then killing the female sniper. Bill Harford seeks sexual release outside the trying comforts of the domestic. There is pleasure in the absurdity, an emotional response to the humbling of these characters, admiration for the skill with which that humbling has been engineered.

The triumph of modernism is the triumph of form over content, of form becoming content, and that content obsessed so often with the diminution of characters. There is a perversity to this, especially when we realize that most film is about triumph of, especially, the male character, their stories told by means of a formal structure that renders itself invisible. It is the triumph of Orson Welles, Alfred Hitchcock, and Stanley Kubrick over the ordinary, the conventional, the banal—even while occasionally mocking the banality of their characters—that creates a profound emotional attachment, a yearning to see more, to penetrate the intricacies of form to find the further perfections of form beneath. This is the passion of the endless satisfaction of the extraordinary.

CODA: AN IMMENSE SHADOW

During the years 2015 to 2016, when this book was being written, Norman Lloyd turned 102. Lloyd was an actor in Welles's theatrical troupe during the 1930s. He was one of the Mercury players. He acted for Alfred Hitchcock in *Spellbound* and as a Nazi spy in *Saboteur*: he's the one who falls from the top of the Statue of Liberty. He has a small role in Judd Apatow's film *Trainwreck*. He produced and directed some episodes of *Alfred Hitchcock Presents,* and he directed a series on Abraham Lincoln for the prestigious early television program *Omnibus*. Stanley Kubrick was a second-unit director on the show. He holds a collective memory of the three directors I've been celebrating but speaks mostly of Welles. *New Yorker* writer Alex Ross did an interview with Lloyd late in 2015 and wrote:

> As we spoke, Lloyd kept returning to the subject of Welles, about whom he had sharply mixed opinions. At one point, he delivered what seemed a laudatory summing-up: "I think he's the greatest talent we ever had in the theatre in America. . . ." Having seen me excitedly taking notes, Lloyd then pointed a skeptical finger at my notebook. "The question is: Who *was* he? What *world* did Orson bring? He brought an energy; he brought an enormous

staging skill—the best. Style, yes. Theatricality, yes. But, you know, you look for the *weight*, the *story* a man brings." After recalling the ending of Chaplin's *City Lights*—the blind girl recognizing the Little Tramp by the touch of his hand—Lloyd resumed the interrogation: "Does Orson have that humanity?" Such questions linger in many people's minds, but Lloyd's slip into the present tense showed that Welles still casts an immense shadow.

The question of our directors' humanity has concerned me throughout this book, at least as it is reflected in their films. It's not grasped at first sight; you have to live with the films to see their deep preoccupation with the fears, the failures, the constant, even if doomed, striving of their characters. The films' humanity lies in their sadness and their horror, in their pessimism about any long-lasting triumph. Their excitement is in the ways they tell these stories. It is the means of telling that casts immense shadows. Hitchcock has had many unsuccessful imitators (perhaps with the exception of Martin Scorsese's *Taxi Driver*, a film that captures the spirit of its predecessor as well as using a score by Bernard Herrmann). Welles and Kubrick are enormous influences on filmmakers, even though their style, their *vision*, is inimitable. But let's not use that word *vision*; it worries me a bit; it's a more pompous word than Welles, Hitchcock, or Kubrick would have wanted applied to their work. I'll stick with the *extraordinary image*, because in their images and the stories those images tell is an extraordinary array of cinematic ideas and ruminations about how we are in the world. They are among the great artists of the twentieth century, and they continue speaking to us with an unmatched eloquence and power.

CHRONOLOGY OF FILMS BY WELLES, HITCHCOCK, AND KUBRICK

These are the films that receive the most attention in *The Extraordinary Image*.

Orson Welles

Citizen Kane, 1941

The Magnificent Ambersons, 1942

The Stranger, 1946

The Lady from Shanghai, 1947

Macbeth, 1948

Othello, 1952

Mr. Arkadin, 1955

Touch of Evil, 1958

The Trial, 1962

Chimes at Midnight, 1965

The Immortal Story, 1968

F for Fake, 1973

Alfred Hitchcock

The Lodger, 1927

Blackmail, 1929

The Man Who Knew Too Much, 1934, 1956

The 39 Steps, 1935

Sabotage, 1936

The Lady Vanishes, 1938

Rebecca, 1940

Saboteur, 1942

Shadow of a Doubt, 1943

Spellbound, 1945

Notorious, 1946

The Pardine Case, 1947

Rope, 1948

Stage Fright, 1950

Strangers on a Train, 1951

I Confess, 1953

Rear Window, 1954

The Wrong Man, 1956

Vertigo, 1958

North by Northwest, 1959

Psycho, 1960

The Birds, 1963

Marnie, 1964

Torn Curtain, 1966

Topaz, 1969

Frenzy, 1972

Family Plot, 1976

Stanley Kubrick

Fear and Desire, 1953

Killer's Kiss, 1955

The Killing, 1956

Paths of Glory, 1957

Spartacus, 1960

Lolita, 1962

Dr. Strangelove or: How I Learned to Stop Worrying and Love the Bomb, 1964

2001: A Space Odyssey, 1968

A Clockwork Orange, 1971

Barry Lyndon, 1975

The Shining, 1980

Full Metal Jacket, 1987

Eyes Wide Shut, 1999

NOTES

Prelude

1 "Ce n'est pas . . .": From Jean-Luc Godard's 1970 film *Le vent d'est* (*Wind from the East*).

2 "The placing of the images . . .": François Truffaut, *Hitchcock*, with the collaboration of Helen G. Scott, rev. ed. (New York: Simon and Schuster, 1984), 265.

3 "represent our incessant effort . . .": Harold Bloom, *The Daemon Knows: Literary Greatness and the American Sublime* (New York: Oxford University Press, 2015), 3, 25.

3 "extraordinary hyperbole . . .": Ibid., 25.

5 what a director intends to do . . . : I'm borrowing liberally from George Toles, who wrote about the expectations of a film director: "Can you imagine this with the energy that I do? Are you up to the demands of seeing what is now before you?" See George Toles, "Rescuing Fragments: A New Task for Cinephilia," *Cinema Journal* 49, no. 2 (2010): 164.

9 "Wellesolator": Simon Callow, *Orson Welles*, vol. 2, *Hello Americans* (New York: Viking, 2006), xiv.

15 "think with their eyes . . .": A paraphrase of a comment made by Klaus Kreimeier and quoted by Ed Sikov, *On Sunset Boulevard: The Life and Times of Billy Wilder* (New York: Hyperion, 1998), 45.

17 "I cannot, will not, ever . . .": From a letter of Kubrick's, quoted by Peter Krämer, "'Complete Total Final Annihilating Artistic Control': Stanley Kubrick and Post-War Hollywood," in *Stanley Kubrick: New Perspectives*, ed. Tatjana Ljujić, Peter Krämer, and Richard Daniels (London: Black Dog, 2016), 50.

18 "Hitch was a frightened man . . .": Michael Wood, *Alfred Hitchcock: The Man Who Knew Too Much* (New York: Amazon Publishing, 2015), 98, Kindle edition.

18 "Kubrick's obsessive fear of the world . . .": Geoffrey Cocks, *The Wolf at the Door: Stanley Kubrick, History, and the Holocaust* (New York: Peter Lang, 2004), 27.

20 Jesuits taught him fear: Patrick McGilligan, *Alfred Hitchcock: A Life in Darkness and Light* (New York: Regan Books, 2003), 24.

21 His mother was a pianist . . . : See Simon Callow, *Orson Welles: The Road to Xanadu* (New York: Viking, 1995), 10; and Patrick McGilligan, *Young Orson: The Years of Luck and Genius on the Path to Citizen Kane* (New York: Harper, 2015), 41.

26 When the *New York Times* reported this . . . : Michael Cieply and Brooks Barnes, "Archivists Find Fragments of an Unfinished Orson Welles Autobiography," *New York Times*, May 21, 2015, C3.

28 "I did it to show people . . .": Mark W. Estrin, ed., *Orson Welles: Interviews* (Jackson: University Press of Mississippi, 2005), 189.

30 "approaches something resembling pure cinema . . .": Michael Anderegg, *Orson Welles, Shakespeare, and Popular Culture* (New York: Columbia University Press, 1999), 137.

30 And then Welles left for Europe . . . : Joseph McBride offers a detailed discussion of why Welles left the United States in *Whatever Happened to Orson Welles? A Portrait of an Independent Career* (Lexington: University Press of Kentucky, 2006). Callow also discusses this in *Hello Americans*, 442–444.

31 he got along well with Desi Arnaz . . . : For Welles's relationship with Desi Arnaz and how *The Fountain of Youth* foreshadows *The Twilight Zone*, see F. X. Feeney, *Orson Welles: Power, Heart, and Soul* (Raleigh, NC: Critical Press, 2015), Kindle edition.

35 horrendous images . . . : Robin Wood has pointed this out. See *Hitchcock's Films Revisited*, rev. ed. (New York: Columbia University Press, 1989), 150.

35 "late style": Edward Said, *On Late Style: Music and Literature against the Grain* (New York: Pantheon, 2006), 148.

36 In a heartbreaking moment . . . : See Stephen C. Smith's terrific biography: *A Heart at Fire's Center: The Life and Music of Bernard Herrmann* (Berkeley: University of California Press, 2002), 267–274.

38 for the startle effect: Brigitte Peucker calls it the "punctum" in her article "Kubrick and Kafka: The Corporeal Uncanny," *Modernism/Modernity* 8, no. 4 (2001): 663–674.

41 because, according to his wife . . . : See Geoffrey Macnab, "Kubrick's Lost Movie: Now We Can See It . . .," *Independent*, Jan. 26, 2009, www.independent.co.uk/arts-entertainment/films/features/kubricks-lost-movie-now-we-can-see-it-1516726.html.

41 installing a fax machine . . . : Rachel Abramowitz, "Regarding Stanley," *Los Angeles Times*, May 6, 2001, 4.

41 Baker's original production designs . . . : "A.I.: From Drawing to Sets," on the supplemental DVD, *A.I.: Artificial Intelligence* (Steven Spielberg, 2001).

41 Kubrickian irony . . . : Vivian Sobchack, "Love Machines: Boy Toys, Toy Boys, and the Oxymorons of *A.I.: Artificial Intelligence*," *Science Fiction Film and Television* 1, no. 1 (2008): 1–13.

The Work of the Body

43 Frederic Raphael . . . : Frederic Raphael, *Eyes Wide Open: A Memoir of Stanley Kubrick* (New York: Ballantine, 1999).

43 "Stanley had a secret fantasy . . .": Peter Bogdanovich, "What They Say about Kubrick," *New York Times*, July 4, 1999, www.nytimes.com/1999/07/04/magazine/what-they-say-about-stanley-kubrick.html.

44 "When I take a bath . . .": Truffaut, *Hitchcock*, 260.

45 Kubrick's bathrooms: See Peter Kubelski, *Kubrick's Total Cinema: Philosophical Themes and Formal Qualities* (London: Continuum, 2012), 14–21.

46 "excremental vision": Norman O. Brown, *Life against Death: The Psychoanalytical Meaning of History*, 2nd ed. (Middletown, CT: Wesleyan University Press, 1985), 179–201.

46 "general neurosis of mankind": Ibid., xix.

49 The famous stories of his multiple takes . . . : See Bogdanovich, "What They Say about Kubrick."

50 the Kubrick mask: Michael Ciment, *Kubrick: The Definitive Edition*, trans. Gilbert Adair and Robert Bononno (New York: Faber and Faber, 2001), 82–84

65 No wonder the film was banned in England . . . : Krämer points out that the film played for two years in England before it was pulled. See Peter Krämer, "What's It Going to Be, Eh?", 220.

Form, Time, and Space

83 "There were so many trick shots . . .": Orson Welles and Peter Bogdanovich, *This Is Orson Welles*, ed. Jonathan Rosenbaum (New York: HarperPerennial, 1993), 79.

92 Perhaps James Naremore . . . : James Naremore, *The Magic World of Orson Welles*, Centennial Anniversary Edition (Urbana: University of Illinois Press, 2015), 2.

93 "the one Wellesian film.": Anderegg, *Orson Welles, Shakespeare, and Popular Culture*, 107.

94 What did Welles mean . . . : Josh Karp, *Orson Welles's Last Movie: The Making of "The Other Side of the Wind"* (New York: St. Martin's, 2015), 112.

98 Welles hoped . . . : Jean-Pierre Berthomé and François Thomas, *Orson Welles at Work*, trans. Imogen Forster, Roger Leverdier, and Trista Selous (New York: Phaidon, 2008), 156.

101 at least three versions . . . : Jonathan Rosenbaum has suggested there may be seven versions; see "The Seven Arkadins," in *Discovering Orson Welles* (Berkeley: University of California Press, 2007), 146–162.

102 Welles despised Antonioni . . . : See Welles and Bogdanovich, *This Is Orson Welles*, 103–104.

110 stopped by a cop: For Hitchcock's attitude toward the police see Truffaut, *Hitchcock*, 205; for Welles's, see Callow, *Orson Welles*, vol. 3, *One-Man Band* (New York: Viking, 2016), 160.

116 K. dies "like a dog . . .": Franz Kafka, *The Trial*, trans. Willa and Edwin Muir (New York: Modern Library, 1964), 286.

121 Michael Wood says of Hitchcock's endings . . . : Wood, *Alfred Hitchcock*, 45.

128 The scene will be mirrored . . . : Michael Anderson, "'I Look Up. I Look Down. I Look Up. I Look Down': The Cycles of *Vertigo*," *Hopkins Review* 7, no. 4 (2014): 518.

130 This movement of shadow and insanity . . . : On Hitchcock's visit to Ufa see McGilligan, *Alfred Hitchcock*, 62–64.

The Dreamworld

131 Hitchcock allows us to share . . . : On the "Merry Widow Waltz" see Wood, *Alfred Hitchcock*, 54.

133 Stanley Kubrick has stated as much. . . . : Kubrick's statements that watching a

film is like dreaming are cited in Elisa Pezzotta, *Stanley Kubrick: Adapting the Sublime* (Jackson: University of Mississippi Press, 2013), 57, 115.

133 The French essayist Roland Barthes . . . : In "En sortant du cinéma," *Communications* 23 (1975): 104–107; see also Laura Rascaroli, "Oneiric Metaphor in Film Theory," *Kinema* (Fall 2002): www.kinema.uwaterloo.ca/article.php?id=141&feature.

135 "In dreams begin responsibilities": *In Dreams Begin Responsibilities* is the title of a 1948 collection of stories by Delmore Schwartz (New York: New Directions, 1976).

136 he did not want Bill and Alice to be Jewish . . . : Raphael, *Eyes Wide Open*, 59.

140 More significant still . . . : I expand on what I have to say here about the sonata form of *Eyes Wide Shut* in Robert Kolker, *A Cinema of Loneliness*, 4th ed. (New York: Oxford University Press, 2011), 181–182; see also Thomas Allen Nelson, *Kubrick: Inside a Film Artist's Maze*, 2nd ed. (Bloomington: Indiana University Press, 2000), 268–269.

142 But so many others were gray, depressed films . . . : Vivian Sobchack discusses the landscape of 1950s science fiction films in *Screening Space: The American Science Fiction Film*, 2nd ed. (New Brunswick, NJ: Rutgers University Press, 1997).

145 The most irritating talk . . . : For a discussion of the institutional spaces in Kubrick's films see Stephen Mamber, "Kubrick in Space," in *Stanley Kubrick's "2001: A Space Odyssey": New Essays*, ed. Robert Kolker (New York: Oxford University Press, 2006), 55–68; see also Kubelski, *Kubrick's Total Cinema*, 77.

147 Just about the time Kubrick was completing his film . . . : Information on black holes came from www.space.com/15421-black-holes-facts-formation-discovery-sd-cmp.html.

148 It is a projection of wealth . . . : See Kubelski, *Kubrick's Total Cinema*, 27–28.

149 In interviews he gave . . . : See, e.g., *Stanley Kubrick: The Playboy Interview (5 Years of the Playboy Interview)* (Los Angeles: Playboy Enterprises, 2012), Kindle edition.

150 "free at last from the tyranny of matter": Arthur C. Clarke, *Childhood's End* (New York: Rosetta Books, 2012), 177, Kindle edition.

150 a very early screenplay for the film . . . : Screenplay available at www.palantir.net/2001/script.html.

152 Douglas Trumbull seems to have . . . : John Whitney's influence on *2001: A Space Odyssey* is noted by Dan Auiler in *"Vertigo": The Making of a Hitchcock Classic* (New York: St. Martin's, 2000), 153.

153 There is some direct imitation . . . : A thorough analysis of the use of paintings in *Barry Lyndon* is in Tatjana Ljujić, "Painterly Immediacy in Kubrick's *Barry Lyndon*," in *Stanley Kubrick: New Perspectives*, 236–259.

155 In her wonderful study of *Barry Lyndon* . . . : Maria Pramaggiore, *Making Time in Stanley Kubrick's "Barry Lyndon": Art, History, and Empire* (New York: Bloomsbury, 2015), 30.

157 Maria Pramaggiore talks about . . . : Ibid., 29–30.

160 "In movies you don't try and photograph the reality . . .": See the documentary *Stanley Kubrick: A Life in Pictures*.

Power and Sexuality

165 Throughout *Vertigo*, recurring like a rhyme . . . : I was reminded of Scottie's comment about power by Dan Auiler in *"Vertigo": The Making of a Hitchcock Classic*, 2.

171 Tania Modleski writes . . . : Tania Modleski, *The Women Who Knew Too Much: Hitchcock and Feminist Theory*, 3rd ed. (New York: Routledge, 2016), 112.

171 These were criticized . . . : Robin Wood pointed out the dreamlike quality of the painted ship in *Hitchcock's Films Revisited*, rev. ed. (New York: Columbia University Press, 2002), 175.

174 Hitchcock liked to brag . . . : Truffaut, *Hitchcock*, 269.

174 George Toles called it "the infection of the eye," . . . : George Toles, "'If Thine Eye Offend Thee . . .': *Psycho* and the Art of Infection," in *Alfred Hitchcock's "Psycho": A Casebook*, ed. Robert Kolker (New York: Oxford University Press, 2004), 120–145.

178 *Wargasm* is the term invented by James Naremore: James Naremore, *On Kubrick* (London: British Film Institute, 2007), 119.

187 Beverle Houston coined the wonderful phrase . . . : Beverle Houston, "Power and Dis-integration in the Films of Orson Welles," *Film Quarterly* 35, no. 4 (1982): 2.

190 Welles once said that two things were impossible to film . . . : The exact quote, in an interview with David Frost is this: "I hate it when people pray on the screen. It's not because I hate praying, but whenever I see an actor fold his hands and look up in the spotlight, I'm lost. There's only one other thing in the movies I hate as much, and that's sex. You just can't get in bed or pray to God and convince me on the screen."

190 But some biographers are now saying . . . : Joseph McBride, for example, in *Whatever Happened to Orson Welles?* 185–187.

The Art of Feeling

194 "an extremely resonant configuration": Royal S. Brown, *Overtones and Undertones: Reading Film Music* (Berkeley: University of California Press, 1994), 159.

197 what Royal S. Brown calls a "grotesque reworking . . .": Ibid., 83.

200 A kind of alienation effect . . .: Anderegg, *Welles, Shakespeare, and Popular Culture*, 141–163.

203 "An ice-pack of a movie . . .": Pauline Kael, *5001 Nights at the Movies* (New York: Picador, 1991), 52.

207 "emotion recollected in tranquillity": See Wordsworth's "Preface to the *Lyrical Ballads*," in *Lyrical Ballads: Wordsworth and Coleridge*, ed. R. L. Brett and A. R. Jones (London: Routledge, 2005), 307.

210 "If inferior in power . . .": Northrop Frye, *Anatomy of Criticism: Four Essays* (Princeton, NJ: Princeton University Press, 1957), 34.

211 From being an allegory of the Nazi extermination of the Jews . . . : The leading exponent of this idea is Geoffrey Cocks, in *The Wolf at the Door*, 172–256.

211 There is pleasure in the absurdity . . . : In *Anatomy of Criticism* Frye addresses the question about how a work of art escapes being "depressing": "If any literary work is emotionally 'depressing,' there is something wrong with either the writing or the reader's response" (94).

Coda: An Immense Shadow

212 "As we spoke . . .": Alex Ross, "The Magnificent Memory of Norman Lloyd," *New Yorker*, Dec. 4, 2015, http://www.newyorker.com/culture/culturedesk/the-magnificent-memory-of-norman-lloyd./

SELECT BIBLIOGRAPHY

Anderegg, Michael. *Orson Welles, Shakespeare, and Popular Culture*. New York: Columbia University Press, 1999.

Auiler, Dan. *"Vertigo": The Making of a Hitchcock Classic*. New York: St. Martin's, 2000.

Benamou, Catherine L. *It's All True: Orson Welles's Pan American Odyssey*. Berkeley: University of California Press, 2007.

Brady, Frank. *Citizen Welles: A Biography of Orson Welles*. New York: Charles Scribner's Sons, 1989.

Brody, Richard. "The Best Movies of 2015." *New Yorker*, Dec. 11, 2015. www.newyorker.com/culture/cultural-comment/best-movies-2015.

Baxter, John. *Stanley Kubrick: A Biography*. New York: Carroll and Graf, 1997.

Berthomé, Jean-Pierre, and François Thomas. *Orson Welles at Work*. Translated by Imogen Forster, Roger Leverdier, and Trista Selous. New York: Phaidon, 2008.

Callow, Simon. *Orson Welles*. Vol. 1, *The Road to Xanadu*. New York: Penguin, 1995.

————. *Orson Welles*. Vol. 2, *Hello Americans*. New York: Viking, 2006.

————. *Orson Welles*. Vol. 3, *One-Man Band*. New York: Viking, 2016.

Castle, Alison, ed. *The Stanley Kubrick Archive*. Cologne, Germany: Taschen, 2004.

Ciment, Michel. *Kubrick: The Definitive Edition*. Translated by Gilbert Adair and Robert Bononno. New York: Faber and Faber, 2001.

Herr, Michael. *Kubrick*. New York: Grove, 2000.

Karp, Josh. *Orson Welles's Last Movie: The Making of "The Other Side of the Wind."* New York: St. Martin's, 2015.

Kubelski, Peter. *Kubrick's Total Cinema: Philosophical Themes and Formal Qualities*. London: Continuum, 2012.

Leitch, Thomas, and Leland Poague. *A Companion to Alfred Hitchcock*. Malden, MA: Wiley Blackwell, 2014.

Ljujić, Tatjana, Peter Krämer, and Richard Daniels, eds. *Stanley Kubrick: New Perspectives*. London: Black Dog, 2016.

LoBrutto, Vincent. *Stanley Kubrick: A Biography*. New York: Da Capo, 1997.

McBride, Joseph. *Whatever Happened to Orson Welles? A Portrait of an Independent Career*. Lexington: University Press of Kentucky, 2006.

McGilligan, Patrick. *Alfred Hitchcock: A Life in Darkness and Light*. New York: Regan Books, 2003.

_____. *Young Orson: The Years of Luck and Genius on the Path to "Citizen Kane."* New York: Harper, 2015.

McQuiston, Kate. *We'll Meet Again: Musical Design in the Films of Stanley Kubrick.* New York: Oxford University Press, 2013.

Naremore, James. *The Magic World of Orson Welles.* Centennial Anniversary Edition. Urbana: University of Illinois Press, 2015.

_____. *On Kubrick.* London: British Film Institute, 2007.

Nelson, Thomas Allen. *Kubrick: Inside a Film Artist's Maze.* 2nd ed. Bloomington: Indiana University Press, 2000.

Pezzotta, Elisa. *Stanley Kubrick: Adapting the Sublime.* Jackson: University of Mississippi Press, 2013.

Pramaggiore, Maria. *Making Time in Stanley Kubrick's "Barry Lyndon": Art, History, and Empire.* New York: Bloomsbury, 2015.

Raphael, Frederic. *Eyes Wide Open: A Memoir of Stanley Kubrick.* New York: Ballantine, 1999.

Rosenbaum, Jonathan. *Discovering Orson Welles.* Berkeley: University of California Press, 2007.

Smith, Stephen C. *A Heart at Fire's Center: The Life and Music of Bernard Herrmann.* Berkeley: University of California Press, 2002.

Spoto, Donald. *The Dark Side of Genius: The Life of Alfred Hitchcock.* New York: Da Capo, 1999.

Truffaut, François. *Hitchcock.* With the collaboration of Helen G. Scott. Rev. ed. New York: Simon and Schuster, 1984.

Walker, Alexander, Sybil Taylor, and Ulrich Ruchti. *Stanley Kubrick, Director.* Rev. and exp. ed. New York: Norton, 1999.

Welles, Orson, and Peter Bogdanovich. *This Is Orson Welles.* Edited by Jonathan Rosenbaum. New York: HarperPerennial, 1993.

Wood, Michael. *Alfred Hitchcock: The Man Who Knew Too Much.* New York: Amazon Publishing, 2015. Kindle edition.

INDEX

ABOUT THE AUTHOR

ROBERT P. KOLKER is Professor Emeritus at the University of Maryland. He is the author of *A Cinema of Loneliness: Penn, Stone, Kubrick, Scorsese, Spielberg, Altman* (4th ed.); *The Altering Eye: Contemporary International Cinema*; *Bernardo Bertolucci*; *The Cultures of American Film*; *Film, Form, and Culture* (4th ed.); and *The Films of Wim Wenders: Cinema as Vision and Desire* (with Peter Beicken). He is the editor of *Alfred Hitchcock's "Psycho": A Casebook*; and *Stanley Kubrick's "2001: A Space Odyssey": New Essays*.